D0236727

85	-5. OCT. 1990	M
985 Y		24. MAY
1986 Y	19 OC	25. NOV. 1992
1986	11. NOV. 90	-6. JAN. 1993
		15. APR. 1993

PAINT
& DRAW
with
Tony Hart

PAINT
& DRAW
with
Tony Hart

KAYE & WARD KINGSWOOD

OTHER BOOKS BY TONY HART:
The Art Factory
Also available in four paperback parts:
Stencils/Prints/Sand art
Ink/Wax/Paper
Metal/Light/Patterns
Stone/Markers/Rubbings

751.4

Z 041900

First published by Kaye & Ward Ltd
The Windmill Press
Kingswood, Tadworth, Surrey
1984

Copyright © 1984 Tony Hart

All rights reserved. No part of this publication may be
reproduced, stored in a retrieval system, or transmitted in any
form or by any means, electronic, mechanical, photocopying,
recording or otherwise, without the prior permission of the
copyright owner.

ISBN 0 7182 2957 6

Designed by Alan Miller
Typeset by August Filmsetting, St. Helens
Reproduced by H.K. Graphic Arts Service Centre
Printed in England by
W. S. Cowell Ltd, Butter Market, Ipswich

For Jean

Contents

Italian Family Positano 82

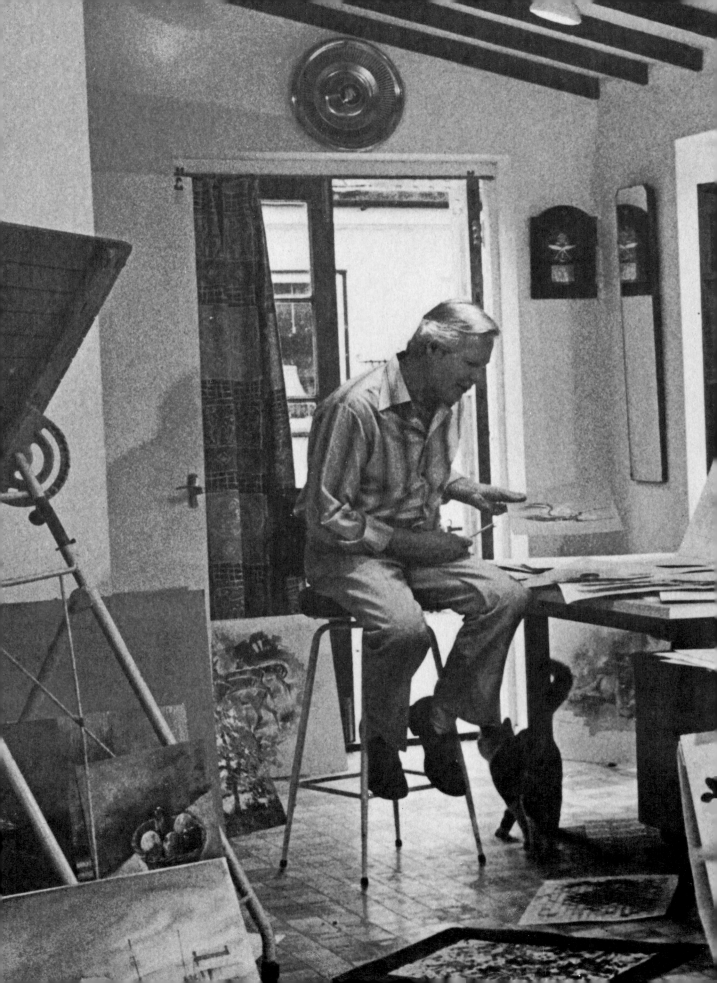

About this book

For many years my books have been slanted more to the sort of artwork you see me do on television. Somewhat unusual art, making use of unusual materials for collages, prints and paintings. So it was an exciting challenge when my publishers invited me to put together a book containing fifty subjects of my choice, worked in a variety of materials, together with an account of the way in which they were made. More orthodox pictures. they suggested, made with more orthodox materials. Well, here they are — a pot pourri of pictures taken from sketches made on or around my doorstep and as far apart as Las Vegas and Johannesburg. Of course, you don't have to travel to gather reference. You can find a whole world in one square foot of grass — if you look!

Anyway, I hope you will enjoy looking at the people, places and incidents I have chosen and that you will find Something of appeal on the way. Maybe you will be enthused to try out some of the media, for there are bound to be some that will suit your particular ability — much to your surprise perhaps.

Tony Hart

Death Valley

Painting Pencils and
Water-colour

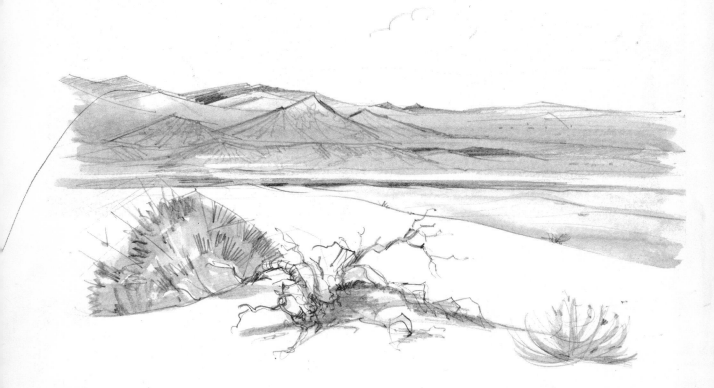

I don't know quite what I'd expected from Death Valley. I suppose I thought it would be like the rest of the Mojave Desert, which I'd visited years earlier. It was, for me, more interesting. There was more variety and more colour – if you looked for it! Arid places seem to merge the natural colours to such an extent that all colour is lost in an overall khaki. It's certainly no use looking at the colour photographs you bring back. Distant hills all take on a misty blue-grey. I found that by stopping often and collecting stones, looking at the rocks through binoculars and generally paying more than just passing attention, that the colours started to leap out at me. I'm very glad that I noted them. Pink, mauve, violet, every sort of ochre, reds, yellows and browns, blues and greys. All were there to be sorted out. I started

with the intention of painting a realistic view of the Amargosa Range but when I was near to completing the picture I found the over-bright colours I was intentionally using were just too powerful to look real. I decided to try something more abstract, or at least evocative. One of my drawings made of a fascinating rock group would be the basis for a highly colourful picture that, while by no means realistic, would have considerable truth within its make-up. The acrylic I had used for the first attempt was dispensed with and painting pencils, used dry, were employed to draw an exaggerated formation of rocks in the same colours as before. Had I not exaggerated my original pencil drawing the bright colours of the painting pencils, made brighter with water, would have made the end result less acceptable I think.

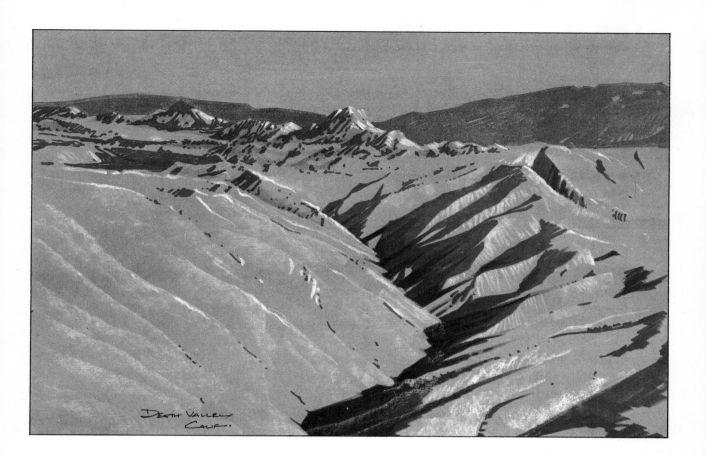

Death Valley
Calif.

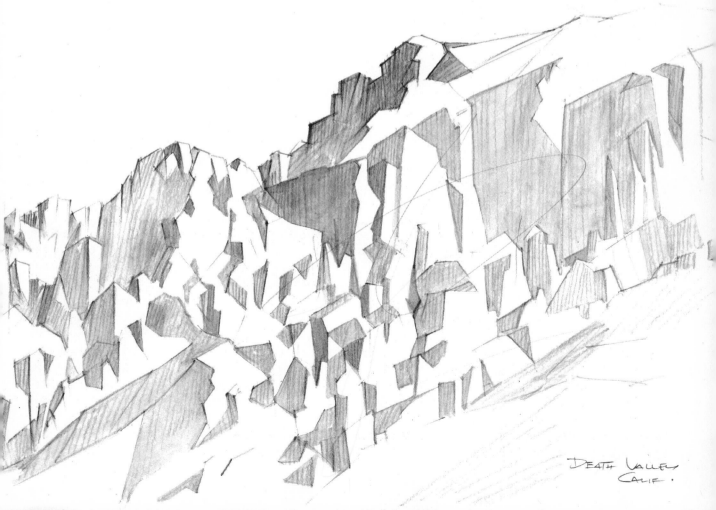

Death Valley
Calif.

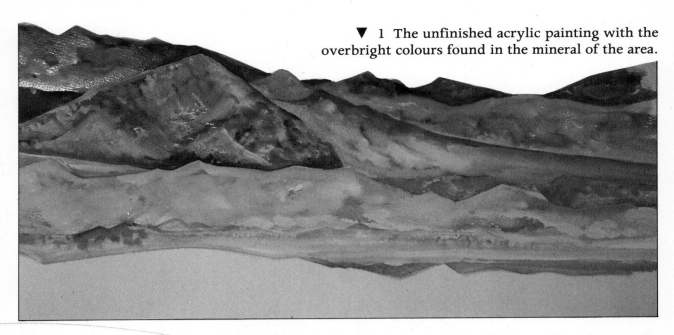

▼ 1 The unfinished acrylic painting with the overbright colours found in the mineral of the area.

▼ 2–4 First stages of drawing using the painting pencils dry and later brushing the colour, with water, into the forms.

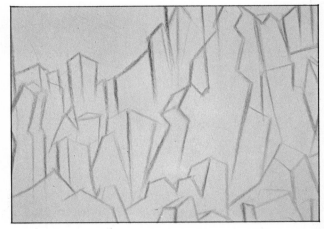

▼ 5 The background card is Colourplan Ivory, so white gives a brighter finish to some of the facets.

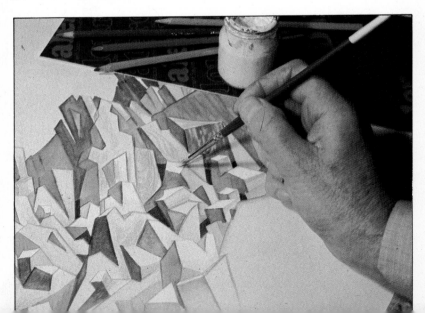

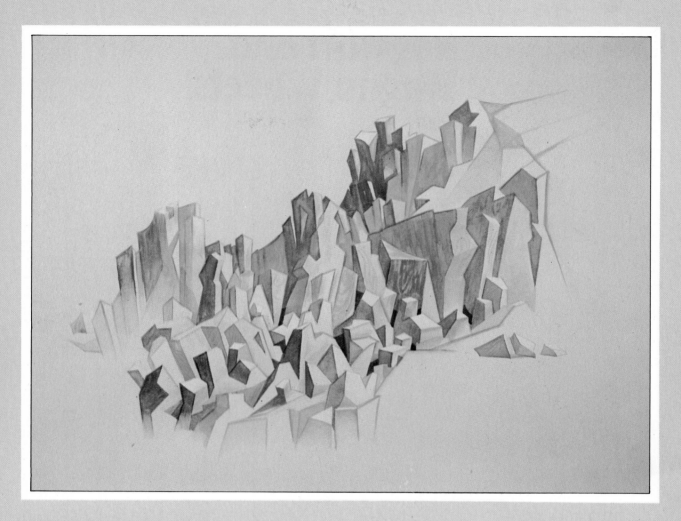

DEATH VALLEY
Painting Pencil
22" × 15"

▶ 6 Plain water turns the dry painting pencil
into water-colour.

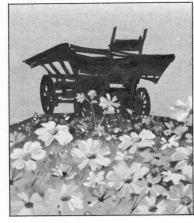

Ragwort and Wagon Wheels

Acrylic

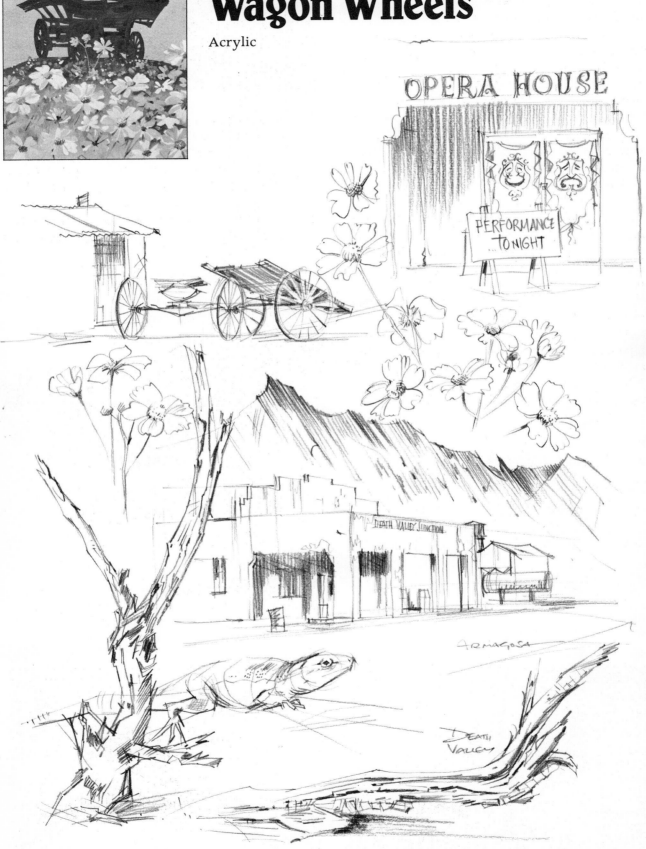

OPERA HOUSE

PERFORMANCE
...TONIGHT

DEATH VALLEY JUNCTION

AMAGOSA

DEATH
VALLEY

Coming out of Death Valley near the State Line between California and Nevada is this extraordinary place called Death Valley Junction. Everything is hard and stark; stark shadows, dead wood and rock. All the props for a 'Western'. Even if there wasn't a stage coach there were wagon wheels, farm carts and – would you believe – an Opera House. A minute place with charming Comedy and Tragedy masks painted on its peeling doors. A sign proclaimed that there would be a performance that night. We were unable to see the legendary Marta Becket's Dance Mime and left that part of Amargosa, where the river water dries to borax 180 feet below sea level in temperatures that have reached 130 degrees, and climbed. After the stark valley it was a surprise to come across masses of yellow flowers. They looked like a cross between a rock rose and a buttercup, flowering ragwort perhaps. Anyway, back home I made a picture of the flowers seen against the stark outline of a wooden wagon.

From my sketch of the farm wagon I painted a silhouette against an acrylic wash of blue and raw sienna. The wagon was painted in thicker acrylic using burnt sienna and cobalt blue. The flowers were painted using acrylics like oil paint. I was almost tempted to use a palette knife but that would have made it just too thick. White pastel pencil was used to indicate the petal forms of the flowers before painting. By using a long flat brush the petals could be put down in single strokes. Whenever I use more strokes than necessary the less attractive the result seems to be.

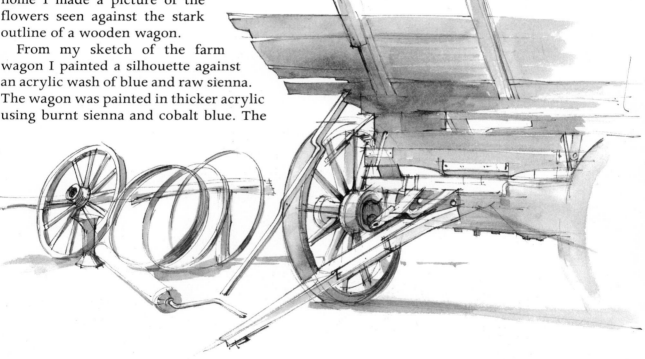

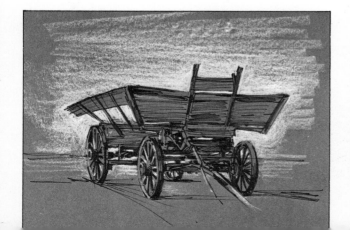

The gradation of tone-colour from dark to light in the background emphasizes the feeling of distances from foreground to the wagon. Blobs of colour, used in the flower painting, give the impression of flowers all the way.

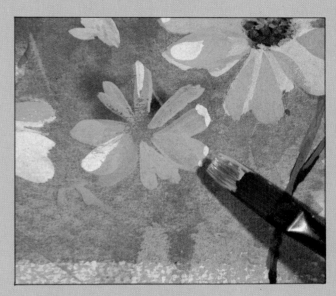

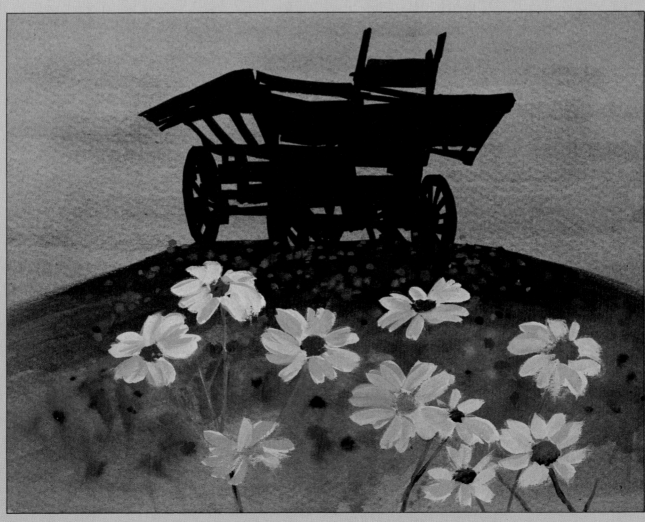

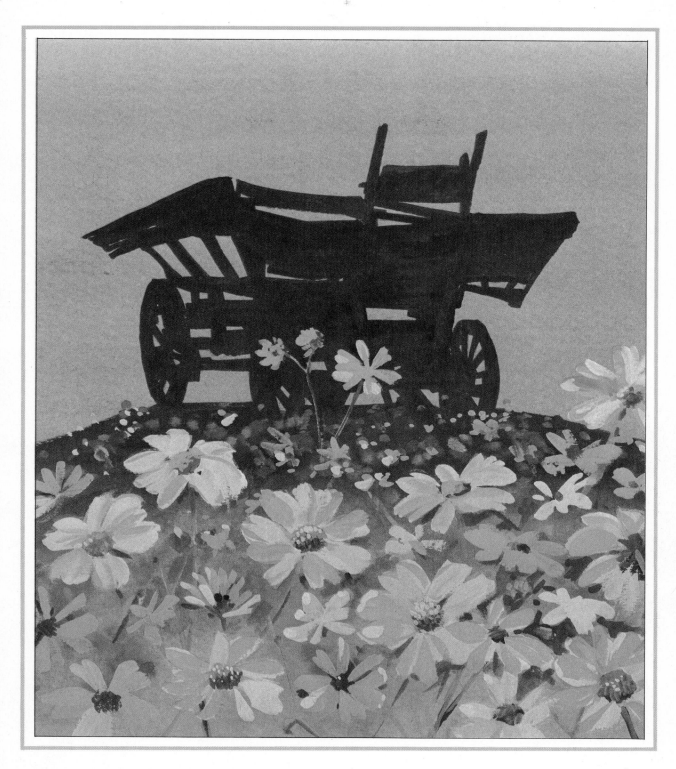

RAGWORT AND WAGON WHEELS
Acrylic
13″ × 10″

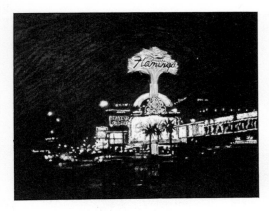

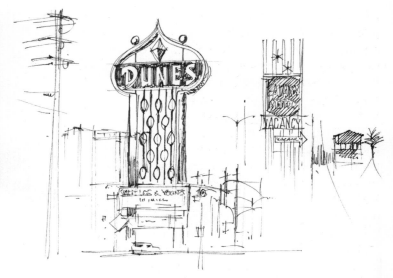

Las Vegas at Night

Pastel

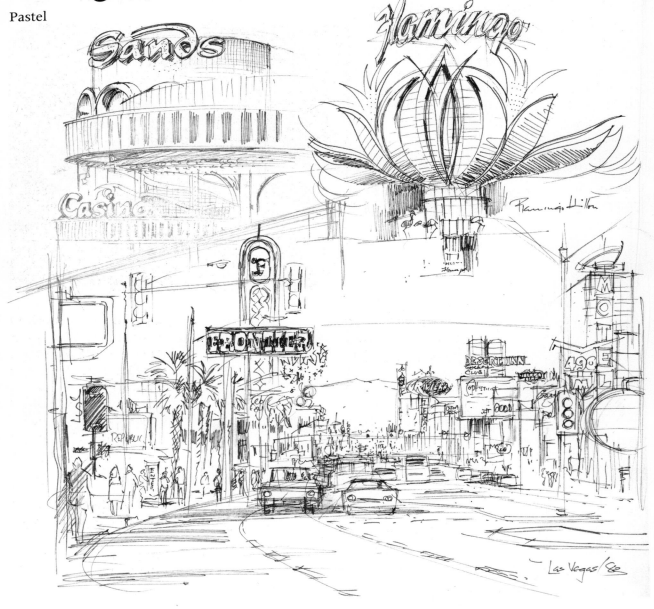

A few years ago I made a pastel picture, on television, of Piccadilly Circus. It took about four minutes and was, needless to say, very rough! Made with a few light, bright pastels against a nebulous blue-black background it was quite effective. Some years ago when I first saw the lights of Las Vegas I was properly impressed by these vulgar, yet awe-inspiring illuminations. Last year I went back. The rough drawings give quite enough reference for a Vegas version of my Piccadilly Circus. I decided to draw the front of the hotel in which we stayed.

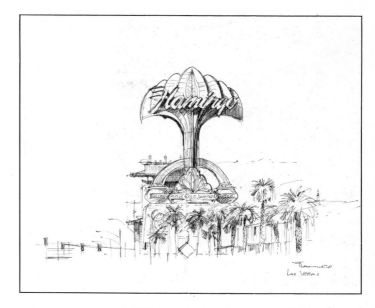

The first stage was to find the right paper or card to work on. I used black Colourplan Card. It has a good surface for pastels but never looks quite black. The nap of the surface relfects some light back giving it an ash grey colour rather than black. Black can be put on black making it blacker – if you see what I mean. You will, if you look at the colour picture overleaf. A little dark blue in sky and at pavement level and a few near white forms start it off. Magenta lines delineate the incredible fountain effect over the rainbow, and orange and yellow pastel suggest the broad lines of the frontage. After that it was a matter of putting in just enough light colour to read as neon signs, traffic lights

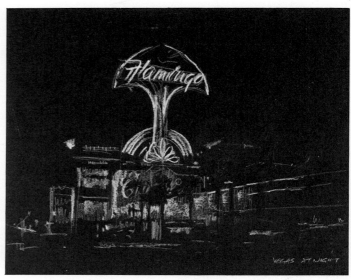

and lit advertisement hoardings. The palm trees silhouetted against a vast white-lit hoarding were over-drawn in black and green to give this effect. To get the full effect of the bright colours it is necessary to dab quite hard to deposit the pastel. This gives a sort of carefree impression. Quite like French Impressionists in character!

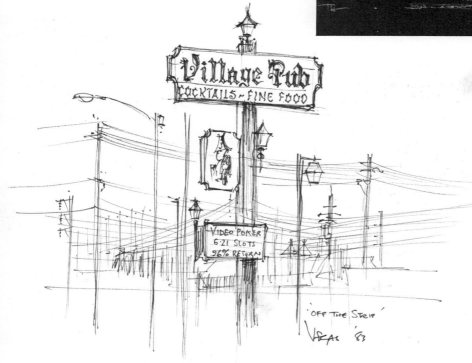

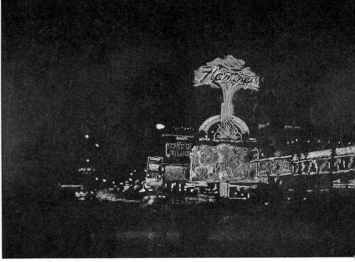

1 First stage drawing on blue-black background.

2 More colours but no real detail.

3 This pattern shows the effect of black pastel on black Colourplan Card.

4 The palm trees have been drawn over the lighter background.

5 The pastels being used at this stage.

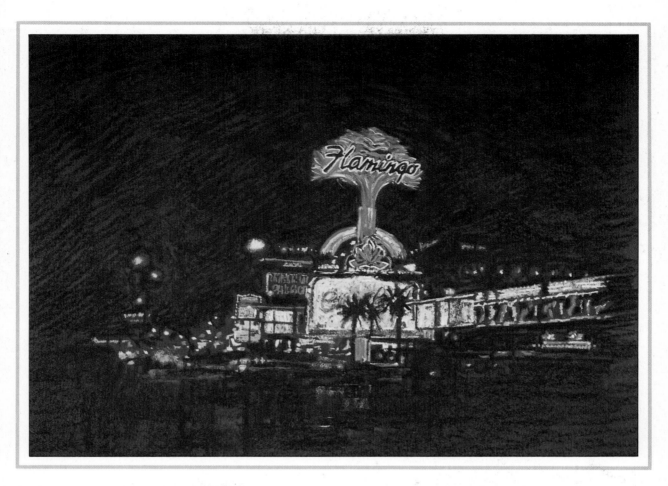

LAS VEGAS AT NIGHT
Pastel
22" × 16"

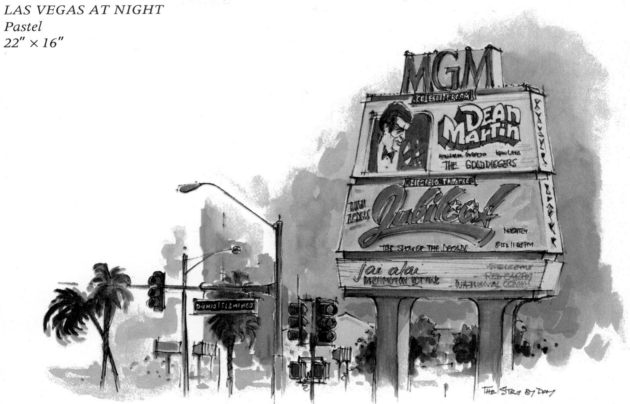

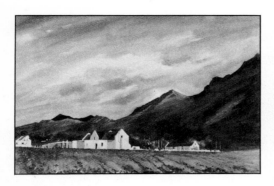

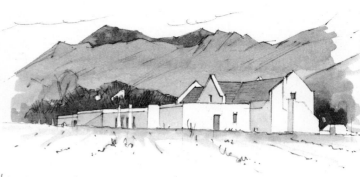

Lanzerac

Water-colour

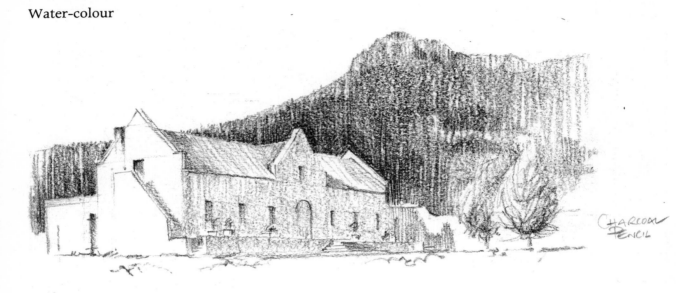

Once an old Cape Dutch Homestead, Lanzerac is now a world renowned hotel near Stellenbosch. It marketed an Estate Wine and the vineyards and buildings are still there for the delight of visitors. I have drawn the old wine building with its splendid proportions and simplified Cape Dutch architecture.

The clean white buildings set among the mountains are simply perfect in showing off angles and shadows. The precise angles of the buildings are set against the natural angles of the mountains. In the black and white drawings these appear somewhat stark and dramatic. In fact the hills are green and softer with vineyards on the lower slopes. I shall try to bring the softer feeling into the picture by using the right colour. The composition has a perspective of lines radiating from the buildings on the left. The actual paint strokes have been made along these lines in the mountains, the sky and in the old vineyard area in the foreground. The medium is water-colour. The basic shape of buildings and skyline are pencilled in lightly on water-colour board, with particular regard to

the horizontal lines. The original drawing is useful to show all the shadow areas. This is one of those paintings where no white has been used other than the original background. Alongside the far buildings there is an indication of individual trees — these have been made by using a pointed brush and clean water on the dark green and removing enough of the colour to leave a lighter mark.

The first stage of painting is done by putting the artwork on a slightly sloping board and working upside down. This enables you to paint around the buildings and let the water-colour flow towards you and to the hilltops. This way you are less likely to get 'tide marks', but if the paint does dry too quickly you can lose the unwanted mark among the trees and grasses.

The close-ups showing the painting detail give some indication of what a good paper will do for water-colours. See how the paint tends to dry a darker tone in the depressions in the paper making pleasant textures. A brush as it dries out and is dragged across the paper produces cloud effects.

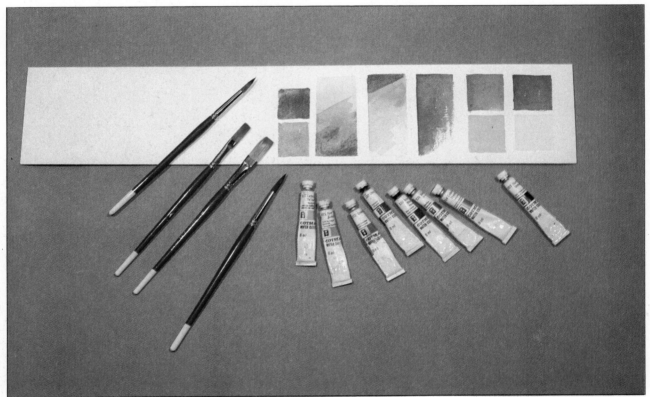

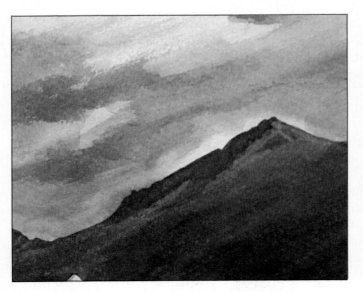

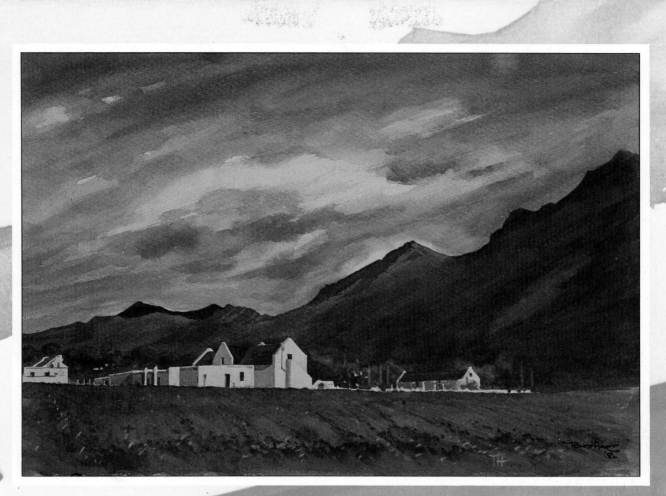

LANZERAC
Water-colour
21" × 15"

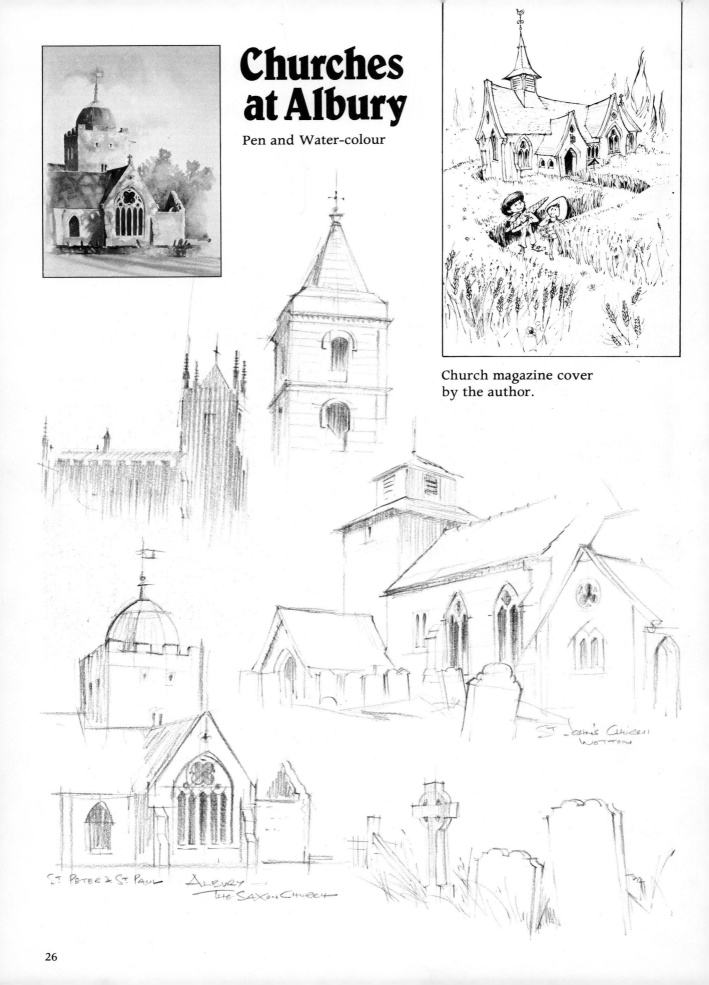

Churches at Albury

Pen and Water-colour

Church magazine cover by the author.

ST PETER & ST PAUL
ALBURY —
THE SAXON CHURCH

ST JOHN'S CHURCH
WOTTON

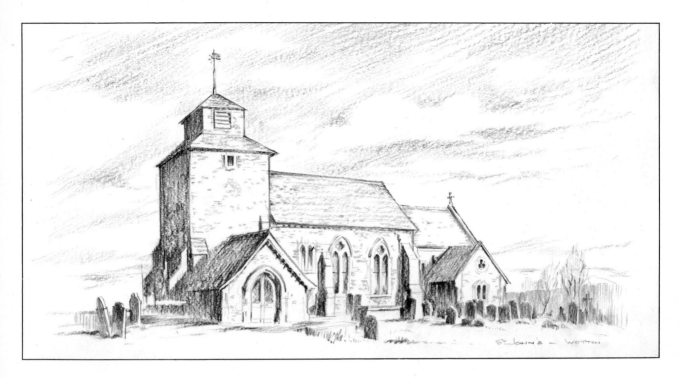

St. John's – Wotton

The village of Albury boasts three churches, two of which are not in use. The beautiful, part-ruined Saxon Church of St. Peter and St. Paul is described on a nearby notice board as 'Maintained by Redundant Church Funds'. Local historians and villagers see to it that it is not only maintained but that the architectural and historic interests within and without the church are made known. Close by stands another, far more imposing church. Goodness knows what's happened here. There is a notice that says it's closed and not functioning as a church, although the building and everything around it is well kept. I've made two pictures in colour. A water-colour of the Saxon Church and a pastel and wash of the other. The water-colour has been painted over a pen and ink drawing. One reason for using ink was that the fiddly drawing of the tracery of the great window gets smudged and unworkable with pencil and the paint has to cope with a dirty base. So, with the ink drawing and the white water-colour board cleaned up, the painting went ahead. It was an interesting study because the varying planes of the known angles of roof and walls were dappled by the shadows of the surrounding trees. I made an overall wash of colour using burnt sienna, cobalt blue,

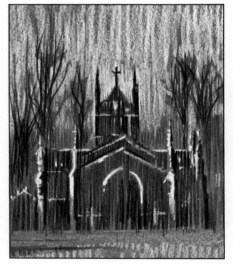

COLESHILL

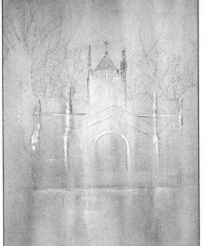 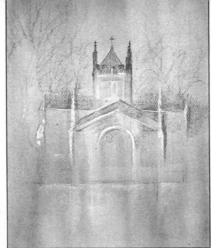 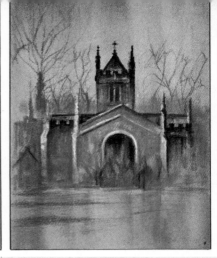

1 A wash of water-colour has been allowed to run vertically down a sheet of water-colour board, producing a diffused, stripey background. The first drawing is in black and white pastel pencil.

2 Pastel Colour has been introduced into the tower and the treeline over the roof.

3 More pastel with some horizontal drawing in the foreground. It was not going too well, further drawing ruined it and if it had any merit it was at this stage!

vermilion and brown. Not these colours mixed, but over a light wash of burnt sienna the other, diluted, colours were touched to the damp board and merged sufficiently to resemble old stonework but not so heavily as to completely dissipate the individual colours.

The stages of painting the Saxon Church show how vital it is to use sufficiently light colours in the first stages so that the darker tones of shadow can be put on to contrast. The underlying colour should be apparent in the shadow. I found that a grey-mauve was useful and that reds, blues and yellows were still apparent. The darkest tone is in the great window.

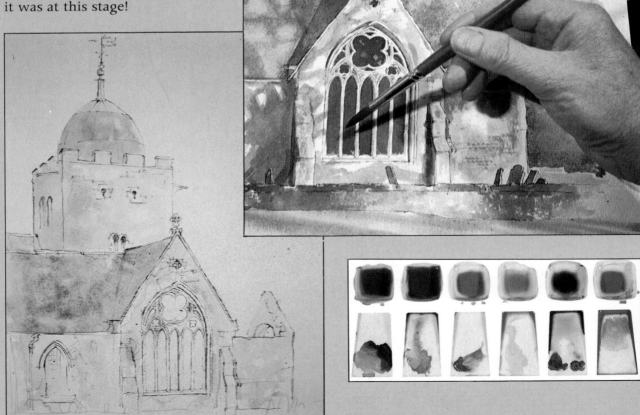

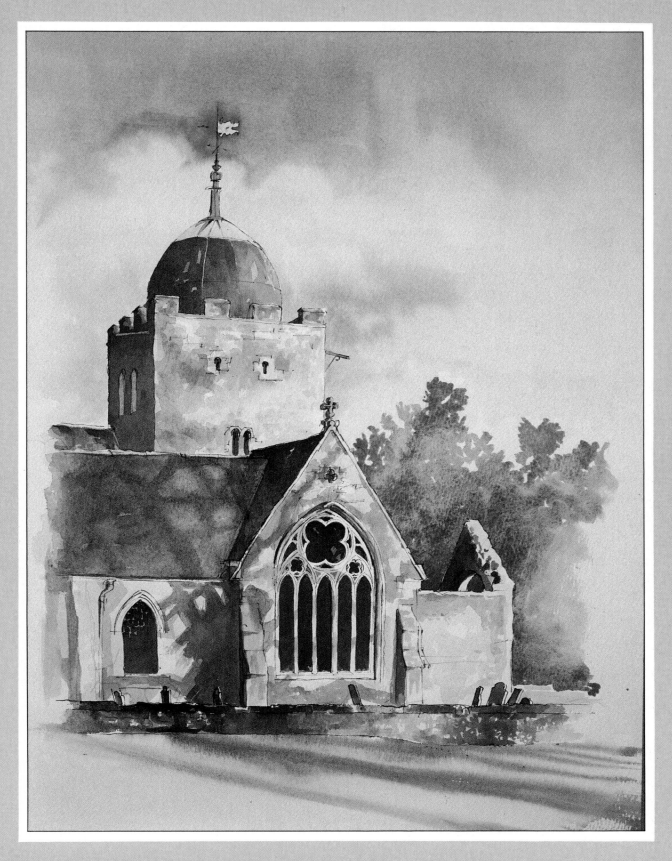

SAXON CHURCH
Pen and Water-colour
20" × 14"

Cactus in Corsica

Acrylic Polymer Paint

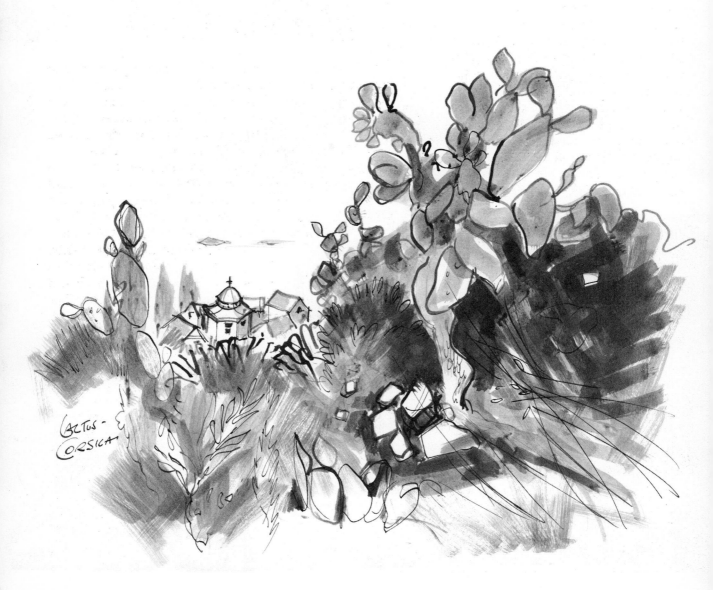

CACTUS-
CORSICA

A great feature of Corsica is the Cactus. Extraordinary Disneyesque forms looking like Mickey Mouse: ears, feet and noses appear as amusing appendages to every plant. They, and the cemeteries, catch the eye everywhere. Every family seems to have a sun-scorched little dwelling to house the earthly remains of their ancestors. Climbing high in the maquis, that arid and stony countryside, you peer down through the myrtle and cactus to see these little mauselea surrounded by the sad, dusty, cyprus.

The ink and wash drawing was made using sepia ink and a sharpened piece of balsa wood instead of a pen, – an eccentric and excellent drawing instrument. A soft, flat brush, a finger and spit completed the job.

The idea in converting the ink drawing into a colourful representation of Cactus in Corsica was to achieve that feeling of heat in an arid place. So different from the countryside in which I live. I started painting in oils, backed up by my drawings and with reference to colour photographs I'd taken. A grave mistake referring to colour photographs for colour! Why? The sky was blue and the cacti were green, what was wrong? It was the feeling. It didn't feel arid – it felt too English. The colour wasn't helping. I overpainted the sky in whites and yellows and suddenly the whole atmosphere changed. The cacti were similarly treated with grey greens and yellows. The little cemetery down below

was painted in muted pinks and greys to achieve the effect of distance and this really changed the scene to how I remembered it. It wasn't how it was, but it was how it felt and so it became right.

Later, I made another painting of the same subject. This time in acrylics. These have the advantage of being able to be used thick, as in oils with brush or palette knife, or thin and washy as in water-colours. Acrylics are mixed with water and are very quick drying so have both advantages and disadvantages. When dry they are quite waterproof and can be varnished if you so wish. Unlike oil paint, which takes days to dry and so allows you to come back and still merge the colours on the canvas, acrylics must be used quickly if you are merging colours. They dry to a flexible, plastic film and wear well on any surface. For my painting I made up a sheet of hardboard by painting the textured surface with white acrylic. The synthetic resin of the acrylic sealed the surface and the board was ready. The textured side of the hardboard having a similar toothed surface to that of canvas. You can see how this works in the picture. Also shown is my first stage, roughly drawn, on the easel. By the side is my first effort in oils.

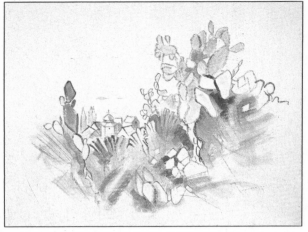

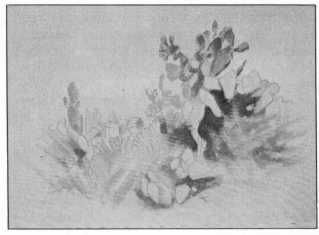

▲ 1 First stage drawing in Burnt Sienna on hardboard using a flat ⅜″ brush.

◣ 2 Second stage has a thin film of Cadmium Yellow and White layed overall. The first stage being dry within fifteen minutes.

▲ 3 Acrylic Polymer paints come in tins, pots and tubes of varying sizes. They are water soluble and can be used for any sort of painting.

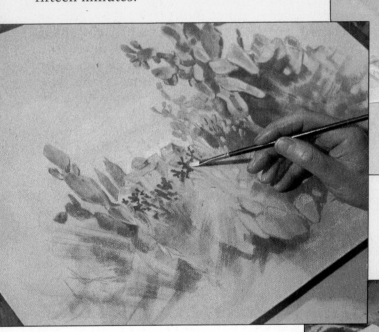

▲ 4 The main colours used were Permanent Yellow, Yellow Ochre, White, Raw Sienna, Burnt Sienna, Cobalt, Cadmium Red and Ultramarine. The brush shown here is a No 1. flat nylon. Others used were flat, and tapered, numbers 4, 6 and 8.

▶ 5 Rather than use a fine brush for grasses I'm using a piece of card to 'print' the paint onto the board.

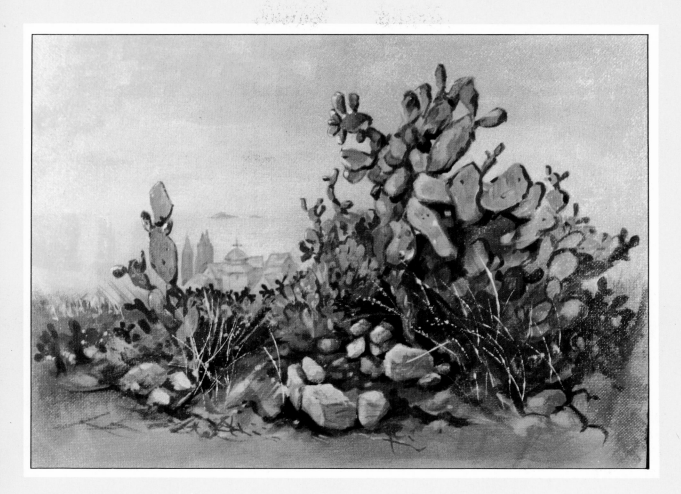

CACTUS IN CORSICA
Acrylic Polymer Paint
21" × 16"

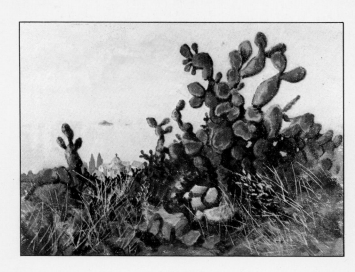

► 6 The first version of the painting, in oils, also on hardboard. In comparison with the acrylic painting it is difficult to differentiate one medium from the other.

From Winterfold

Oil Pastel

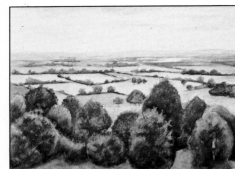

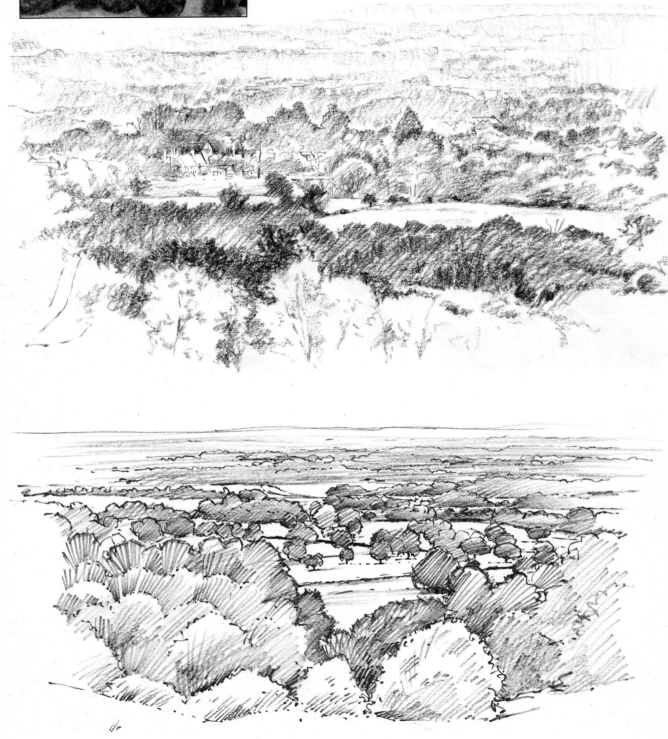

Near my home is a heavily wooded hill. Five hundred feet below, the land stretches away for twenty-five miles to the coast. This land is a patchwork of fields and woods with villages tucked away among the trees. From the country road that climbs up through the woods you can push your way through the trees and bracken until you come out onto the hillside from which you get a superb view. I was up there in the summer and sketched the view. Everything seemed to be green and gold. Some of the fields, covered in mustard, were the brightest yellow and my picture cried out for colour. I'd been drawing with soft pencil and although giving a reasonable idea of the countryside it wasn't quite right. I did another, bolder, drawing, using an old felt-tip marker that had practically run out. This gave a stronger and more economic

drawing, one that I could adapt for colour. Back home I redrew my view using diluted Plaka colour, a water resistant poster paint, on a sheet of water-colour board. This drawing was done fairly roughly with a brush in a blue-grey colour and delineated the fields and trees. I used some artists' licence to show rather more of the patchwork fields than in the original drawing!

The textured water-colour board was tough enough for something heavier than water-colour so I decided to use oil pastels. These can be used like chalk pastels covering the existing drawing where necessary and building up colour in a similar way. White spirit can be used to dilute and merge colours bringing about something of the feeling of an oil painting.

▶ 1 Water diluted Plaka paint applied with a No. 8 size water-colour brush.

◢ 2 Darkening the foreground trees silhouettes the landscape and makes it appear brighter.

▼ 3 Oil pastels, water-colour board, brush and turpentine.

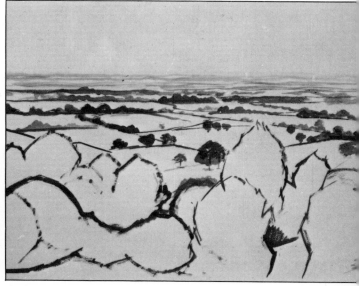

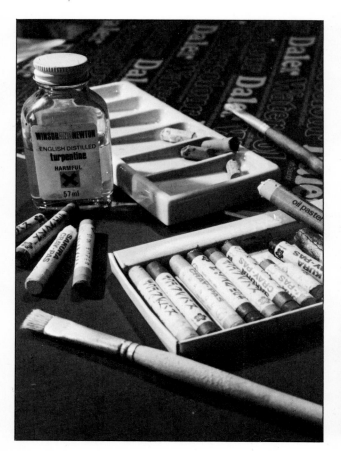

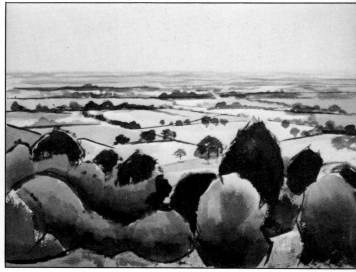

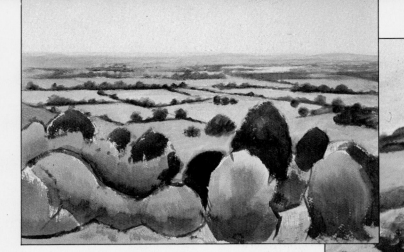

▲ 4 Yellow and green oil pastels used like wax crayons – they take well on the water-colour board. The colours can be used on top of each other and blended. For the distant colours I applied white over the greens.

▲ 5 Most of the fields are coloured in now. Mostly, I've been using inexpensive Japanese oil pastels with the odd more expensive one as I happened to have it!

▲ 6 Two or more colours drawn together can be merged together using a bristle brush and a little white spirit.

▶ 7 The trees were looking a bit 'Toy Town'. The rounded tops needed to look more like real foliage. So I dabbed yellow and light green at them, letting the oil pastel deposit feathery blobs against the darker greens.

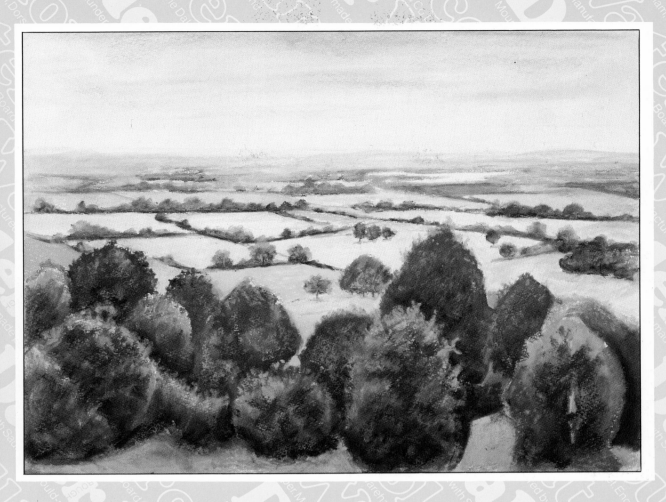

FROM WINTERFOLD
Oil pastel on White Daler water-colour board
21″ × 16″

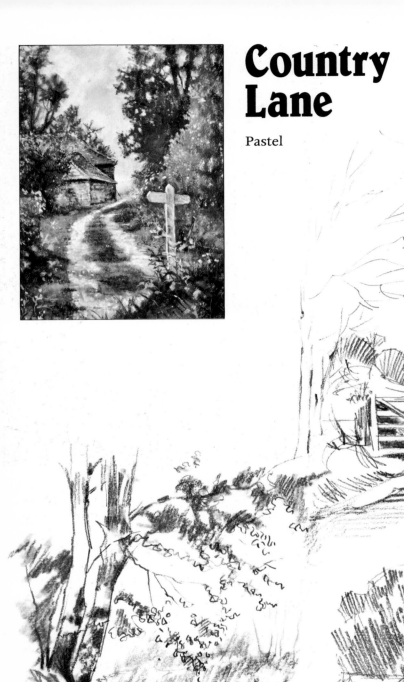

Country Lane

Pastel

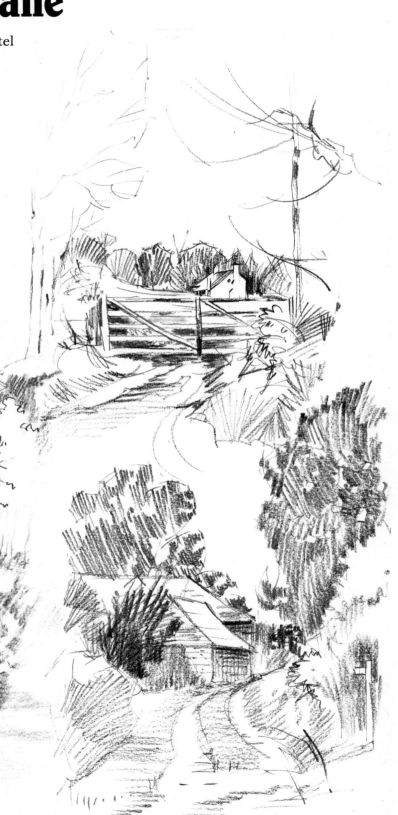

In summer country lanes come into their own. Gone is the windswept bleakness, and instead of a depressingly damp roadway bordered by soggy leaves, the lane is transformed by greenery, wild flowers and a golden dusty light. The sketches on this page give an indication of what that might be like, but colour has got to be used and I'm going to use pastels. Like pencils, pastels can be hard or soft. Soft pastels have a velvety characteristic and come in a range of nearly 200 colours. They can be bought singly, or in boxes, usually multiples of 12. The largest I know (but do not possess) has 144! I should start with a dozen or so, adding to the collection as necessary. It's worth buying good ones as the cheap variety are a bit gritty and do not produce such good results. I don't look after mine as well as I should but it is possible to keep them clean and tidy. Save even the smallest bits, they can be used right to the end. Hard pastels last longer but have more of a pencil effect. I use soft pastels held between forefinger and thumb and close to the working surface, using both tip and edge of the pastel. For finer lines there are pastel pencils, which can be sharpened. These can be used in conjunction with soft and hard pastels and come in a wide range of colours.

Paper or card is usually used to draw on. Tinted paper is useful and makes a good back-

ground. White shows up well and the background can be left as another colour or can be covered completely.

On television, when using pastels, I have the paper or card flat, or at a slight angle on the drawing board. I can understand why many artists use an upright easel; you don't have to keep blowing the pastel dust off your work!

You can use pastels over a drawing done in felt tip, colour or black. This works well covering the underlying drawing completely.

The only disadvantage of pastel drawing is the danger of smudging, not only when it's done, but when you're doing it. A piece of paper under the working hand is a help and treating the finished work with a fixative helps a lot. Fixative is a cellulose liquid coming in bottles or aerosol cans that you can blow or spray over your work to protect it.

For my pastel I shall be using a variety of colours, but starting with grey and white on a buff coloured card, roughly delineating the tree areas, the lane and the buildings. Then blocking in the lighter and darker areas. I've moved the signpost from the original pencil drawing position. I wanted it bigger and positioned in the foreground.

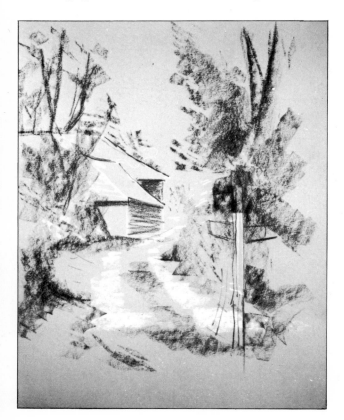

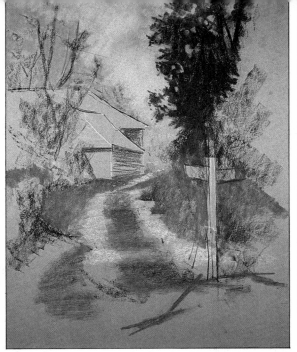

In the photographs of the three stages you'll see that the colour forms are balancing the pictures. The dark and light greens are arranged to give a better sense of distance in the lane. In the second picture I have used reds, browns, greys and yellows for the tiles and brickwork of the buildings. I have also drawn in a triangular, dark foreground. This stops the lane from falling out of the bottom of the picture.

The third picture shows that what seems to be detail is really just dabs of pastel to bring about the effect of stones, flowers and grasses. The finished pastel has had a few refinements added. Some leaves catching the light and, because the signpost looked rather stark, some foreground leaves and grasses were drawn in to break that bare, vertical line.

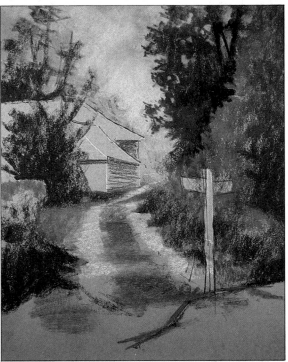

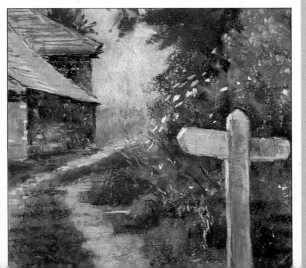

COUNTRY LANE
Pastel on tinted card
24" × 18"

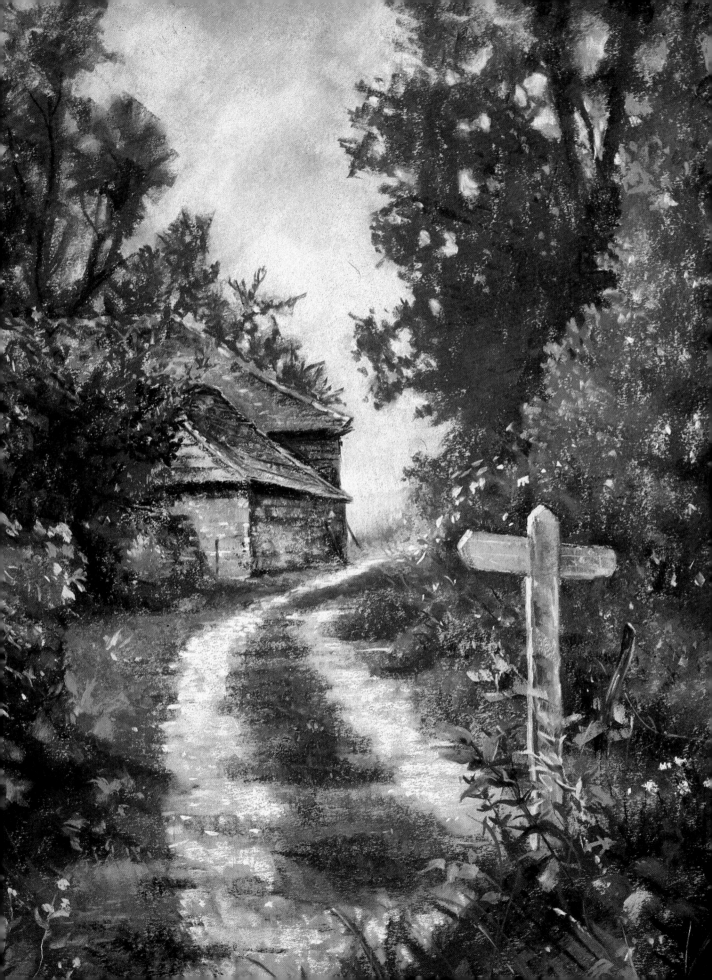

Porlock
Weir

Water-colour

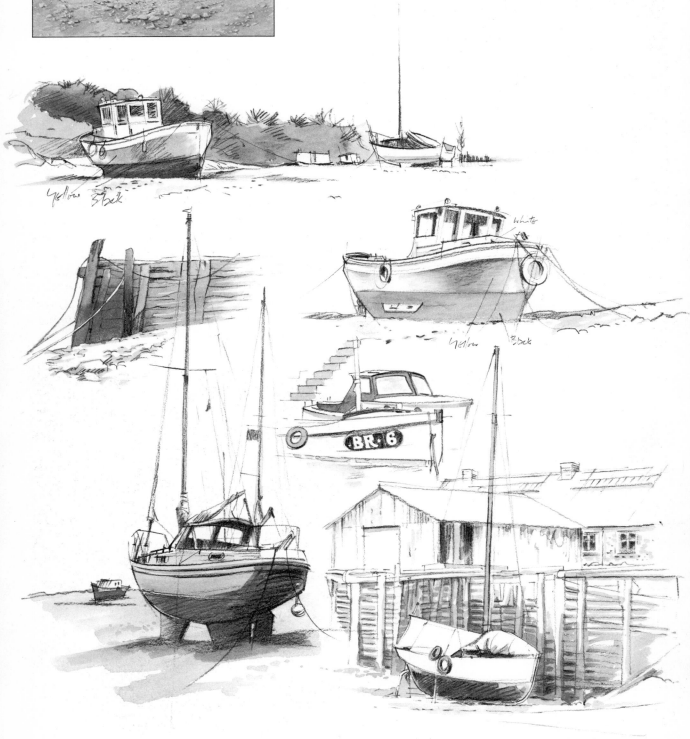

of the drawing and the flat one for getting water-colour onto the board quickly and efficiently. If you dampen the board with wet cotton wool you'll find that hard edges and tide marks are less likely to occur. The foreground of muddy shingle is achieved by using a No 8 brush and washing the area over with grey-blue but leaving little bare patches of varying sizes all over the place. These are made to look like stones and rocks by painting darker areas below and to one side of the white bits. One of the attractions of water-colouring is that we shouldn't use white paint. White areas should be shown as the paper or card on which we work. That was how I was taught but of course you can do as you like. Many artists do use white especially if working on tinted paper. Look at the 'ropes' in the earlier stages of the picture, that's the white of the water-colour board.

In general, background colours should be lighter than those in the foreground. This gives a feeling of distance. Water-colours dry lighter than they look when first applied, so bear this in mind. I prefer not to use black as such, there isn't any in this picture. Red, blue, and yellow, if you experiment with the proportions, will give you a very dark colour; preferable, I think, for this sort of water-colour.

All round Britain on seashore, estuary, lake and river we find boats. Boats of every description. Just such a place is Porlock Weir in North Devon. Out of season in the Autumn the place is deserted of holiday-makers and the boats, many of them high and dry for the winter, lean about on the muddy shingle like old horses put out to grass. I was there in October and thought that one of these might make a picture. There was little or no sun so hardly any shadow. The sky was doing what it so often does in England; showing a dark, thunderous background while the immediate area in which I was getting mud over my ankles was relatively bright. Armed with sufficient drawn reference I decided to make a water-colour using detail from my pencil drawings to compose the picture.

In the studio, at home, the first stage was to draw up the composition very lightly in soft pencil on rough water-colour board. Having delineated the outline of the boat and the far hills the next step was to paint the sky; a job that necessitates turning the board round so the drawing is the wrong way round and tilting it so that the very watery colour tends to flow towards the top of the painting. The picture here shows what I mean. You need a No 6 or 8 brush with a fine, pointed tip and a flat $\frac{3}{4}$" or a 1" brush for this. The pointed one for outlining the edges

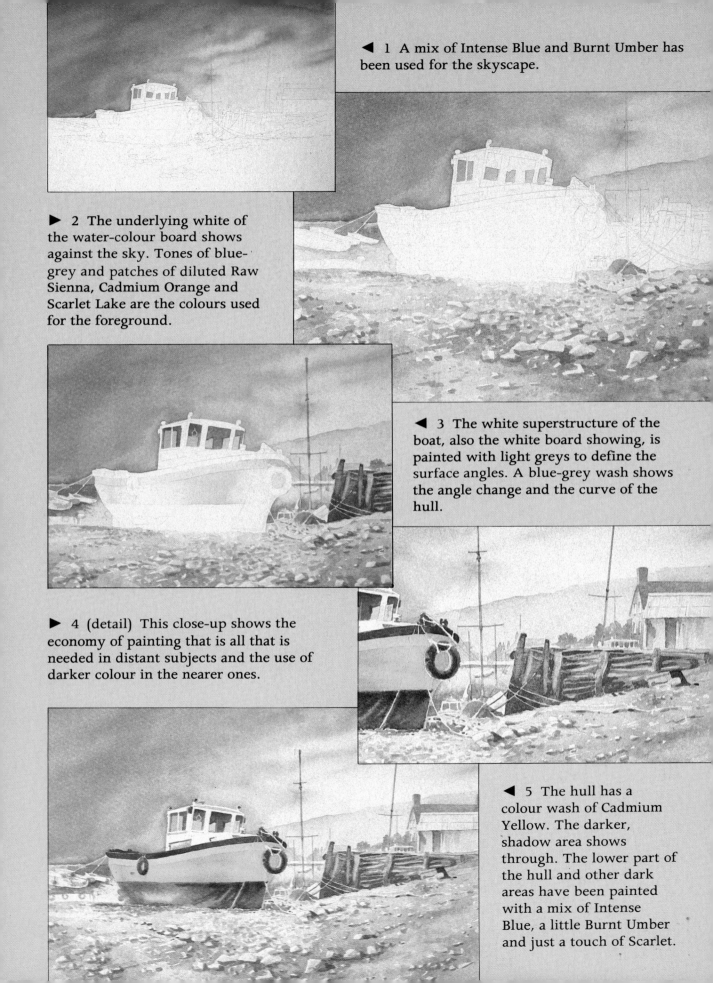

◄ 1 A mix of Intense Blue and Burnt Umber has been used for the skyscape.

► 2 The underlying white of the water-colour board shows against the sky. Tones of blue-grey and patches of diluted Raw Sienna, Cadmium Orange and Scarlet Lake are the colours used for the foreground.

◄ 3 The white superstructure of the boat, also the white board showing, is painted with light greys to define the surface angles. A blue-grey wash shows the angle change and the curve of the hull.

► 4 (detail) This close-up shows the economy of painting that is all that is needed in distant subjects and the use of darker colour in the nearer ones.

◄ 5 The hull has a colour wash of Cadmium Yellow. The darker, shadow area shows through. The lower part of the hull and other dark areas have been painted with a mix of Intense Blue, a little Burnt Umber and just a touch of Scarlet.

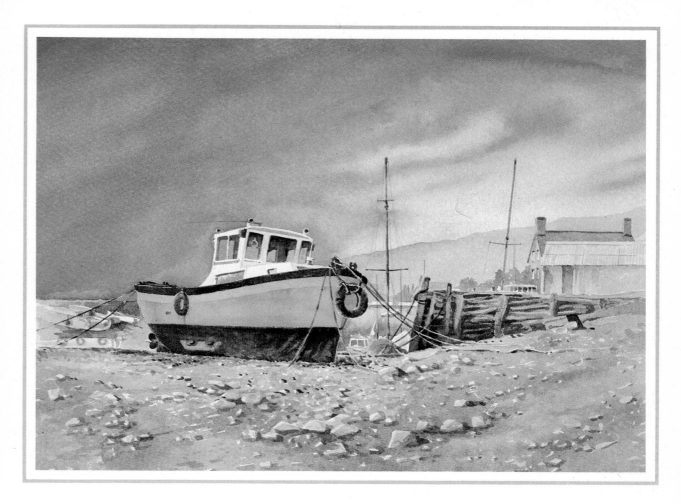

I have shown the finished painting with much less foreground than I had originally intended. This extended the sky and gave the whole subject a feeling of isolation that I found more pleasing.

After having written so much about the white areas in a water-colour I have broken my own rule. In my original pencil drawings the super-structure of the boat was curved at the back. I thought that angle was looking wrong. So I had to overpaint the dark sky with opaque white to put it right. Oh, well. Rules were meant to be broken – sometimes!

PORLOCK WEIR
Water-colour on Daler Rough White Board
16" × 12½"

Village Houses

Pen drawing

Until you are thoroughly experienced at drawing with a pen it's a good plan to draw with pencil first. In the first place you can make a lot of quick pencil studies and use one to convert into a pen drawing, and in the second you have a chance of rubbing out what has gone wrong, as well as those all important construction lines.

The two drawings on this page have been done with an HB pencil (top) and a 4B, very soft, (bottom). I much prefer the second. The first is rather overworked and looks too linear and hard edged, while the other is more economic and the lines softer.

Here is the first pencil construction for my

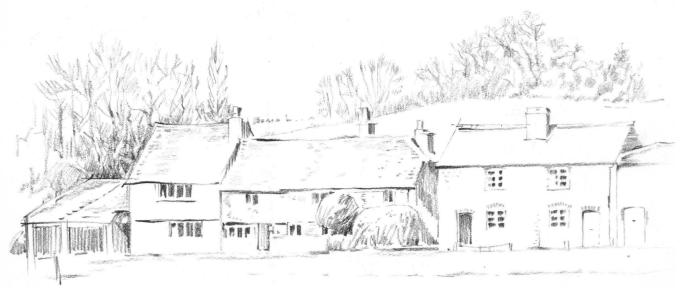

pen and ink drawing. Vertical lines and some perspective lines at the horizontal help enormously to prevent the buildings getting out of scale or out of balance. Now is the time to choose the pen. Today, we don't have to carry a bottle of ink around. Fountain pens, Rotring Isograph type pens, and fibre-tipped pens all produce their own style of line. I'm going to use a simple plastic fibre-tip. It has some flexibility so, although it normally produces a fine line, added pressure can increase the strength of the line.

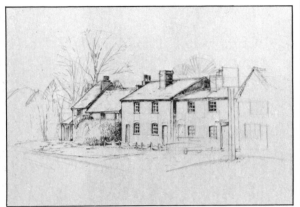

▲ 1 and 2 All tone value has to be shown by a series of black marks, ticks, dots and lines because black is the one and only colour. Too much detail will make a fussy drawing. The shrubs are a curved scribble and the brickwork is shown by small regimented ticks. The windows look like windows but are really just a few vertical marks.

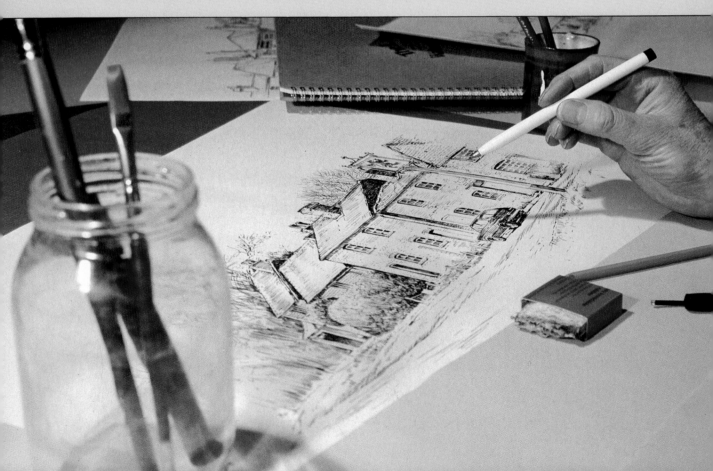

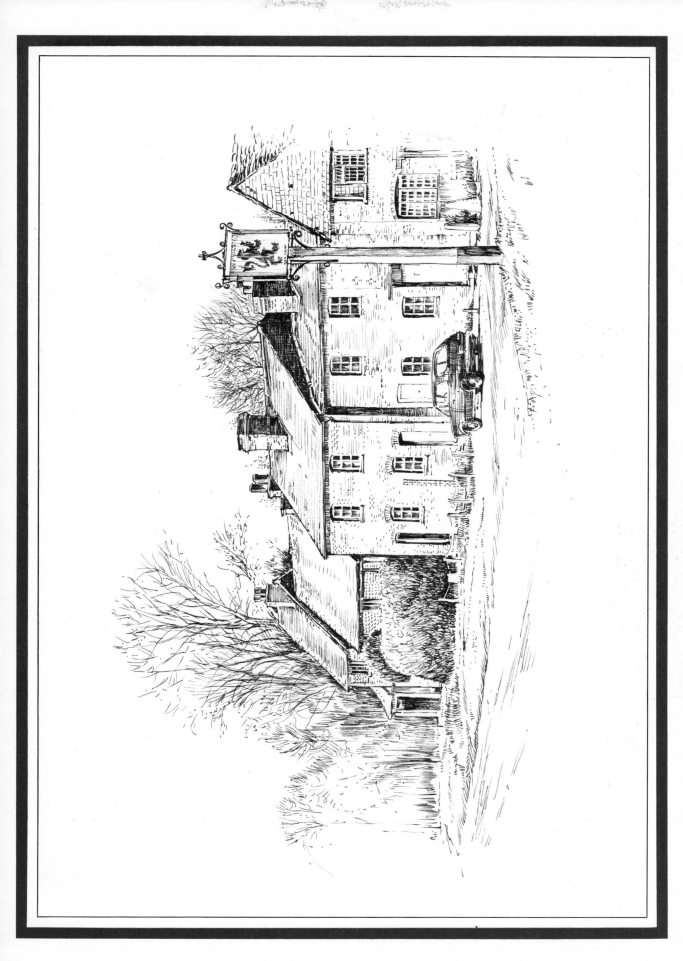

Lake Castle

Gesso

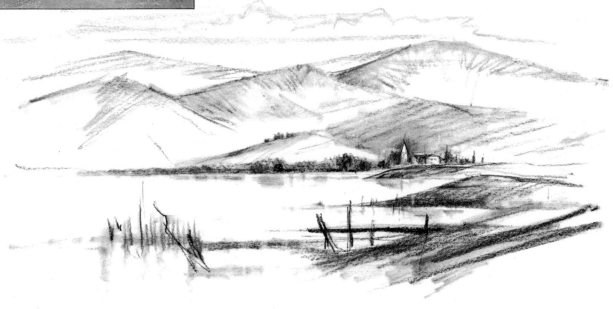

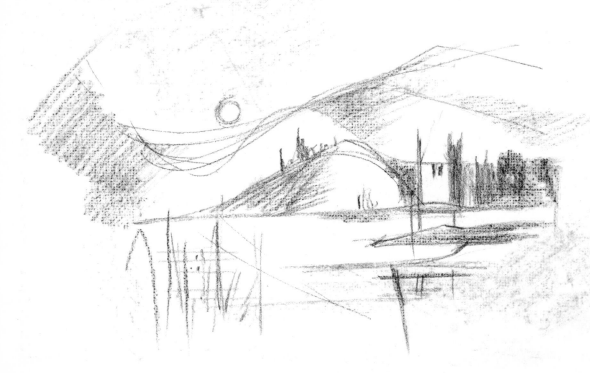

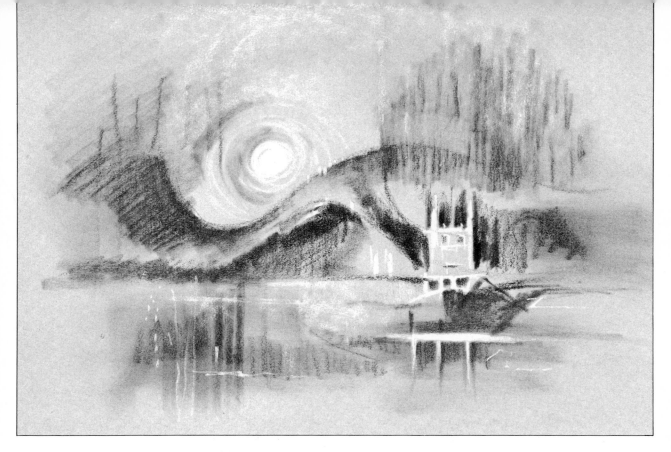

Gesso, pronounced Jesso, is Gypsum really, or plaster of Paris used by artists to give a sculptural effect. We can paint things to look as if they are in relief or we can use paint so thick (Impasto) that it actually is in relief. Gesso work gives the relief without the expense of shovelling paint on an inch thick! It can be colour-dyed before use, or painted later. I had an idea for a semi-abstract painting of a castle in a lake. I think it was the Castle of Chillon on the Lake of Geneva that gave me the idea, but it was sketches in the Lake District of Cumbria that started this end result. The drawings became more stylised until I had a semi-abstract design from which to make a relief picture. If you can't find Gesso powder, Plaster of Paris mixed with powder-colour works just as well. I mixed green acrylic paint with my Gesso so that the first application was a mild khaki colour, which I applied to the textured side of a sheet of hardboard that had been prepared with white acrylic. I find the best thing to put the Gesso on with is a piece of cardboard. It can be dragged through the plaster – the edge used to 'print' lines of plaster – or it can be pulled away from the plaster to give texture.

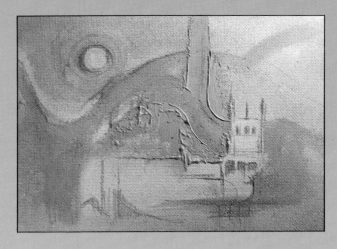

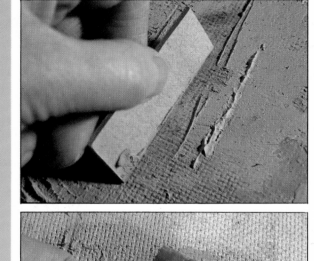

When the relief has been satisfactorily built up and the picture is 'readable' by the shadows made by that relief, you can colour with ink or paint. Experiments will give you great pleasure. Transparent ink gives a very different effect from matt paint. The higher relief dries lighter than that nearest to the base board.

I used acrylics and inks to get my results and when everything was dry, varnished it. Details of the painting make rather pleasant abstract pictures on their own.

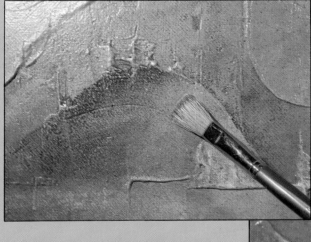

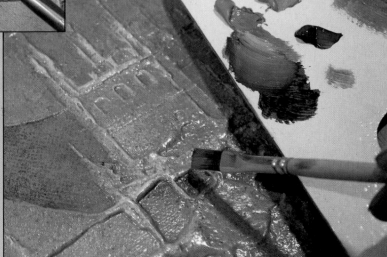

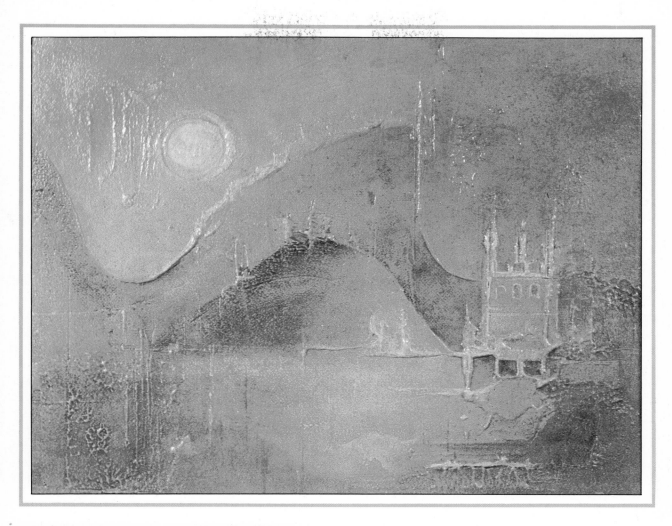

LAKE CASTLE
Gesso
20″ × 16″

Blue Port

Acrylic

This painting that I call 'Blue Port' was done fifteen years ago and went through a metamorphosis before it was finally hung over the staircase in our cottage. It changed from a realistic painting to a highly stylised, if not semi-abstract, acrylic for which the paint was 'laid on with a trowel' over the first effort. It went into an exhibition in a London Gallery and narrowly missed being bought for the reception room of a Harley Street Specialist. He did not find it big enough!

It originated one Autumn on the Ligurian Coast of Italy. Having taken a local train down the coast we got off at one of those small stops between Rapallo and La Spezia and retraced our journey on foot over the hills until we came to one of those wine growing villages in the Cinqueterre that could only be reached by sea or on foot. No one will recognise this scene because my drawing is a compilation of places seen on that trip. Or, perhaps, those who know the region will see one of their own favourites.

Returning home I made a further drawing on a sheet of hardboard, first prepared with a coat of white acrylic paint. This was roughly like the original pencil and wash. Then I started to paint, using the acrylic in varying consistencies from watery washes to thicker daubs. After a few

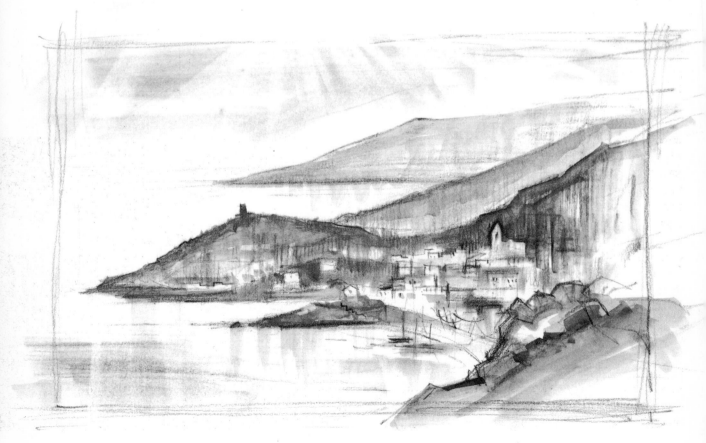

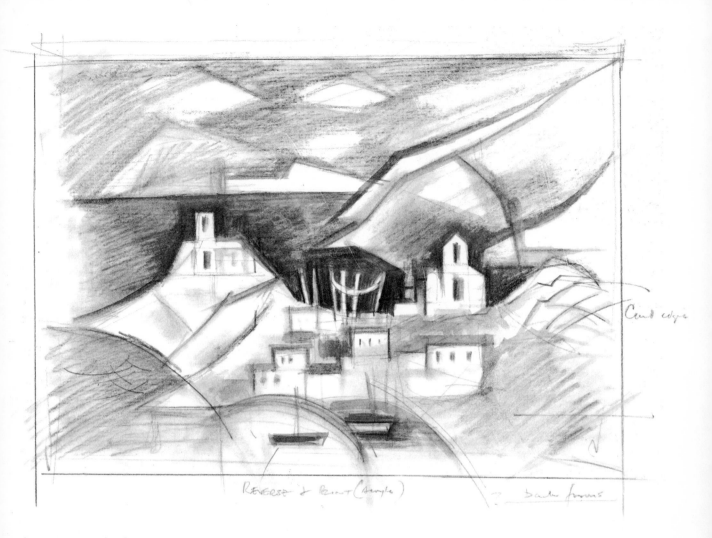

hours it was looking ghastly. In despair I started overpainting with even thicker dollops of paint. I well remember thinking I've ruined it so there's nothing to lose, and just enjoyed myself shovelling the stuff on like plaster, moulding it into relief and turning the whole thing into a highly textured mixture of hard and soft edge painting. At this stage it seemed sensible to make a rough charcoal drawing of the forms and the composition of dark and light areas with notes as to what might be done to indicate windows, masts, nets, etc. I didn't have to conform slavishly to the drawing but made changes as I wanted to. When I'd finished, the whole thing was allowed to dry to a hard plasticity and was then given the odd touches of paint to delineate some of the relief forms and eventually varnished.

On the colour pages you can see these techniques in detail. I even printed boat-shaped forms and curved lines by thickly painting pieces of card with acrylic and pressing them to the background. This produced an uneven,

textured form characteristic of paint printing. For me, another happy accident. I'm rather glad we've still got it and that it's not hanging above a mantelpiece in Harley Street.

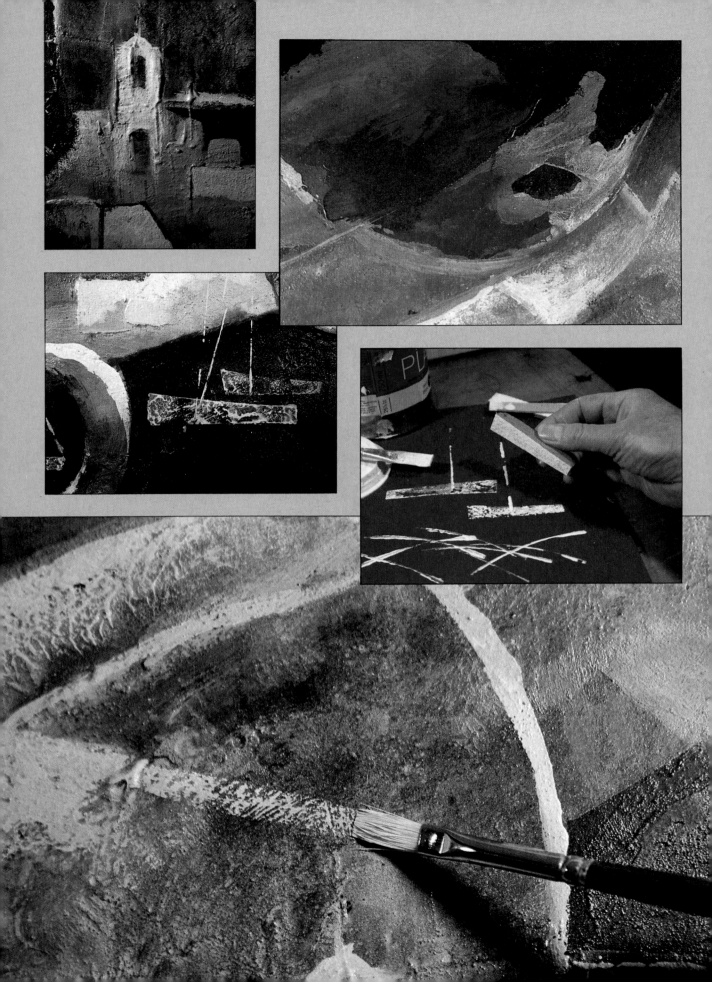

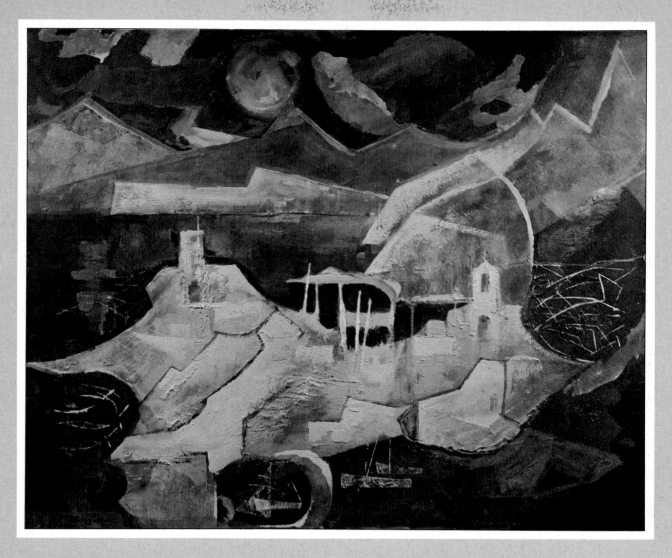

BLUE PORT
Acrylic
24" × 20"

▶ *Blue Port* on the stairs in the cottage.

The Yellow Field

Oil Paint

The pen drawings on the other page were done with one of those plastic-tipped pens. One of the most useful pens, doing away with the need of ink bottles, or filling a reservoir pen. The sunset is a drawing in soft Conté pencil. They were all done within a stone's throw of our cottage. The tangle of branches and dead wood is typical of the willows here and reminds me of the work of Edmund Dulac and Arthur Rackham whose illustrations have delighted me all my life. There is something magic about trees and fields. Perhaps it is the mystery of what might be over the hill, behind the gate, or within the woods. The glimpse of yellow-bright fields of mustard or buttercups, seen framed by trees and greenery in shadow, take me back to my prep. school days. Hot summer afternoons on the cricket field. Little boys making heavy weather of a practice game and me at long-stop edging nearer to the cool green trees bordering the field where a much more interesting world of flora and fauna had its being. It was day-dreaming on that cricket field that caused my broken front tooth. No

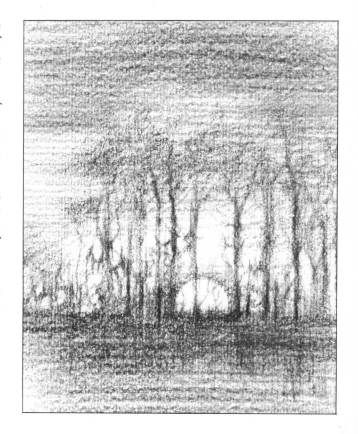

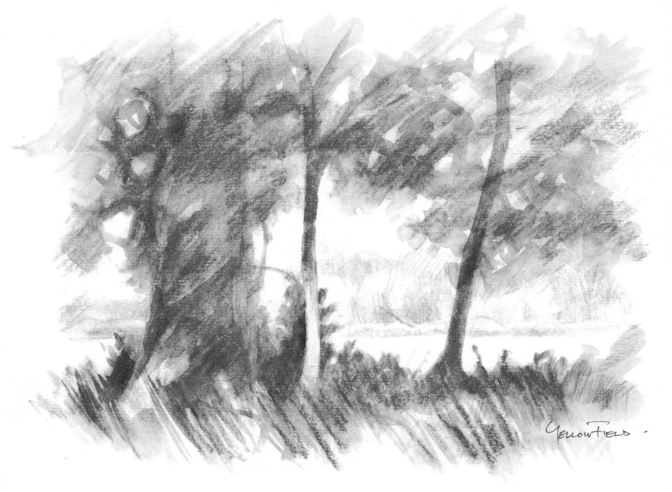

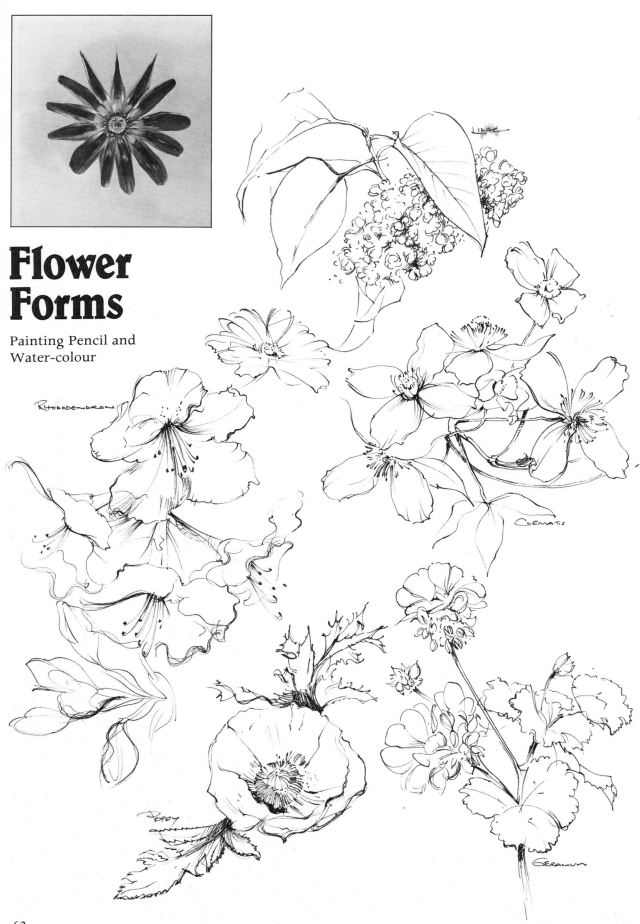

Flower Forms

Painting Pencil and
Water-colour

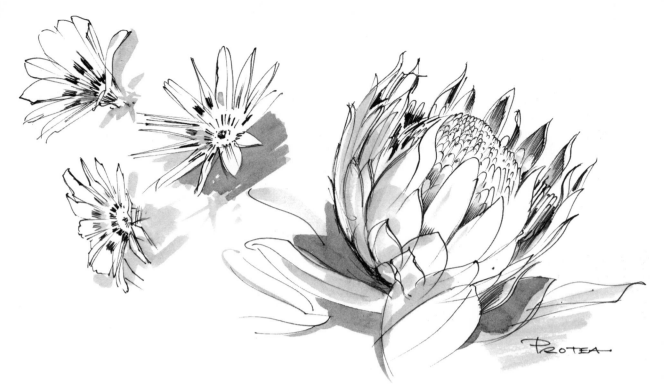

It was after drawing the garden flowers early last summer that I realised the pen and ink sheet contained only one that had any sort of spikiness about it, and that only in the leaves of the cultivated poppy. Of course we can find plenty of spikes among our English flowers, but two from South Africa caught my fancy, and from my last visit there I brought back the reference for the two on this page. There are many types of Protea, most looking like exotic fir cones, but this little star-shaped flower we found growing close to the ground near our hotel during the African winter. I was intrigued with the way some of the petals curled, rather like a tomato skin after cooking. This was the flower I wanted to paint. Having already made a colour study of Cosmos, I felt this was a rather tougher little chap and would stand a somewhat harder approach in drawing. Oddly enough I had a sheet of white wash-board with a nebulous background colour already on it. This had been saved from something else that had not progressed. The first drawing in red and blue-grey painting pencil was made straight onto it. Most of the drawing was done with the painting pencils. As and when necessary clean water and brush turned the dry colour into water-colour. Only at the final stages was water-colour paint used.

▼ Black felt-tip marker and white conté crayon on mid-grey paper.

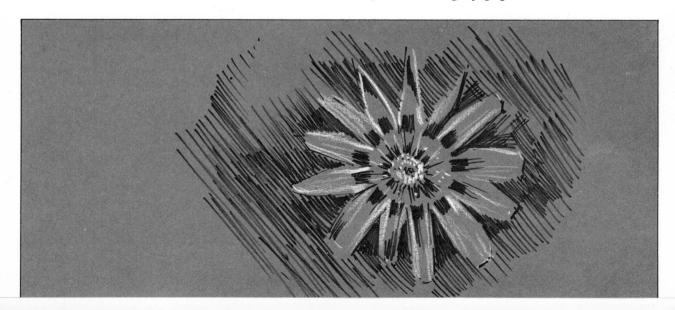

Chinese Ink

Pen and Gouache

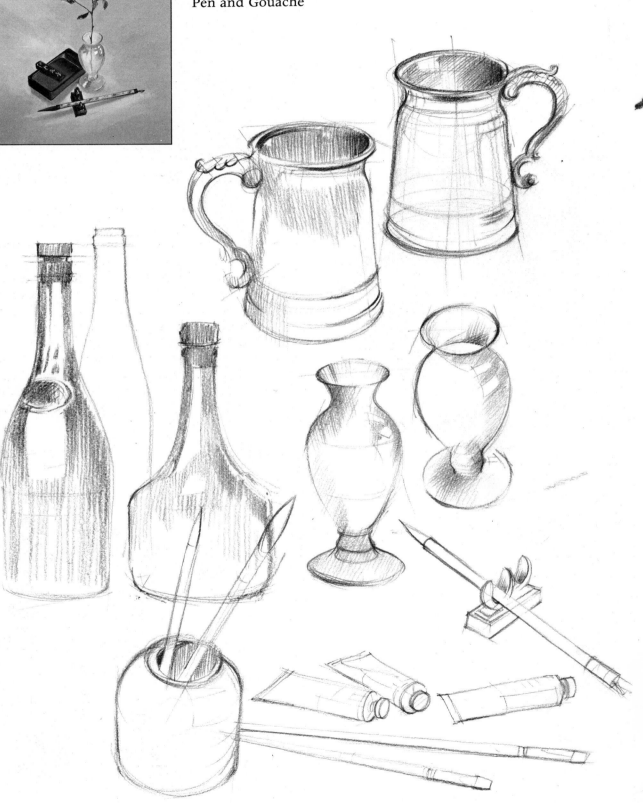

I wanted to make another Still Life different from the 'Fruit Basket'. I had been drawing elliptical shapes: the round tops of the bottles, mugs, and a rather pleasant little jade green vase. Another vase contained my Chinese brushes and that brought about the idea of this Still Life. I have a Chinese ink stone, ink and other paraphernalia associated with Chinese Art, so I used a very few of these for my picture. A spray of leaves from a shrub in the garden was a lucky find. The colour of the underside of the leaves was so like the little vase. The black of the stone and ink, the dark and light browns of the brush and stand completed the colour scheme. The background is Colour Plan Card in a Mandarin Yellow. The medium, pen and black ink with a gouache colour-wash. After the ink drawing I put a grey wash into the darkest areas; the ink stone and ink stick, the shadow areas of the vase, brush and leaves. The Chinese characters on the ink stick were drawn into the yellow card showing as gold. As gouache can be used as both a wash and as a thicker opaque colour I was able to overlay light colours on darker ones. The ink stone had a part matt, part gloss finish and the blacks ranged from ash grey to steel blue. At one stage I put a light wash of blue over the grey; it dried to just the right colour and gave the appearance of that part of the stone on which you rub the ink. The brush I was painting – not the one I was painting with – is beautiful, a friend brought it back from Peking, bamboo,

with dappled brown markings. Orange-brown went into the brush and into the carved wood brush holder which is the same sort of thing they rest chopsticks on in some Chinese restaurants! The composition is a bit unusual. This is because I wanted to see an uninterrupted background and also because the round shapes and the square shapes in relation to each other make interesting angles. The last sequence of painting was to use gouache white as a light wash on the background yellow to intensify the shapes of the objects and apply it more heavily to the brightest spots where the light was reflected from the vase.

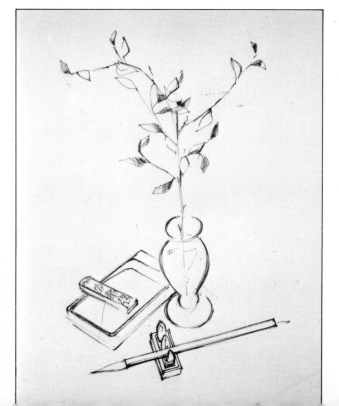

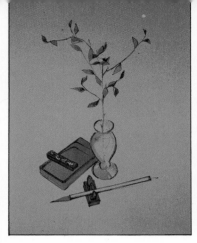

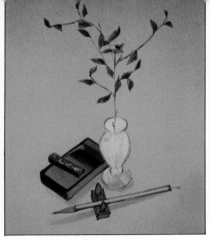

◀ 1 First stage of colour on black drawing.

◀ 2 Opaque white overpainting of vase.

▼ 3 Fibre-tip pen used for drawing with gouache colours.

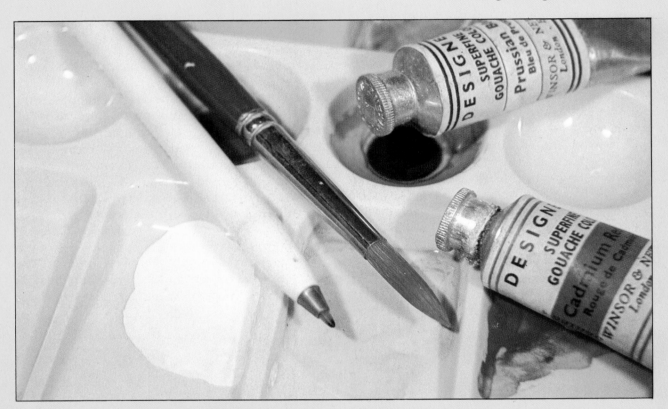

◀ 4 Colour work nearly completed.

▼ 5 Use of white on background and highlights.

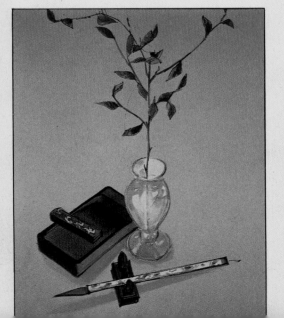

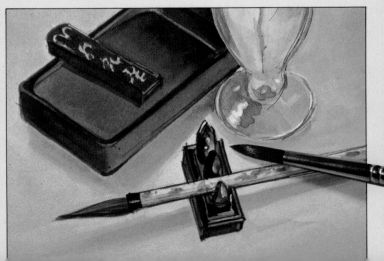

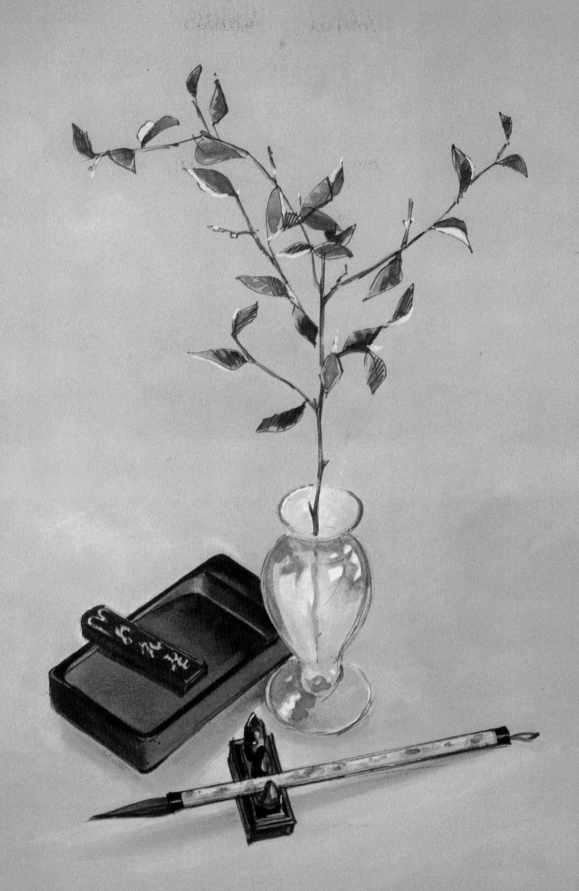

Basket of Fruit

Acrylic

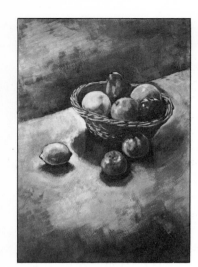

I suppose the reason that so many still life subjects are compositions of fruit, vegetables, game and other edibles is that the artist can eat his subject after he's made use of it for his work. Portrait painters can't put their subjects to such a use unless they're cannibals. Interesting thought!

I think the interest in fruit and vegetables lies in the shape and texture. Colour is attractive, too, but comes third in my book. Spheres and cylinders seem to be the constructional make-up of things like tomatoes and apples, carrots and leeks. But this is very basic. I found that in drawing these items there were subtle differences in shape. An orange may look round but it's not – the light reflected from the surface shows a many-faceted shape, rather like one of those folded geometric shapes of paper – dodecahedron.

A very simple arrangement of two grapefruit, two tangerines, an orange, a pear, an apple and a lemon gave seemingly roundish forms but were, on close inspection, quite angular. I made a rough monochrome sketch in black and white on a mid-tone paper to work out the shadows and highlights. Then I made a similar one in black acrylic on rough-textured white board and, when dry, put a light terra cotta wash all over it. This darkened the white and lightened the black, giving a pleasant basis for the acrylic overpainting. I was using the acrylic like oil paint, shovelling it on with little use of water to dilute the colours. The background was all but covered, small patches show here and there becoming part of the overall table colour which is made up of blue, red, yellow and white, the flat brush strokes showing up individual colours. I found this more effective than combining the colours to a flat mix of uncompromising mud.

The composition is set against the light which reflects from the table-top and brings the eye to

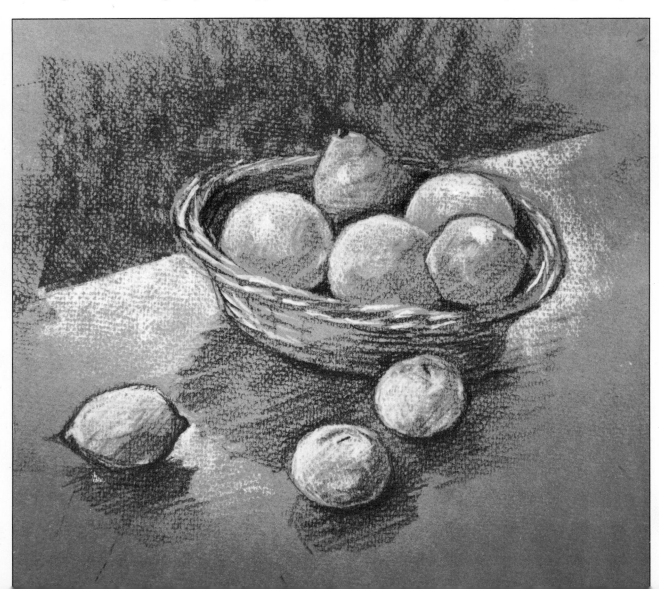

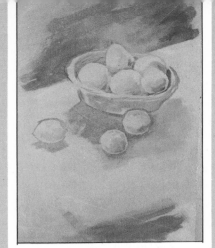

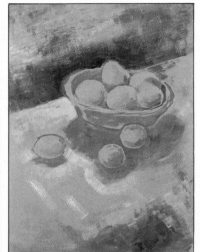

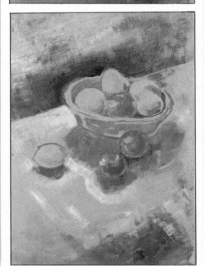

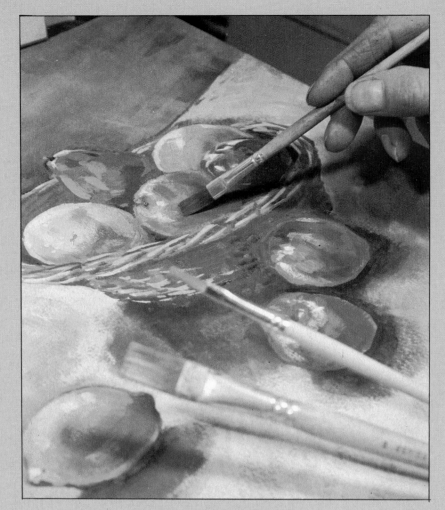

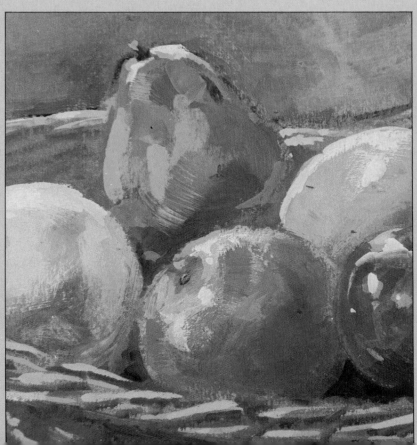

**BASKET OF
FRUIT**
*Acrylic
21″ × 15″*

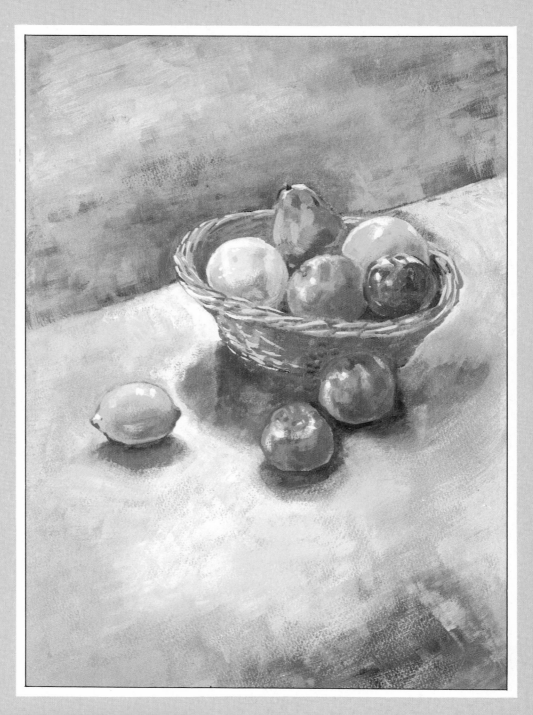

▼ Acrylic
paints come in
containers of
many shapes and
sizes.

that hot spot between the lemon and the shadow
of a basket.

A subtlety of reflecting surfaces of the fruit is
shown by repeating the colour of the tangerine
on the side of the basket and painting the orange
throwing its colour against the yellow of the
grapefruit. The apple, having a much shinier
surface than the other fruit, reflects the light as
brighter spots.

The rough hard skin of the pear is painted
with some eight colours. Shades of blue, green,
brown, yellow, orange and white.

Cosmos in the Drakensburg

Painting Pencil

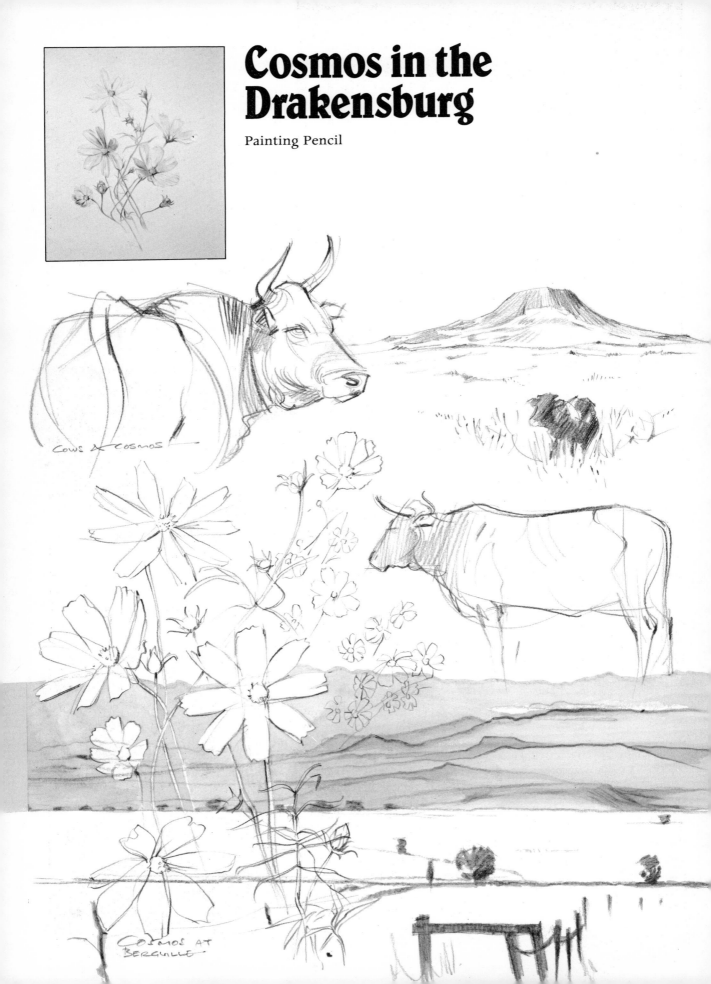

COWS & COSMOS

COSMOS AT BERGVILLE

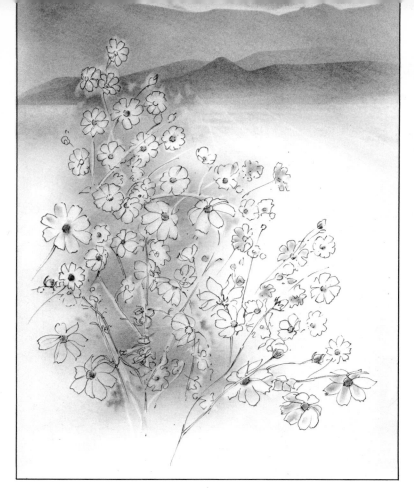

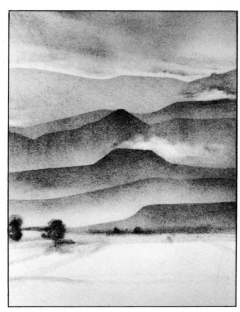

I expected to find cave paintings in the Drakensburg but not Cosmos in such profusion. These colourful and delicate flowers grew everywhere, fringing every field and bordering every lane and road. Over the mountains and among the mountain ranges drifted layers of white clouds looking like smoke. The ranges looked peaceful from twenty or thirty miles away, rather as though they'd been stencilled one upon another. I made pencil sketches of the mountains and working drawings of the flowers. I did an acrylic painting of the scene which I gave to our host, a photograph of which is reproduced here. I think it was a bit heavy and on returning home I made other interpretations, once actually using a stencil cut from paper and using chalk dust and cotton wool to achieve the effect. The Cosmos were drawn in pen and ink over the chalk dust and, where most effective, a putty rubber was used to remove some of the chalk dust. Then, wanting to do a more disciplined study of the flowers, I started to draw using the Conté painting pencils that I used for the Impala Ram. This time I wanted to use them as a water-colouring medium. Overleaf you can see that delicate work can be achieved using the colours straight away in place of a graphite pencil. Luckily, mistakes can be rectified by rubbing them out as long as this is done before water is used over the colour. Clean water and a pointed brush has merged the colours and brought about the effect of a water-colour.

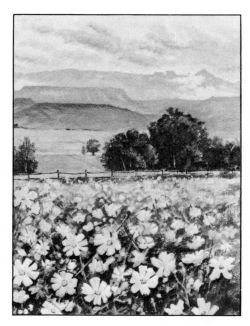

Hibiscus

Oil Paint

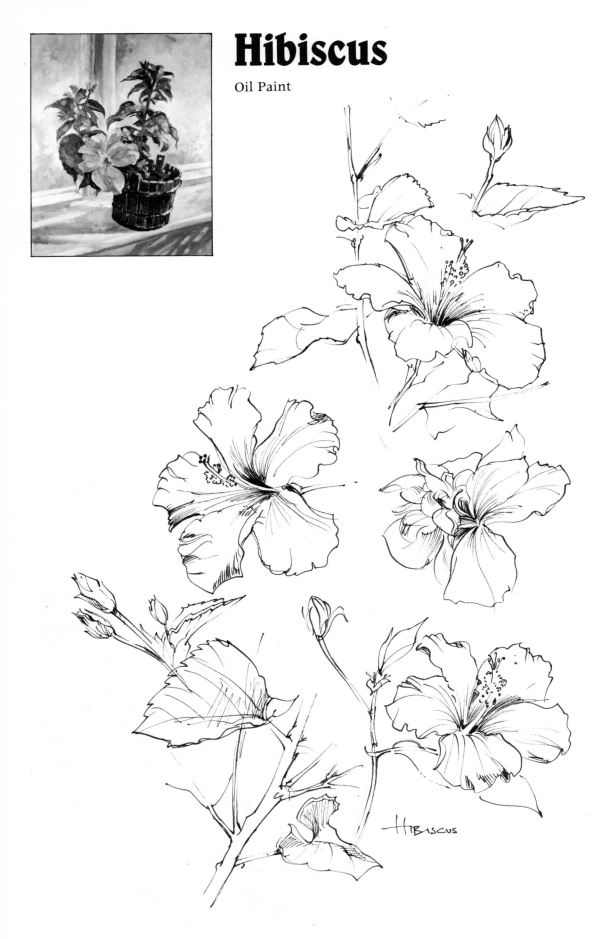

Hibiscus

The page of pen sketches shows the Hibiscus, as I love to see it, growing freely in hedges. We were once lucky enough to stay in a villa on the Caribbean Island of Montserrat, the garden of which was surrounded by just such a flower-laden hedge. Almost an embarrassment of riches! At home in England we do manage to grow hibiscus, but not in our gardens. One potted variety had, in contrast to the more usual scarlet flower, yellow, almost rose-like petals and this became the subject of a still life. The choice of oil paint was because I needed the slower drying process of the paint to enable me to push it about, make changes and generally merge the colours without hard edges forming when I didn't want them. But to enjoy this advantage it is no good wishing for instant results and I had to get used to the fact that because of its slow drying you can't shovel a brushful of white or yellow over a darker colour without the darker colour coming through where you don't want it! You have to put the painting away for a day or so and do something else until it's dry enough to lay on the lighter colour effectively. On the other hand the merging process of colour was delightful, rather like playing with lubricants.

The canvas board has been prepared with a rough preliminary drawing in Burnt Umber mixed with turpentine. Brushes, oil colours, white spirit for cleaning and plenty of rags are the essentials.

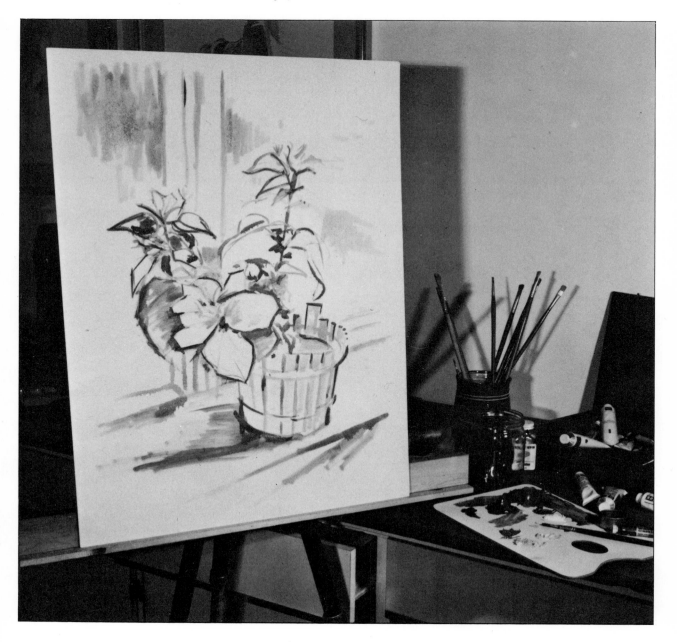

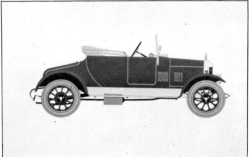

Vintage Cars

Ink and Acrylic

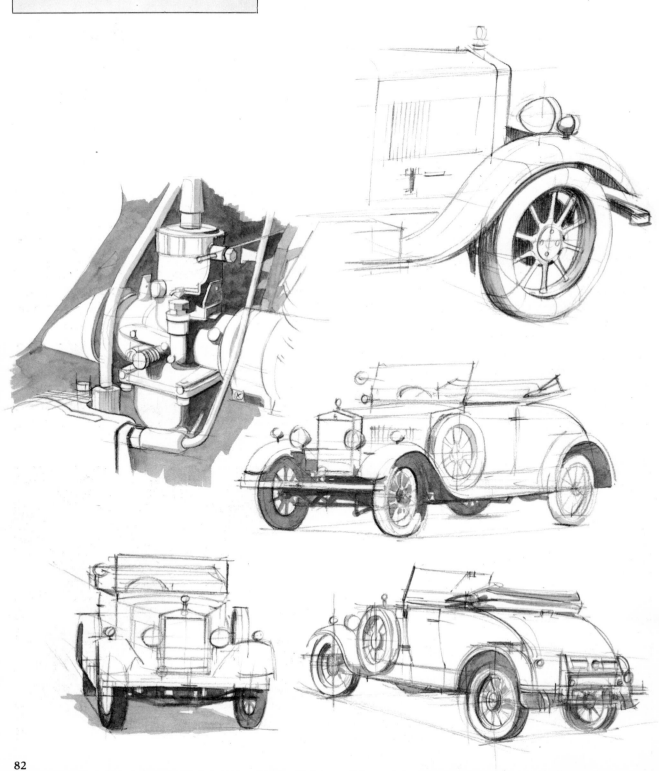

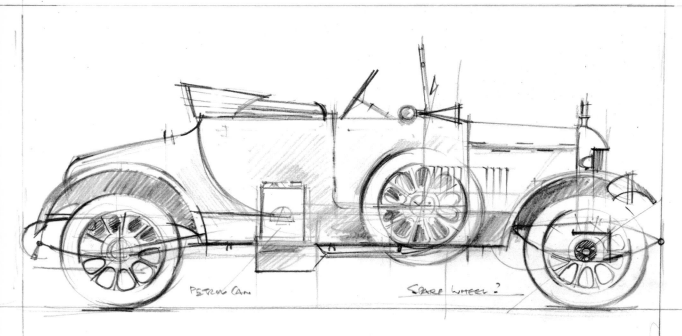

It was suggested to me that I might include some machine drawing in this book. A very good idea because I know that many people have great ability in this direction and much prefer mechanical drawing to any other. When it's a matter of mathematical knowledge for required information there is no other way of drawing as draughtsmen, architects and many designers know well. Very attractive artwork can be the result and I've attempted to make a picture of a delightful motor-car, born in the same year as myself. My uncle owned one, and it was the first car I can remember. Many years later my brother bought one – by now a veteran car. He and another chap, when drama students, shared it. I remember painting 'Minnie' on its bonnet.

We christened it with a bottle of beer and it became an object of dubious approval around South Kensington in the early fifties.

The other day I found a vintage car in a local car park. Not the bull-nose Morris, but a very useful model, which had on it much of the detail usable for my drawing of the 'Bull-nose'. I also had a photograph, taken in 1925 showing a three-quarter view of the car. From this I was able to make a side elevation drawing, and this, together with further reference from motoring journals, became the basis of my ink and acrylic painting. I used acrylic paint for the colour areas because once dry I could use another colour on top without risk of 'lifting' the underlying colour.

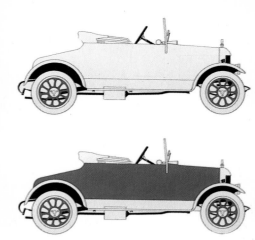

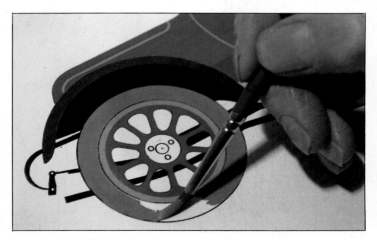

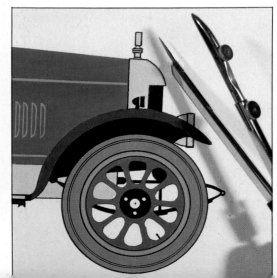

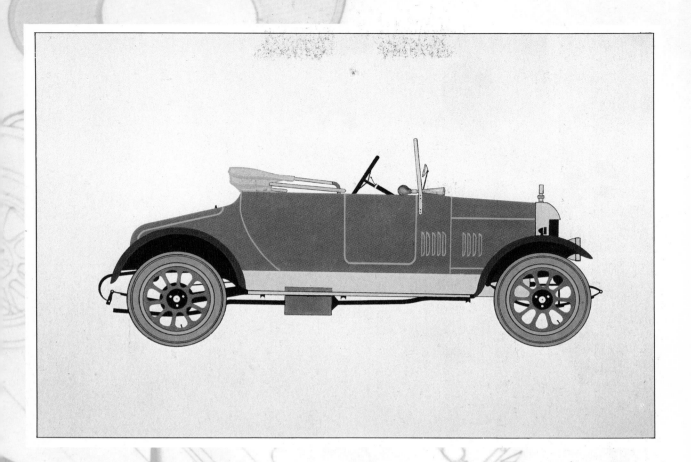

BULL-NOSE MORRIS
Ink and Acrylic
10" × 7"

◀ The initial drawing in black ink has been
made with compass and ink pens. Further
work in acrylic paint has been done using
both pen and brush.

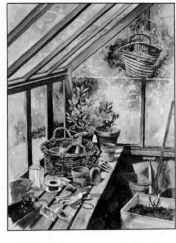

The Potting Shed

Water-colour

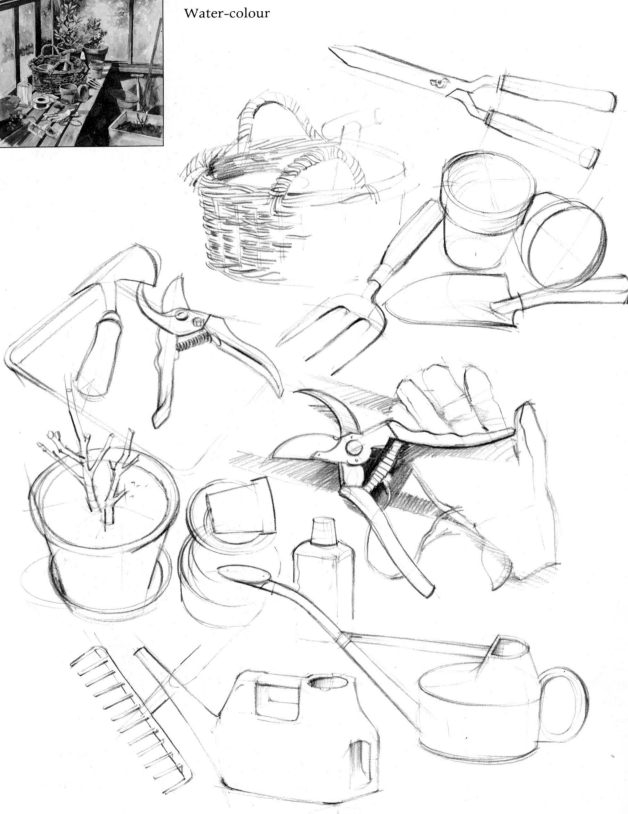

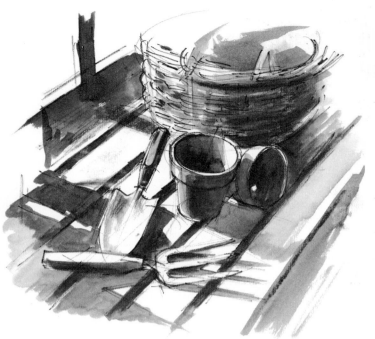

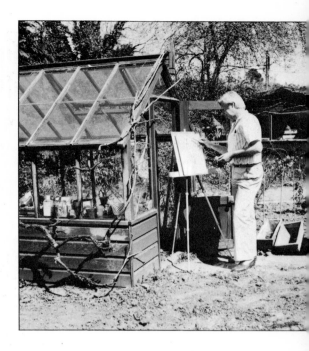

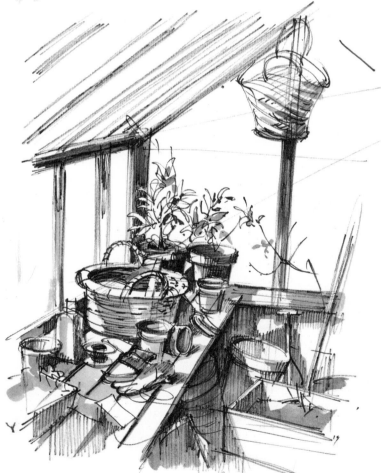

The potting shed was a perfect place for a still life. It had the advantage of seeming both exterior and interior which gave good light with interesting shadows. The shape and texture of all the things to be drawn made a fascinating study on their own. By deciding to make a watercolour drawing I was able to think first of the layout and composition and next of colour. The shadows, as always, were constantly changing, so quickly that rough drawings in marker pen and wash were essential to record their positions in relation to the objects being drawn. When the final colour drawing was made I started off in pencil on a Not surface colour-wash board then overdrew with a fine-tip marker pen, as near to Raw Umber in colour as I could find. This drawing enabled me to go to town on the detail and then rub out the pencil work. The marker pen ink tended to merge with the watercolour when this was applied but this softened what would otherwise have left hard linear edges. The potting shed is really a study in reds and browns. The terra cotta of the pots, the wicker-work basket and the wood of the shed. The light greens of the exterior are picked up in the brighter leaves inside and in the string and trowel handle. The handle of the fork has the deepest red but all the colours are subdued so as not to overcome the drawing.

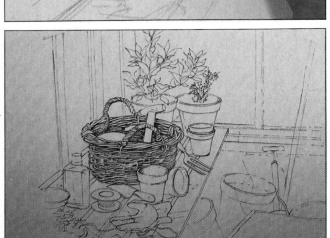

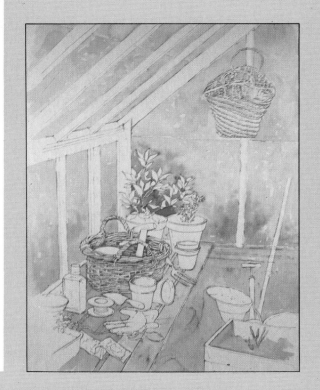

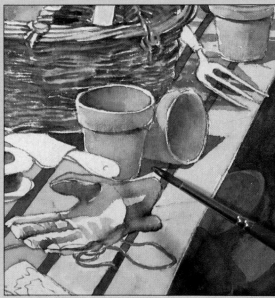

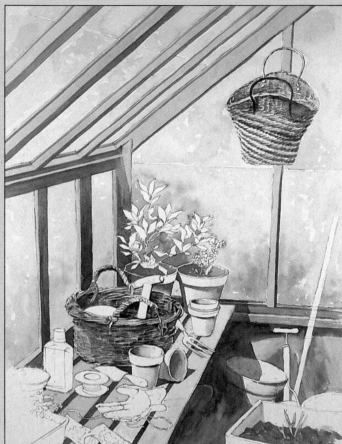

88

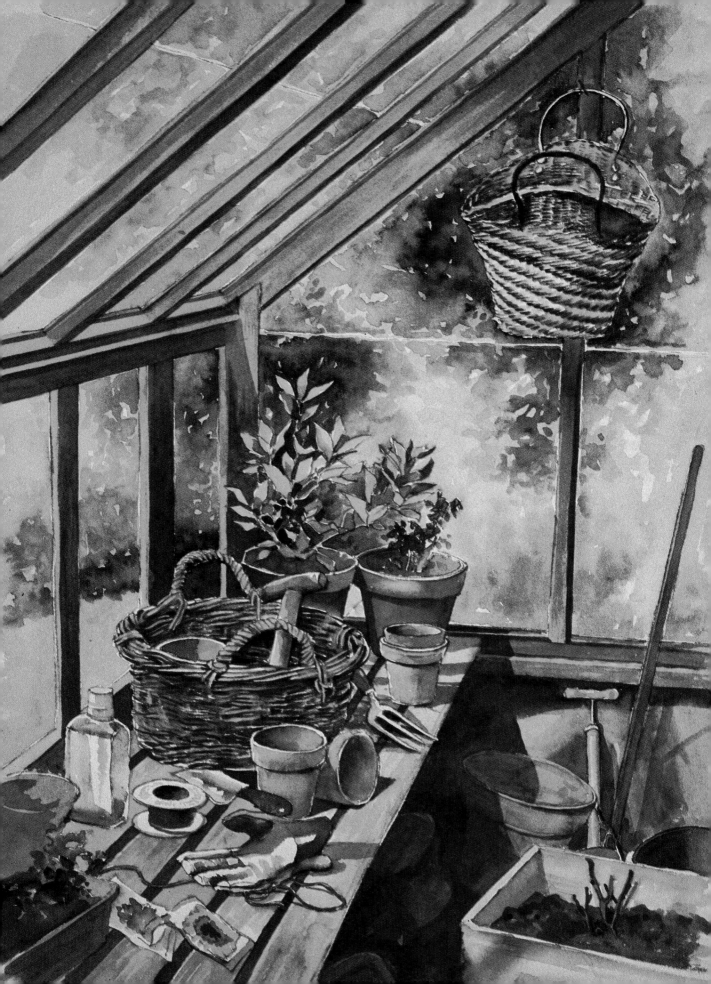

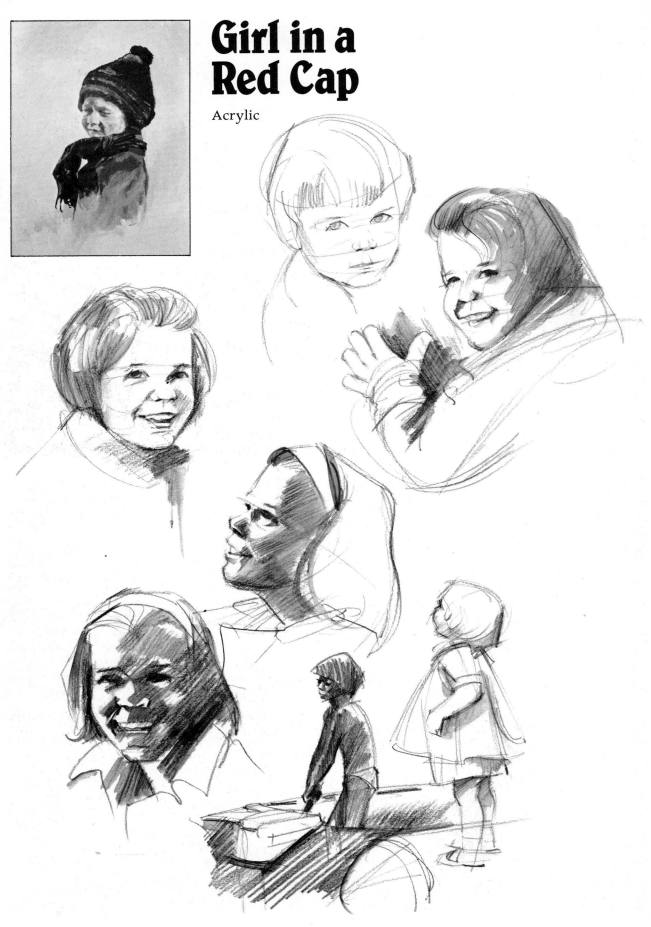

Girl in a
Red Cap

Acrylic

If there's a difference between drawing and painting I suppose it could be said that we think of drawing as being linear. We recognise that lines deliniate a form which our imagination fills in. Of course we usually go on drawing with pencil and pen making lots of hatch lines so we can actually see areas of light and shade. With painting, a brush can put down a form in one go so that the area made by the brush stroke could be the equivalent of many pencil lines.

On these pages everything is drawn with pencil lines, although those on the left have some grey wash added to further the shadow areas.

The girl in the cap and scarf is going to become a painting. After the initial rough layout with a brush, only larger brush strokes will be used to make form and colour.

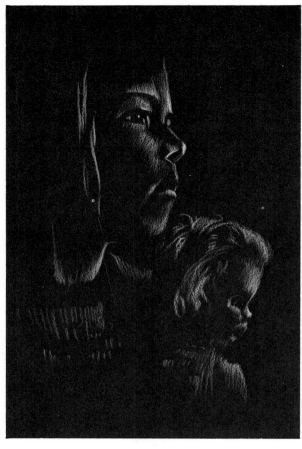

◄ The drawings here have a progression of shadow area ranging from little to a lot. Half close your eyes and look at the girl's face with a lot of shadow. It starts to take on a real feeling of roundness.

► These drawings show how little information is required to 'read' what is there – highlights alone are sometimes sufficient.

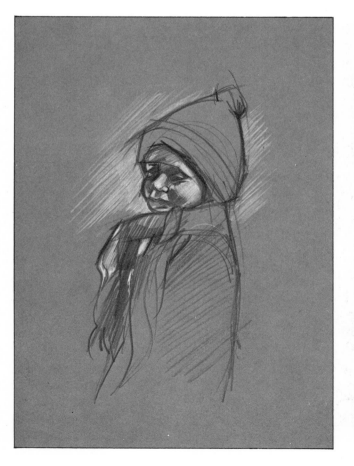

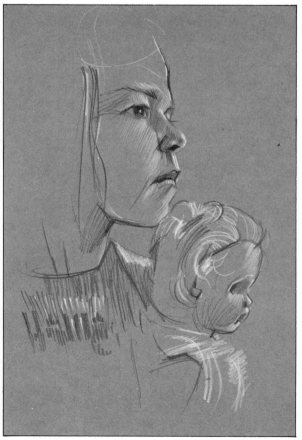

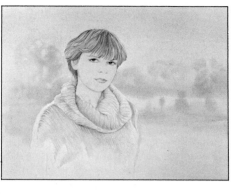

Carolyn

Pastel Pencil
and Wash

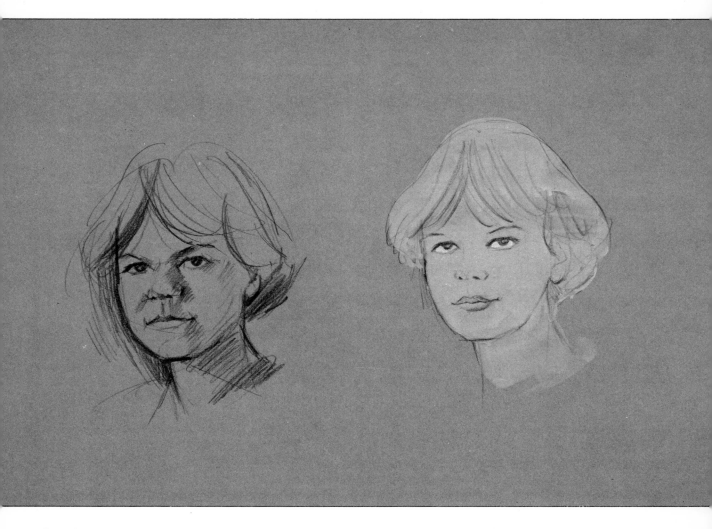

Elsewhere in the book is an oil portrait of 'A.J.J.W'. Here is a portrait of his wife, who happens to be my daughter. I wanted to make a portrait of Carolyn that contrasted with that of her husband. Carolyn is a mercurial person whose mood and appearance is changeable. Sometimes turning up on a motorbike in leather and jeans and then reappearing as the suave cosmopolitan, or wearing something soft and sweet in her role of English Rose. Variety, as we know, is the spice of life and so it is with art. So this is going to be a soft sweet portrait, done in pastel pencil and water-colour.

I made two sketches on grey paper; one, as I usually make rough sketches, indicating the shadow areas to give form to the face and one with a minimum of linear information and no shadow forms to speak of. This latter I washed over with a white gouache to see if it would destroy the Conté pencil lines. It didn't, it just softened it slightly. I then knew what I was going to do. I made an economic line drawing of Carolyn using a Sanguine pencil for face and hair

and pink and blue pastel pencils for the loose wool sweater. With a medium flat water-colour brush I then put a cream-coloured wash all over the face and head. This was done as quickly as possible to prevent tide marks and with the drawing upside down and on a tilt starting at the neck line. Single side to side strokes with a minimum of pressure laid the wash evenly over the features. As the wash started to cover the hair I thought it might smudge the pastel lines, but, as with the rough, it only softened them a little. When the head was dry I used a pointed brush to make darker forms, giving a red-brown wash, to the hair. The mouth and eyes were similarly treated. The darkest parts of the portrait are the pupils of the eyes which have become the focal point.

It was a temptation to darken the shadow areas made by the folds of the woollen sweater but this would have detracted from the focal point. A very light wash of magenta and cobalt blue was put over areas of the pink and blue pastel just to balance the colour tones.

Young America

Marker Ink

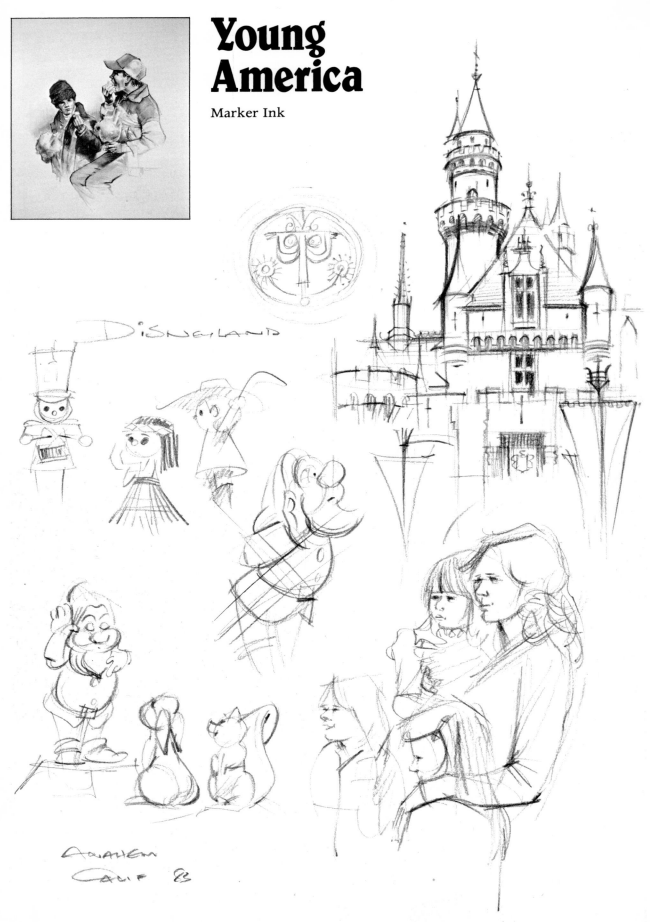

DISNEYLAND

ANAHEIM
CALIF 83

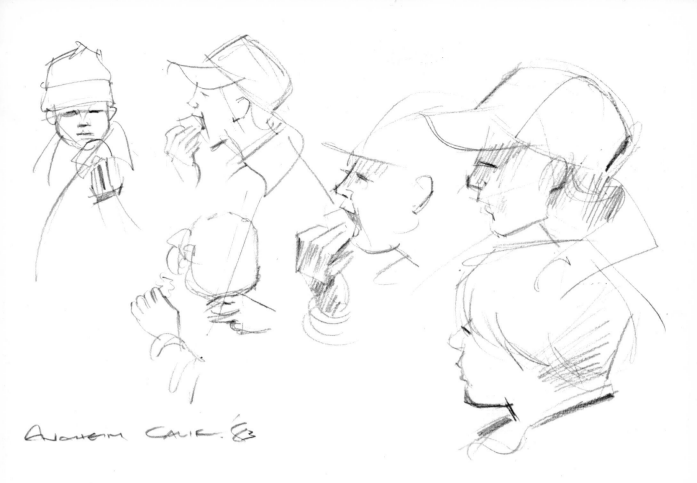

ANAHEIM CALIF. 83

You'll find Young America and the 'Young' of all ages and nationalities at Disneyland. I first visited this magic world eight years ago. I was entranced then and had no reason to change my feeling last year. This time I was more aware of the crowds and what they did when they weren't actually being entertained by the incredible number of attractions. They ate! Sitting on walls, sitting in restaurants and walking about, they ate. With some thirty eating places, snack centres and refreshment areas, there's no lack of good, fast and junk food. Jumbo packs of

popcorn and candy floss seemed to be in unlimited supply. It was the sickly pink of the candy floss matching the head gear of one young American that determined me to try to capture this exotic scene. Because of the occasion and the larger than life colours I wanted it to be brash and gaudy. I found the ideal colours in a variety of Marker Pens. These come in Permanent or Soluble Inks. Permanent means just

Children

Pastel:
The Deserted Beach

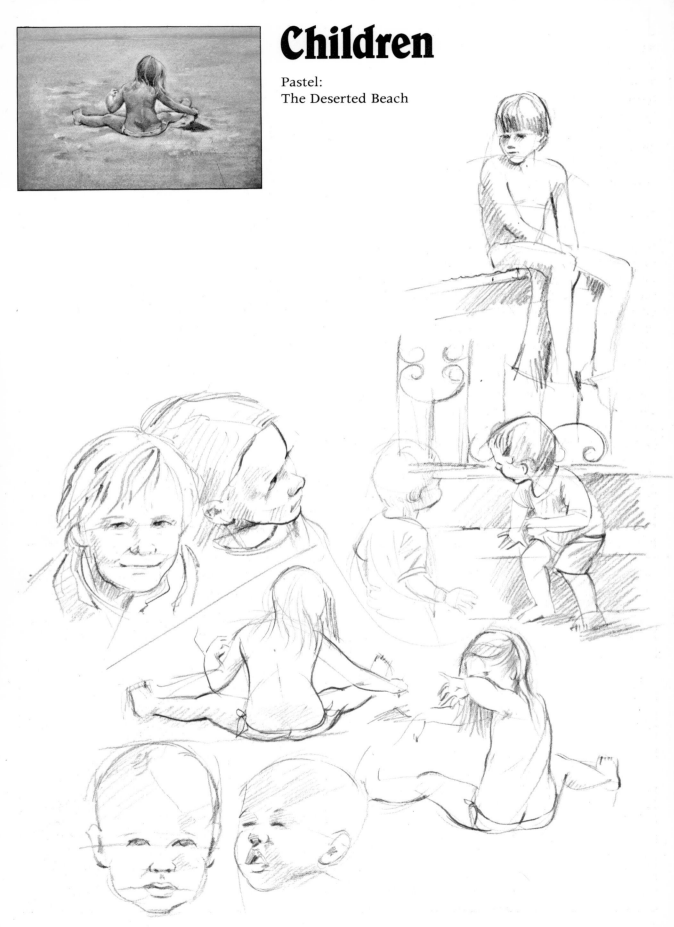

Children, like animals, are mercurial, so you have to take them as you find them as models. Very lucky you'll be, unless they're asleep or actually wanting to pose for you, which can happen if they're interested in what you're doing, but you must make quick sketches. Over twenty years ago I was commissioned to draw a child to publicise Famine Relief. My contention was that most drawings of this sort depicted an emaciated, skeletal little creature which, while provoking pity and horror, was not the best way of reaching the hearts of people. For this study, one evening I took my five-year-old daughter from her warm bed, carried her downstairs and sat her on the floor. I gave her a wooden bowl to play with and made a quick sketch. I merely reduced the chubbiness of a healthy child and exaggerated the eyes. This was the rough drawing from which I was to make the finished one, but I never did it. The rough was probably the best thing I've ever done and that is what was used. Now, blotched with stains and torn at the edge, I would not part with it for anything. The child on the beach was completely absorbed in making a little mound of sand. Although I've called the picture 'The Deserted Beach' it was in fact, packed with ebullient Italian families, but the child was blissfully unaware of anything except her construction in the sand. I chose pastels and a grainy paper for this project, put my child firmly in the middle and surrounded her with empty sand. Because she is so occupied she doesn't appear to be in the least lonely. I well remember as a small child I was similarly occupied on the beach at Cliftonville. At the end

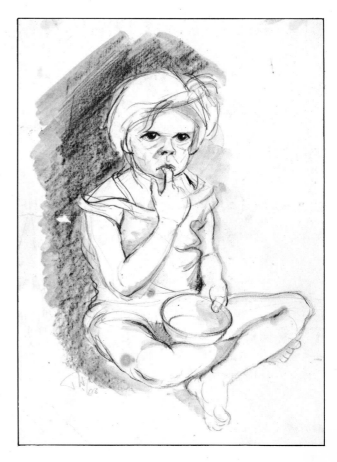

of the day the family moved off telling me to 'come along'. I, of course, didn't hear and went on with the engrossing work. I know the sun was low when I looked up – and they weren't there. For a few moments – panic – then I saw them. It must have happened to us all. I don't think it could happen to my model surrounded by Italian families in Positano.

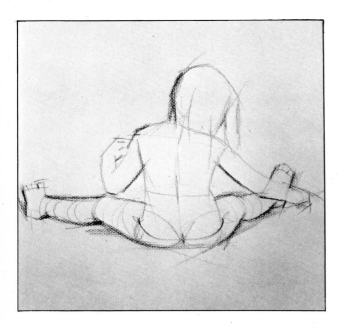

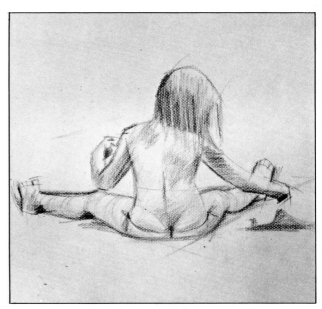

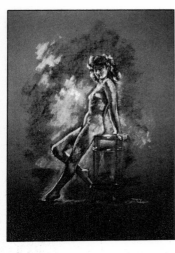

Female Nude

Pastel

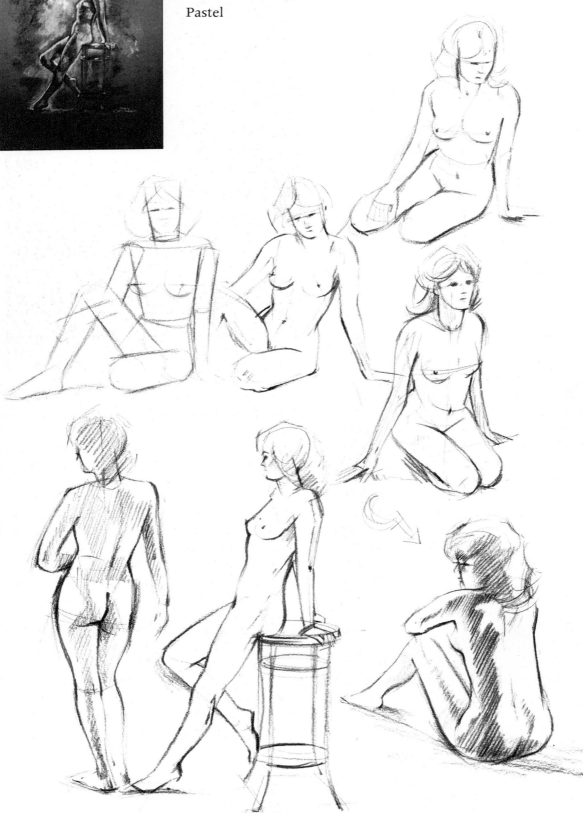

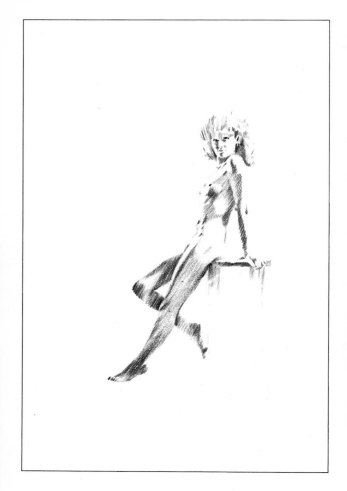

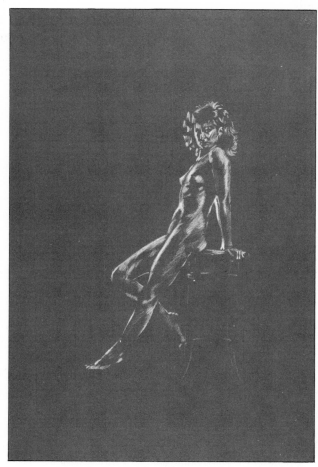

I suppose the reason why art schools throw us in at the deep end by packing their students off to the Life Class is to get it out of their minds, once and for all, that art is easy! Exciting, fun even, but quite definitely not easy. And the human figure is perhaps the most difficult to draw. As it is some time since I last attempted such a study, I was both interested and pleased to find that my training and years spent as a graphic artist and Cartoonist did not hinder my attempts at drawing the human body. Indeed, knowing where to exaggerate for a cartoon illustration made me aware of the pitfalls when trying to establish a realistic drawing. Just as I use a construction of lines and shapes in my normal work, so I used them here. The human form is made up of cylindrical shapes like barrels and drain pipes. So, if you get these shapes down lightly first you can over-draw, gradually doing away with the hard lines, and bring about the curves that are really there. That is the obvious drawing. Much less obvious is the effect of light. We take it for granted when it produces shadows and highlights thus making us see and understand the form. I've made an experiment. After drawing a

figure that gave almost sufficient information I studied the effect of light on the body, on those cylindrical shapes and where it hit depressions and protuberances. Then I made two studies, one on white paper of all the shadow areas, and one on grey paper, using a white pencil, of all the areas hit by light. Both perfectly readable and, I think, attractively economic. This is the stage that I am always telling myself, "Leave well alone. If you do any more you'll spoil it". Very good advice, but I wanted to bring a little colour and warmth to my nude. A warm background, warmer colours and more information in the result but less detail in drawing.

The result and the stages of work are overleaf. Terracotta Canson paper was used to draw on. Conte Carré crayons and pastel pencils to draw with. The terracotta paper becoming the mid-tone colour of the figure and Sanguine, red, orange, Madder Browns, Yellow Ochre and white being the other colours.

Gemma

Conté Sanguine
Pencil

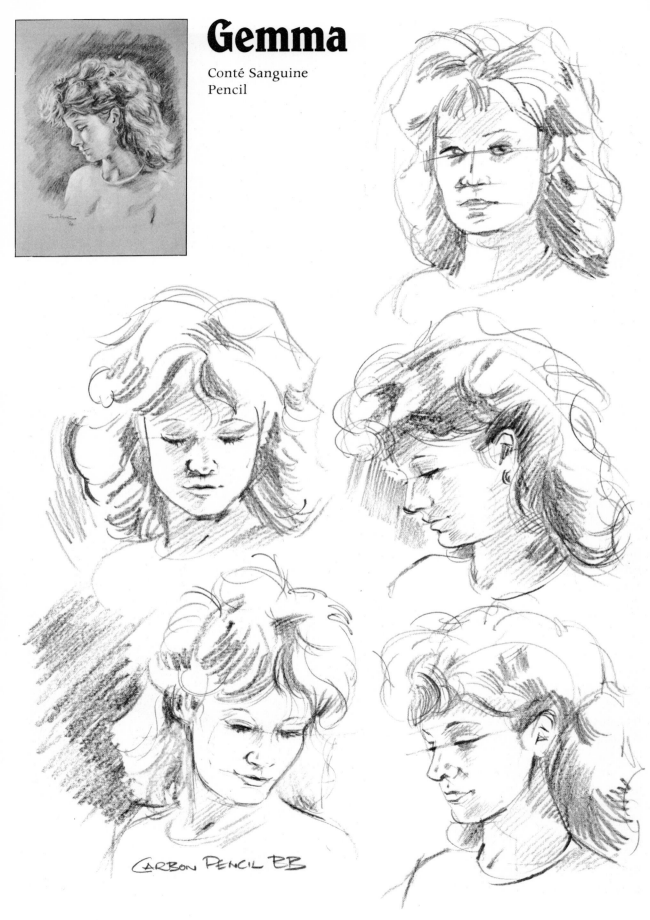

CARBON PENCIL BB

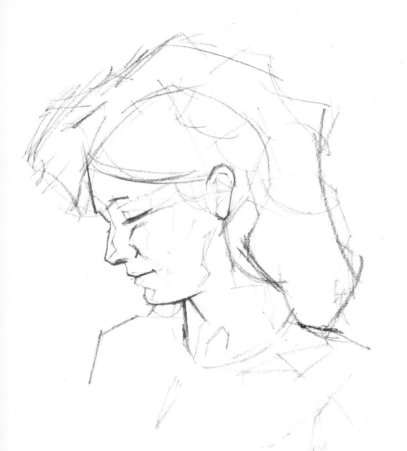

dark and thus mould the face.

I'm going to use two pencils. A red-brown 'sanguine' pencil and a white pastel pencil. The background paper is Canson Grey, a slightly mottled paper with an attractive texture that comes out in the drawing. Unlike using pencil and white paper, the whites of my drawings are not seen as the paper but as an added lighter tone to the grey background. This has the effect of creating an even more three dimensional effect than that shown in the drawing on this page. Should the Sanguine pencil prove too light in tone I can always add a minimum of detail with a darker Sanguine. The word is French. Blood coloured, it describes either the drawing or the crayon you draw with. It's made from iron oxide.

For an artist to have a professional model is a luxury. However well meaning and compliant your friends and family may be, they will find it hard to hold a pose for any length of time. I well remember, when at Art College, the mutterings of frustration from we students when it was discovered that the model, quite unknowingly, had changed the pose and thrown our work into confusion. It's not a bad plan to make quick pencil drawings that will catch a pose and, having got that right, use it to establish any further work. If you've noted the planes of the face and how the light falls and where the shadows 'occur, you can quickly delineate these areas, and at a later stage make the forms that denote light and

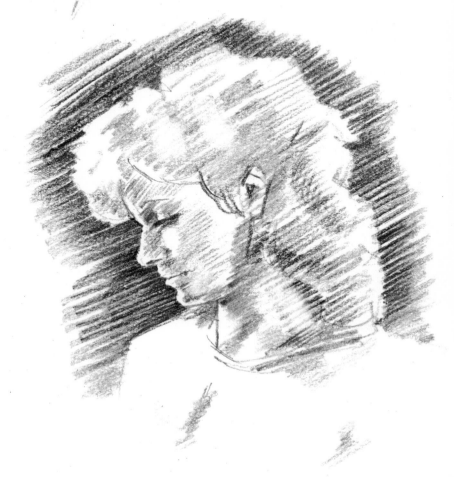

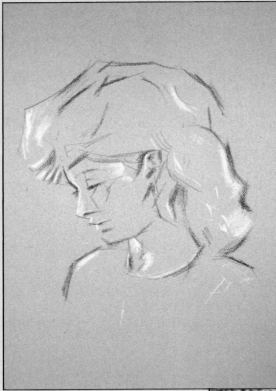

◀ 1 First stage of drawing using Conté Sanguine pencil and pastel white on Canson paper.

▼ 3 The close-up shows how the pencils can be used to make the most of the texture of the paper. Used with pressure the mark covers all the paper, used lightly it leaves the indentations showing and provides different tone values.

▼ 2 Second stage builds up the light and dark masses before going into detail.

▼ 4 Three pencils were used. The larger, darker Sanguine used only for minimal detail at eyes, nostrils and mouth.

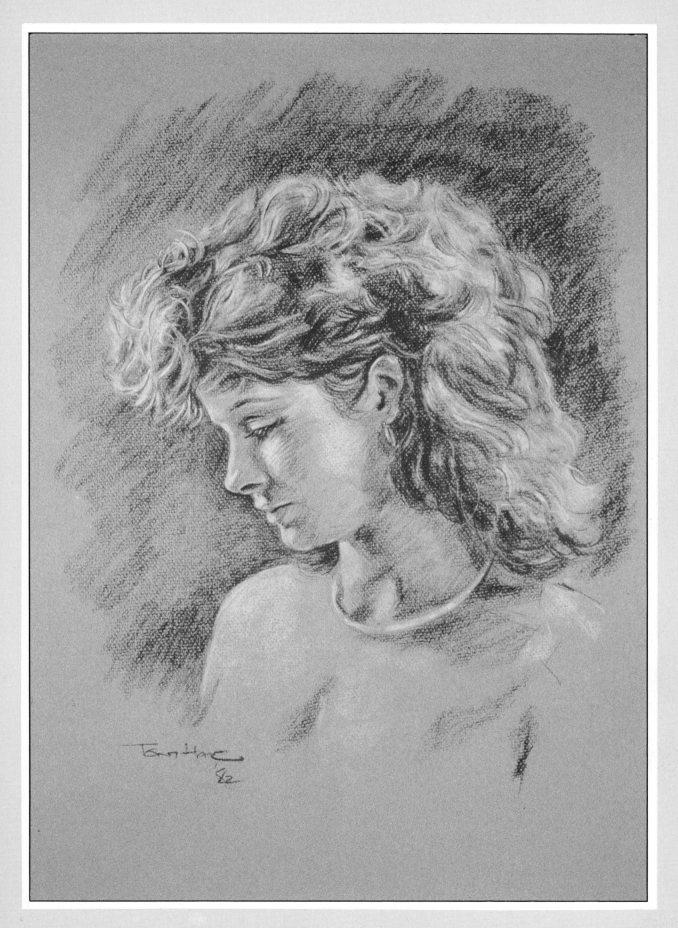

A.J.J.W.

Portrait
in Oils

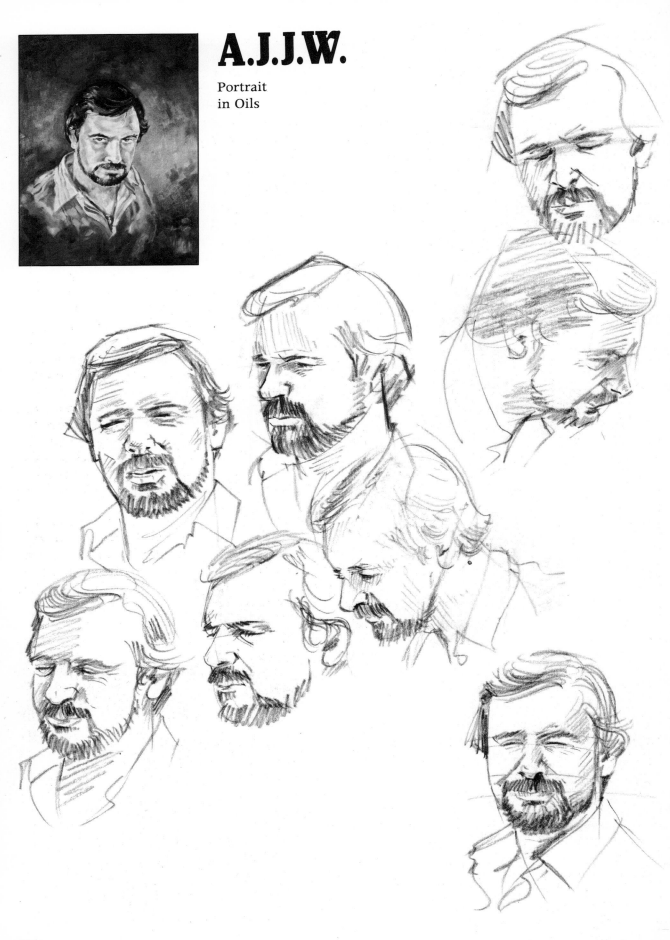

Now for a portrait in oils. So far, I've used them for landscape and still life paintings, but the technique used for this picture has to be different. The use of line to make up forms should now be abandoned and single brush-strokes should be used to put down a statement in colour, where perhaps I would have used several strokes in a drawing. My patient son-in-law was very good in letting me get the rough pencil drawings down. He also sat for the much more detailed black and white drawing (top). What I did was to make a very rough statement of light and dark areas (bottom) omitting as much detail as I dare so that I see the whole face not as a series of lines but as they might appear through half-closed eyes or out of focus. Rolf Harris once told me that when painting a subject he often takes off his glasses to stop him seeing

too much detail which he might otherwise be tempted to put in!

Having made a rough sketch, with the salient features marked, in Burnt Umber on prepared canvas, I brushed in a background of Burnt Sienna, Prussian Blue and black. Then, using the same colours, though not so diluted with turpentine, I put down the dark mass of the hair and touched some brush strokes to the moustache and beard line. The flesh tints and tones are surprising. When you really look at someone's face you realise that mixing up a vague sort of pink and putting that on is quite useless, it looks like a mask or a doll, not a living face. Quite apart from the skin which can be of any colour the shadows and highlights take on colours ranging from whites, yellows and reds, to blues, greys and greens. The shadows thrown to one side of the nose, for instance, could be warm reddish brown ochres perhaps. While lower shadows at the neck and under the chin might be cool. Blues and grey green may be right. The difficulty is in making these brush strokes of colour large enough to be seen as separate colours, but not so large as to look ridiculous. If the varied colours are put down too close and too small the effect is almost back to the overall pink, except it's more likely to look like overall mud!

When I'd finished the portrait I found the background colour too cold. I also thought my model was looking piratical. So I warmed up the background with ochres, reds and umber. Not a complete success, but not a bad poster for the "Sea Wolf"!

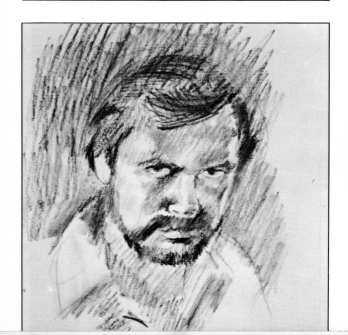

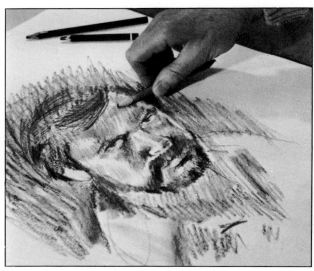

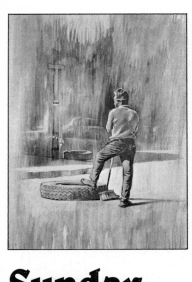

Sunday Morning

Carbon Pencil
and Acrylic

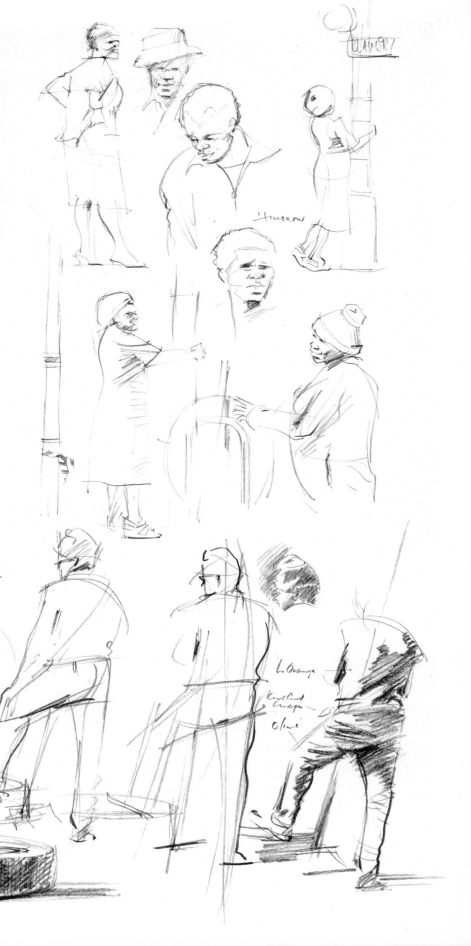

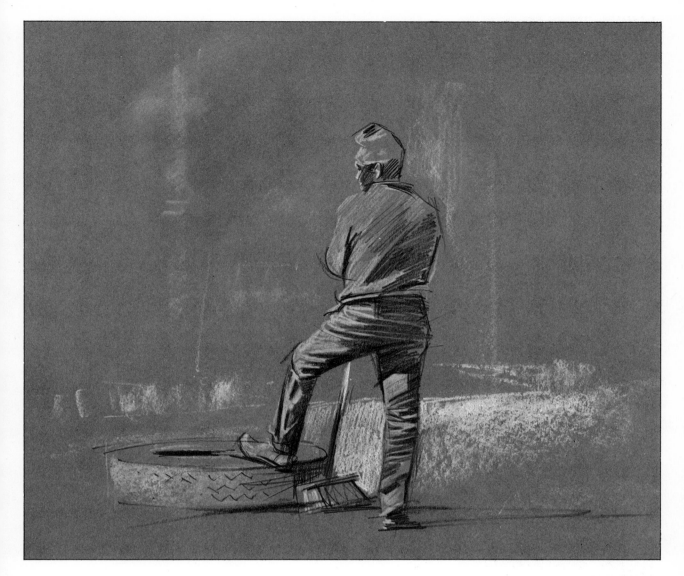

There is a fascination about living and working in another place. I was staying in Johannesburg working on a television series and also making personal appearances to entertain multi-racial children within the Johannesburg area. Sunday was my one day off. My wife, Jean and I used to explore the place on foot. One Sunday morning in June, that being winter in South Africa, I collected the reference for the drawing of the road workman. It was a beautiful sunny day, hot in the sun and cold in the shadows. Other drawings from my sketch-pad were made in Hillbrow. The girls were hanging about, as you can see, on their day off. I was intrigued by strips of coloured cloth reminiscent of old school ties tied to lamp posts and other bits and pieces that seemed to belong to the men working on the road. I came to the conclusion that as the colours matched the rings on the lamp posts, these were

to help the workmen to take their stuff to the right place of work. I made a number of drawings of my subject, detailing things like the folds in clothes and the shadows and highlights. Later I made a more detailed study in monochrome from which the finished colour-work was done. I well remember the dust. It was everywhere, catching the light and making strong contrast between the light and the shadowed areas.

The detailed drawing I transferred to a water-colour board using black carbon pencil, but first I painted a rough wash of vertical brush strokes in acrylics. This, when dry, took the carbon pencil well. I now had a drawing on a multi-coloured background of the colours as I remembered them. The next stage was to paint in the dark areas of the subject using an acrylic wash of one of the background colours.

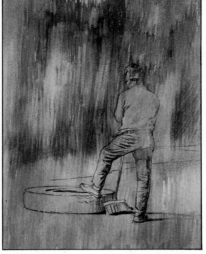
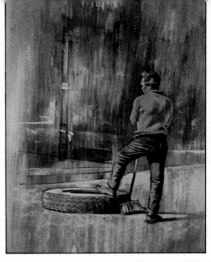

Further tones of olive, grey-blue and orange were used to paint darker washes within the drawing to heighten the shadows. It was interesting to see how forms, when painted in with either darker or lighter colours, made the subject stand out from the background. This was particularly evident when the sunlit areas were made lighter with washes of white and cream. Nebulous light brush marks in the background gave the impression of cars parked in the shadows. The only other colour used was for the touches of red in the 'Old School Tie'!

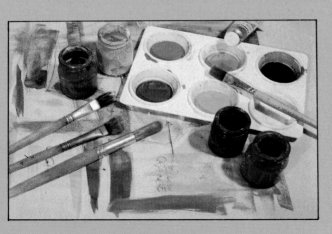

◄ Acrylic paint made up as colour washes for overpainting carbon pencil.

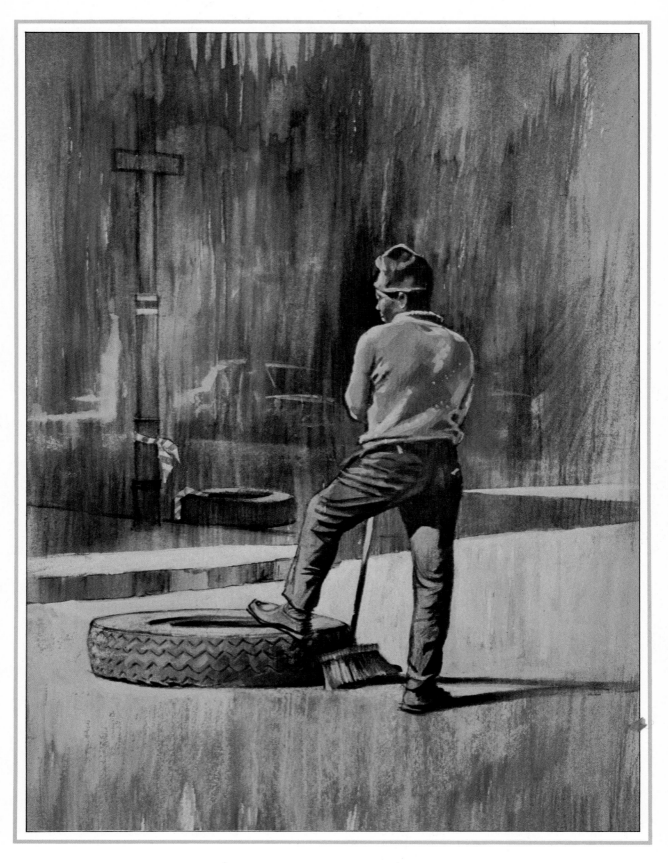

SUNDAY MORNING
Acrylic
16" × 21"

Floating Market

Water-colour

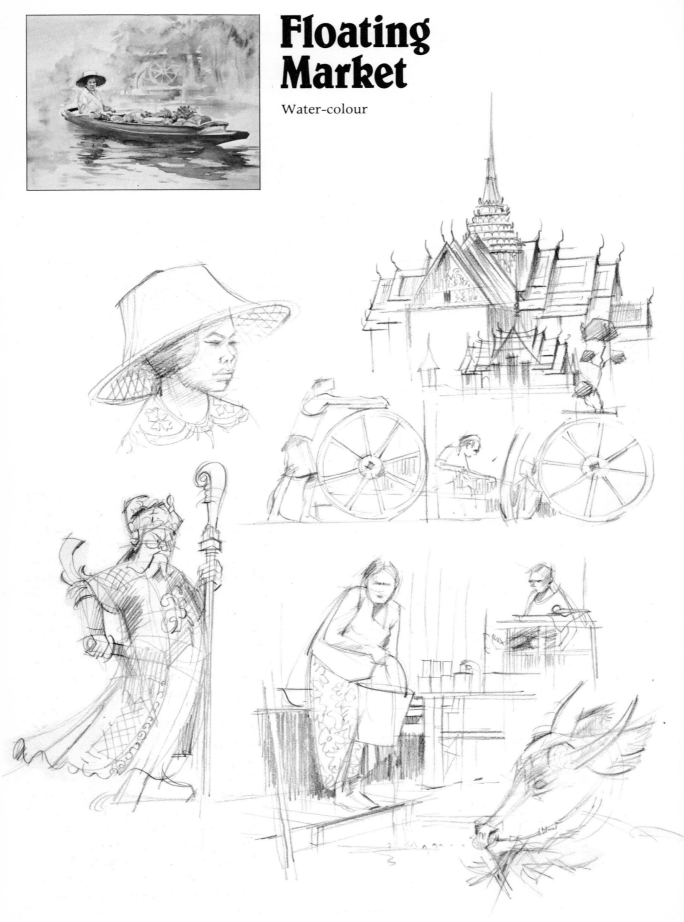

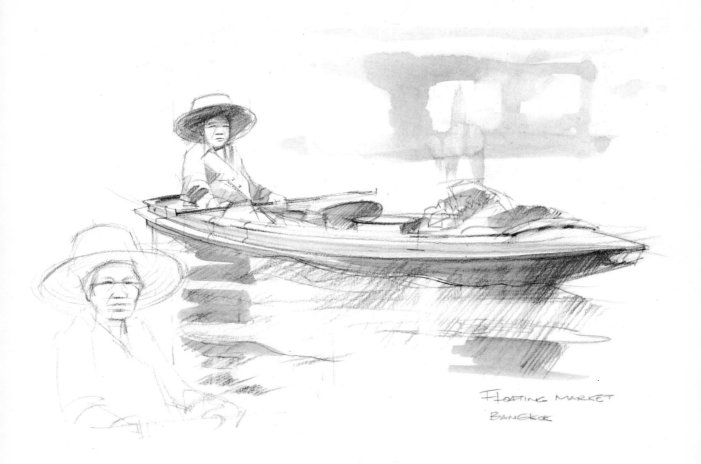

FLOATING MARKET
BANGKOK

STONE CARVING — BANGKOK
'78

I hadn't been back to the East for thirty years, so when I did go it was with a mixture of nostalgia for what I remembered and surprise at what I'd forgotten. True, this was Thailand not India, but the colours, the noise, the smells, the beauty and the ugliness were all of the East. In Bangkok the two colours found everywhere were a sort of magenta pink, as in the water lilies, and acid green. On the river life went on with people working and living in huts and houses on stilts above water level. Trade was carried on from boats, boats piled with fruit and vegetables and rowed by men and women of all ages. My picture has tried to bring about the feeling of all this. The magenta reflections, while being quite impossible, give the colour I remember. Something man-made in the background was called for, so I included wheel shapes that I'd seen carpenters working on. These are indicated very roughly in the water-colour.

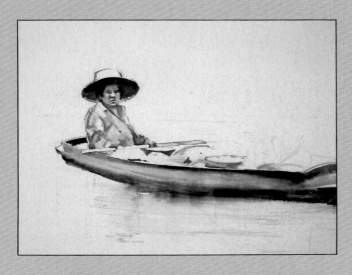

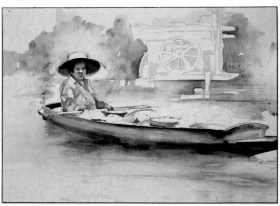

Here are the stages from a pastel pencil drawing, on colour-wash board, through the application of water-colour. I have not attempted to paint detail but rather to make brush strokes of colour to give a readable impression of features, fruit and vegetables.

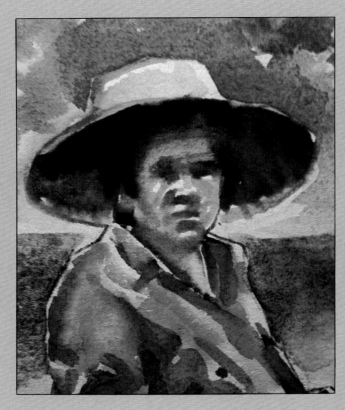

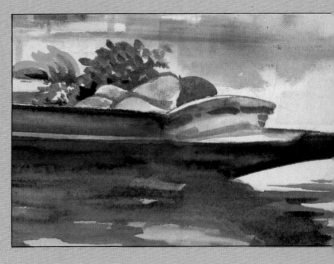

The reflections gave some trouble. Without sufficient reference to actuality I had to find a river barge nearby at home and draw the effect of its reflection in the water. This gave me a reasonable feeling of what it might have looked like in Bangkok. I think this is what is called 'Artists' Licence'!

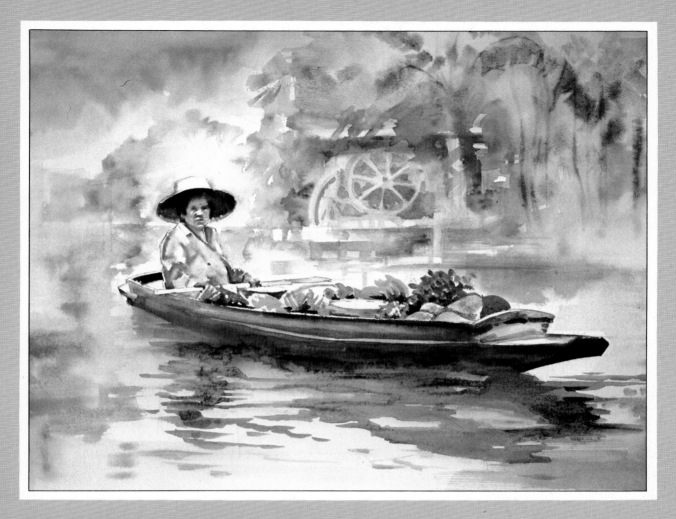

FLOATING MARKET
Water-colour
15" × 21"

▶ Finger talk! Author and friend. Compare the girl's headress to the spire of the pencil drawing a page or two back.

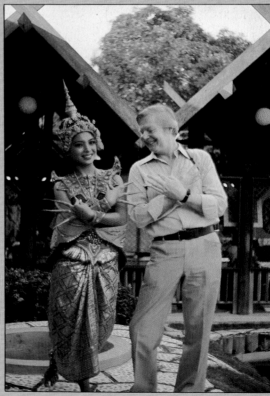

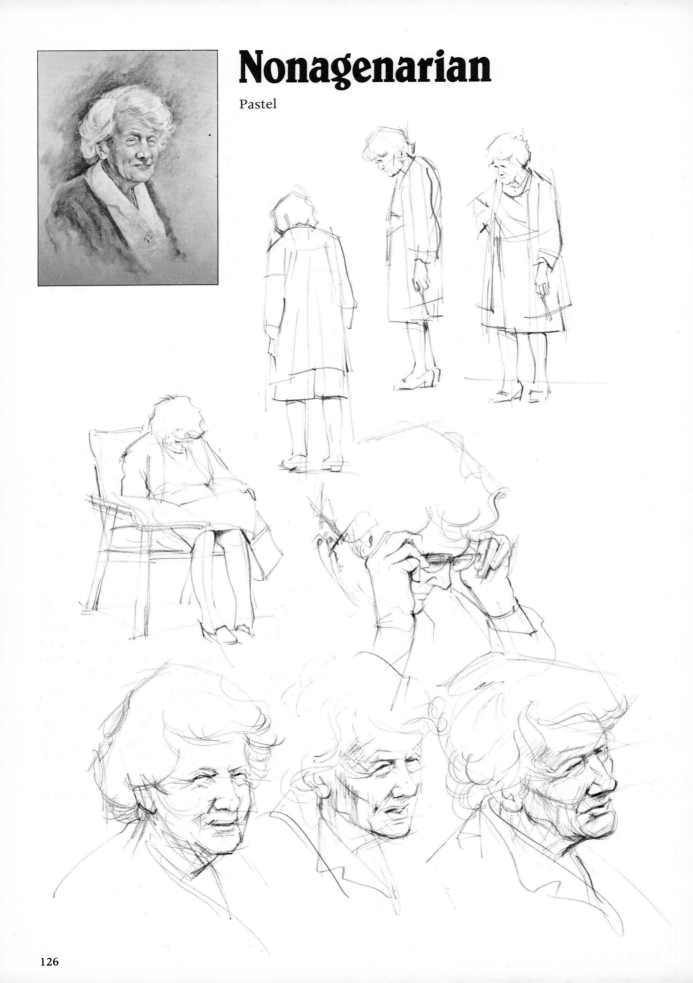

Nonagenarian

Pastel

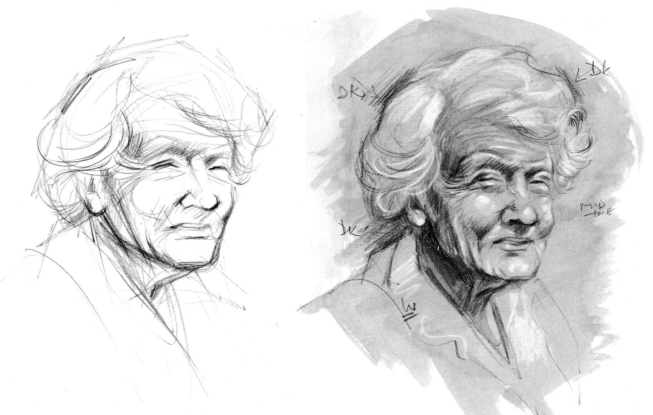

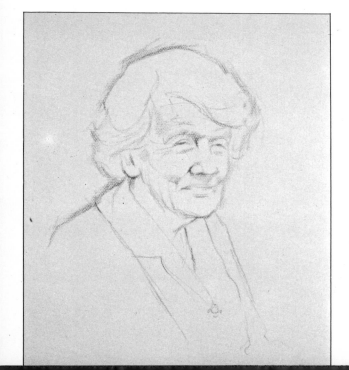

Over the years I have perceived a phenomenon in the results of portraiture. The artist, usually without realisation, tends to paint his subjects as looking older than they are. I have a friend who most certainly grew to look like his picture. At the time we all said, ''She's made you look far too old!'' This applies even more to caricaturists. The subjects slowly, but perceptibly grow into the caricatures of themselves. Watching a prominent politician on TV last night confirmed this to me. But, conversely, is it possible that we portray really elderly people as looking younger than they are? I believe we do. It's not flattery. We have to look incredibly closely to analyse what happens to flesh in action or repose over the bone structure as we get older. And in painting it we either make it look like a boy, made up in a school play and playing an old man, or we paint what we think we see, which is so subtle we tend to strengthen the ageing face.

The lady in my drawings is ninety-three years old. Truly she is an incredible looking woman for her age. I am prejudiced – she happens to be my mother-in-law. The antithesis of all M. in L. jokes. I've got it right in the standing and sitting drawings, but the head portraits in pencil and wash are of a stronger, younger woman. For my pastel, shown overleaf, the colours help to determine the softening of skin area relating to underlying bone and the shadows brought about by these changes. This use of tonal colour softens the whole of the face, takes away that wooden feeling of it being carved and allows the humour to show through.

◀ First stage of pastel drawing on Canson paper.

127

Water Buck

Pastel

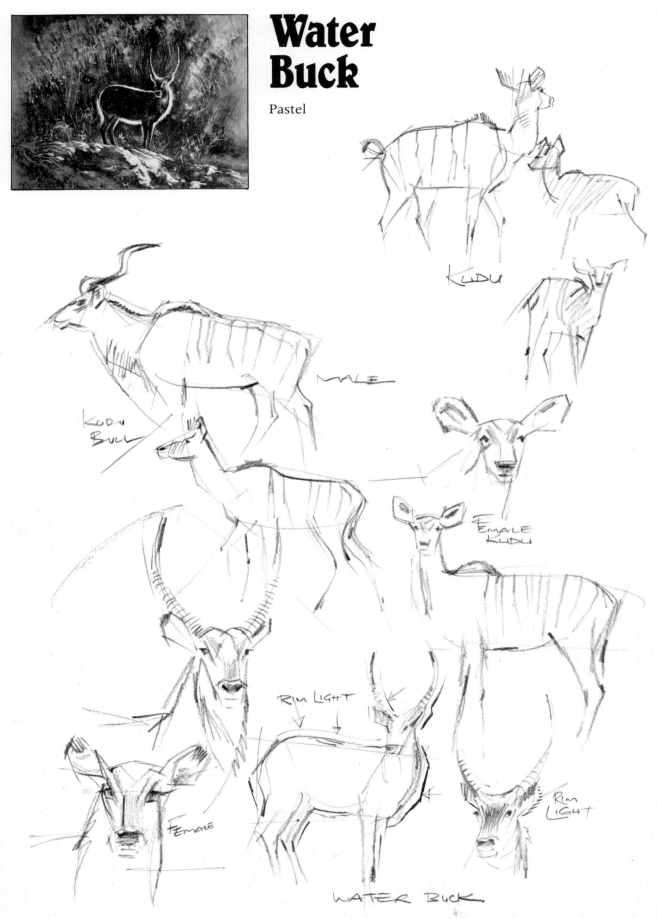

KUDU

MALE

KUDU BULL

FEMALE KUDU

RIM LIGHT

FEMALE

RIM LIGHT

WATER BUCK

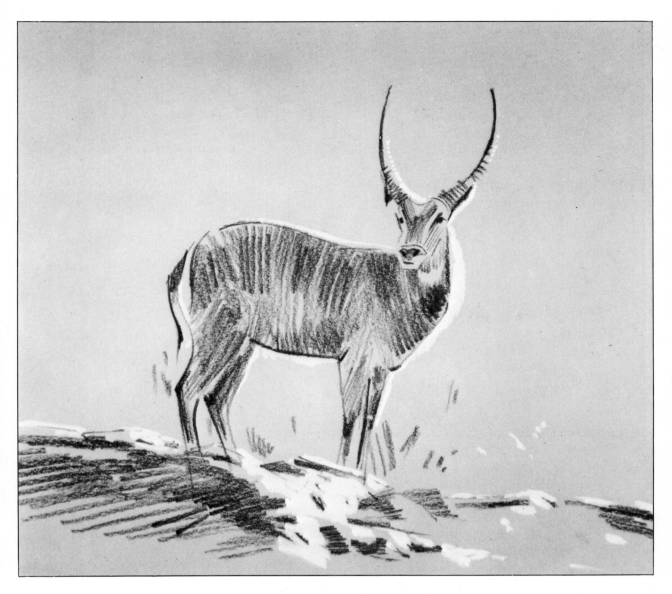

Sometimes it's as though animals realise that they are looking superb and actually become artist's models, posing so as to make the best of themselves. I once had a dog who did that – you only had to bring out a camera for Baggy to show herself to advantage! In the case of most wild animals they are simply defending themselves, freezing and hoping to make use of their natural camouflage to make themselves difficult to see. Sometimes an animal freezes, but instead of merging into the background stands out dramatically. Just such an occasion occurred when I saw a splendid Water Buck standing against the low evening light which rimmed his shape and made the hair around his body appear as though on fire.

With the pencil drawings and notes as to the extraordinary lighting I made a further monochrome drawing showing how and where the light appeared on the animal and on the stones and grasses.

The medium for this picture I thought should be pastel. Pastels take well over each other and I knew that there would be a lot of redrawing and overdrawing to get this as I wanted it. It was necessary to start work on a mid-tone card so that both dark and light colours could be built up, but leaving the background colour of the card here and there. Olive green was the main colour as I remembered the scene, so olive green card was used. The actual body of the Water Buck and the background were of a similar tone value – both as dark as each other. So the first stage was to use browns and greens of equal tone value and bring the animal to light, literally, by delineating the body with white pastel.

Antelope Herd

Water Colour

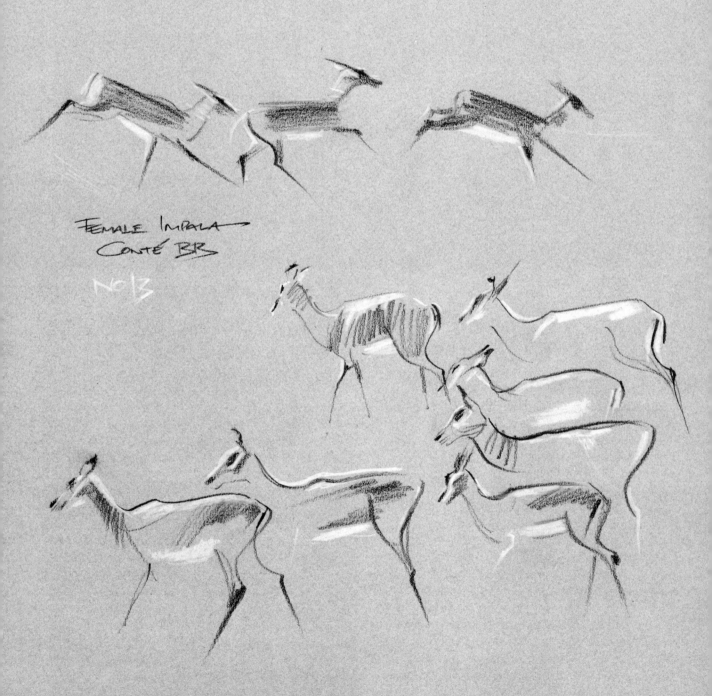

FEMALE IMPALA
CONTÉ BB

No 13

134

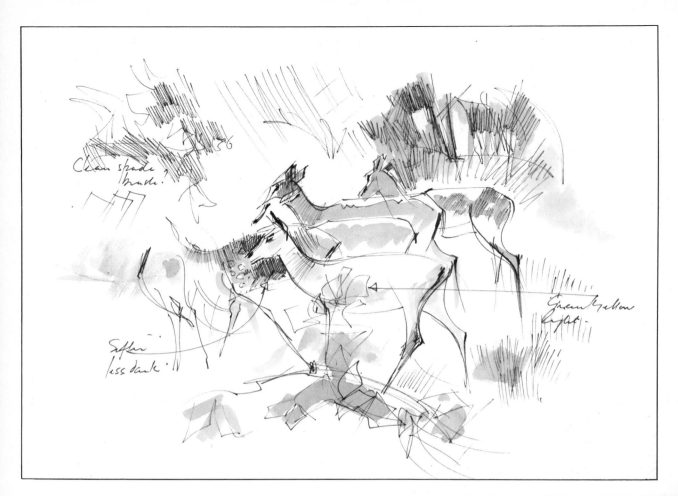

Elsewhere in this book I have drawn a male Impala — a rather dramatic study in Conté pencils. Now I'm attempting a much less formal study of the female Impala. Always seen in herds they move about the African bush, sometimes plainly visible and sometimes less easily seen among the trees and scrub. With their characteristic white markings on back and underbelly and a sort of horseshoe marking on the rear they are easily recognisable. These drawings, made with black and white pencil on grey paper, give some idea of the animals moving fast; and just meandering about happily!

The pen and wash drawing is a rough idea of what I want to do as a water-colour. I'm going to use a brown fine-point marker for the drawing. This is a non-permanent marker so when I come to use watercolour I must remember the marker will run. This can be quite effective and gives a softer line as the ink merges slightly with the damp surface. I'm working on roughish watercolour board — a delight to use for both hard edge painting and soft edge work. 'Tide marks' are not so evident on the textured surface.

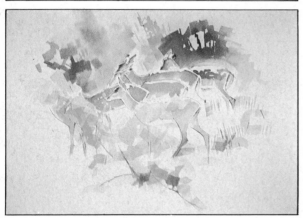

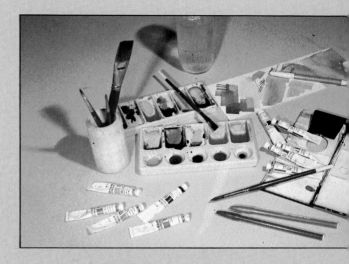

▼ 1 Brown marker pen, Raw Sienna and Cadmium Yellow mixed and diluted for the first stage.

◄ 2 The blues and yellows, mixed, diluted and less diluted with water are used to make the greenery.

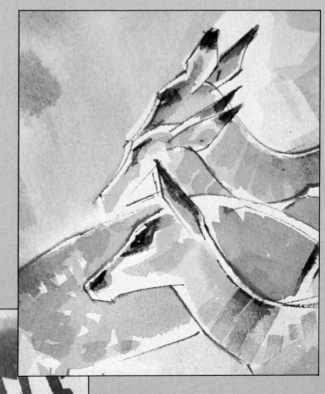

▲ 3 The subtle colours of the Impala are made from Ultramarine, Cadmium Orange, Raw Sienna and Scarlet Lake, with a touch of lamp black.

▲ 4 The reddish browns and slate grey colours can be seen here in detail, also the effect of water on the non-permanent marker ink.

◄ 6 Pointed and spade shaped brushes.

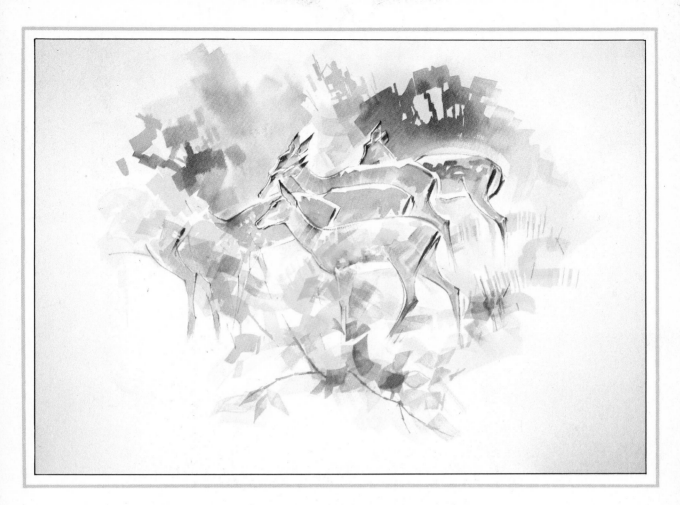

I'm using three or four brushes and making use of their shape. A No 9 soft, pointed brush is used specifically for keeping areas of the board damp with clean water. This is for when soft edges are required in the painting. A No 8, similar brush for laying down colour on the animals, while two 'spade' brushes are used for the stylised tree shapes and leaves. These bring about a very square brush stroke or can be used to make grasses and twig shapes by dabbing the brush rather than pulling it across the paper. The two markers used for the drawing are brown and orange. The water-colours are Raw Sienna, Ultramarine, Cobalt Blue, Cadmium Yellow, Cadmium Orange, Burnt Umber, Scarlet Lake and Lamp black!

ANTELOPE HERD
Water-colour
26" × 21"

Giraffes

Acrylic

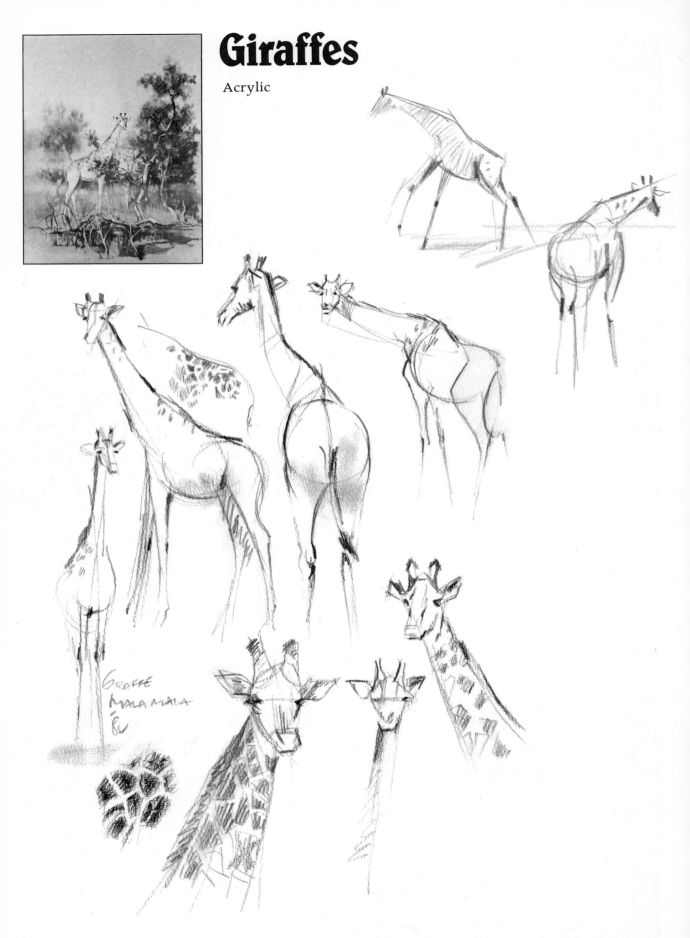

Groffe
Mala Mala
'8[

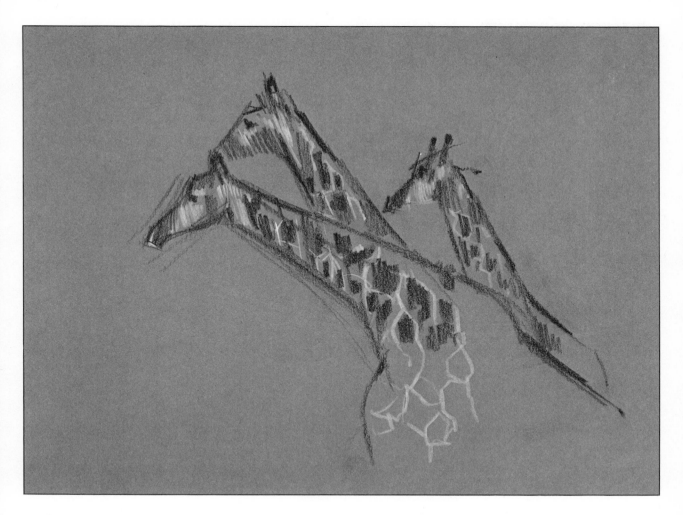

A very popular creature, the giraffe. Ever since zoos have imported them for the public to see, their height, their slow motion movement and charming docility have captured our imagination and made them a great attraction. My daughter, taken to Chessington Zoo on her fouth birthday, had her day made for her when a giraffe lowered its head from some eighteen feet down to her level and nuzzled her neck.

Twenty-two years later she still talks of it. I have watched giraffe in the the early morning before the mist had risen from the ground and in the short African twilight I have seen them moving like long thin ghosts, only their faces and ankle socks showing as pale forms against the darkening bush. I learned much more about them than their appearance, I saw how they moved and what they fed on. I had no idea that their blood circulation was so complicated. As the giraffe's brain is such a long way from its heart it has a blood pressure three times higher than ours in order to get it there. This leads to all sorts of complications, but nature has it all worked out. The giraffe can still eat and drink at levels of extreme difference without ill effects. I've shown the giraffe in my acrylic painting as I remember them one early, misty morning. The prepared water-colour board has a diluted acrylic wash of cobalt blue and raw sienna as a background. When dry the animals were drawn in lightly with a pointed brush and grey-blue acrylic.

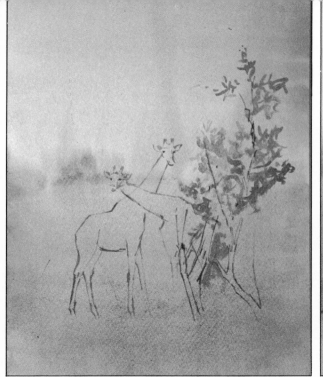

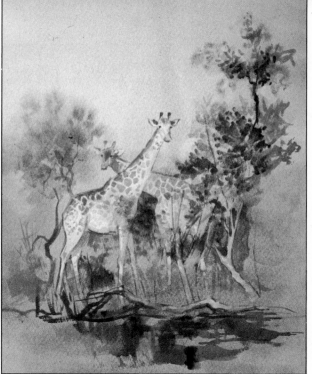

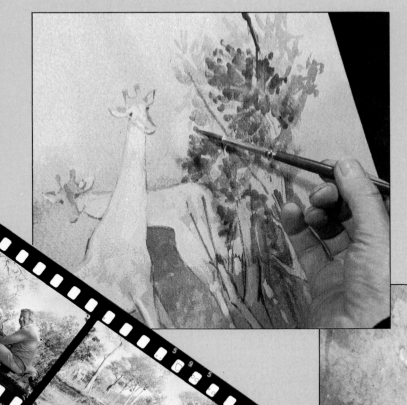

▼ 1 First stage of drawing and painting.

◄ 2 Raw Sienna, orange and browns are used in moulding the bodies – no detail of markings until this is done.

▲ 3 The trees are looking too detailed with leaves and a damp paper technique looks more effective.

▼ 4 The markings follow a pattern. They are not just spots but regular four- or five-sided forms, often with a darker rosette within the form. They resemble leaf shadows which effectively camouflage the animal.

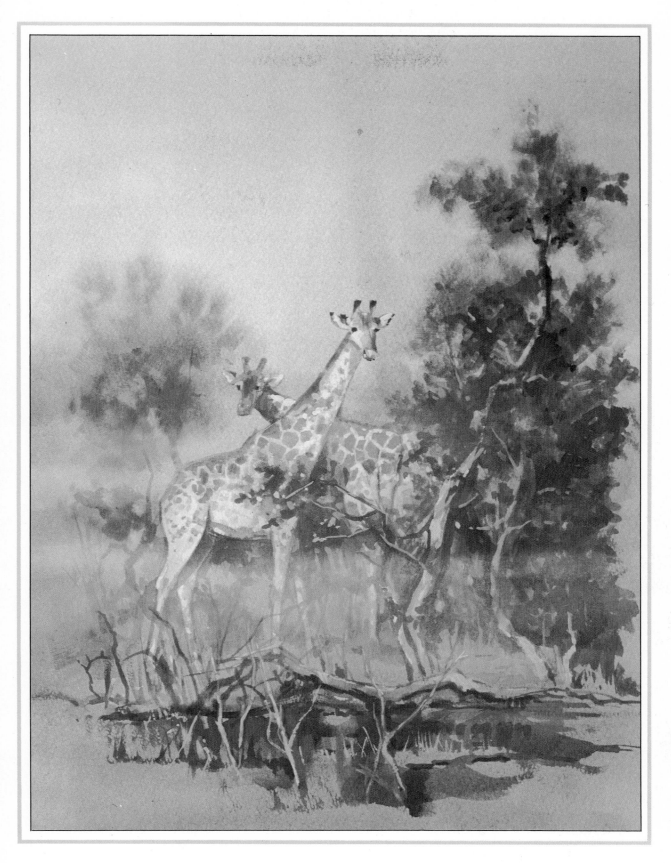

GIRAFFES
Acrylic
19" × 14"

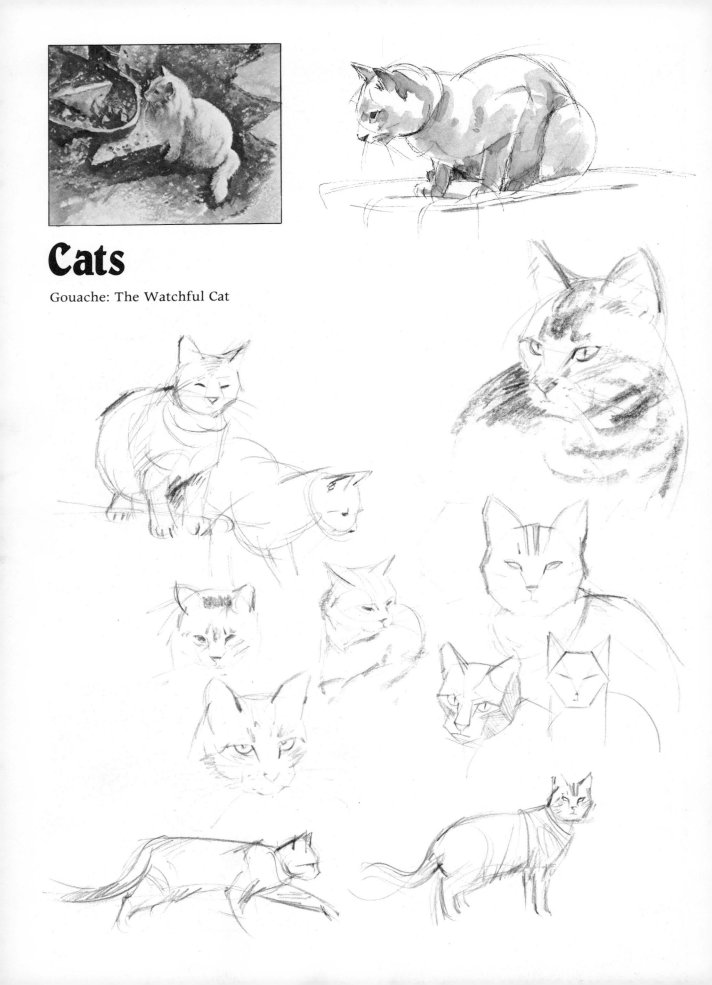

Cats

Gouache: The Watchful Cat

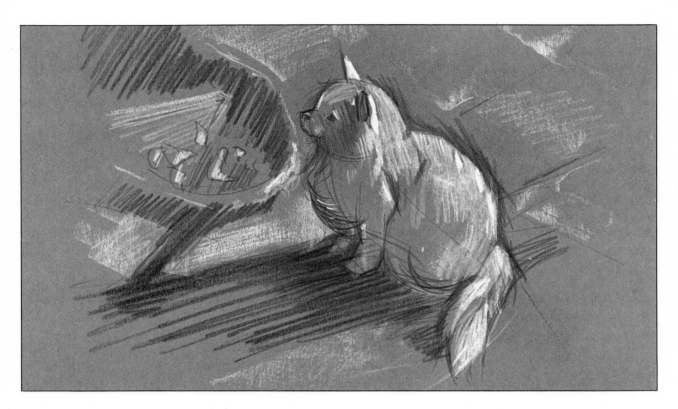

I'm fascinated by cats. The way they move, the way they don't. Their enigmatic expression and their utterly self-centred way of life. I watched a cat watching a spider. It was still watching after I'd committed it to paper. The creature in my drawing looked more like a Pomeranian than a cat so some alteration was necessary for the painting. Gouache is really only a water-colour. Mixed with white, and sometimes with gum, it is more opaque than water-colour and can be used as a sort of delicate poster-colour. For my picture the light was important. Highlights were introduced on the shadows on the right. Fur is difficult to paint, and on this occasion I dampened a very rough water-colour paper and poked a mauve-grey colour at it with a pointed chinese brush and let the paint spread and fill the depressions in the highly textured paper. The texture was so marked that I've made a wax rubbing of it just to show you what I was painting on. This kind of surface would be ideal for the basis of a cave painting, rather like painting on rough stone. However, the grain of the paper chosen in this case to emphasize the texture of fur produced an interesting effect. You can study this in the close-up picture in the stages of work.

Seagulls in Monterey

Ink and Wash

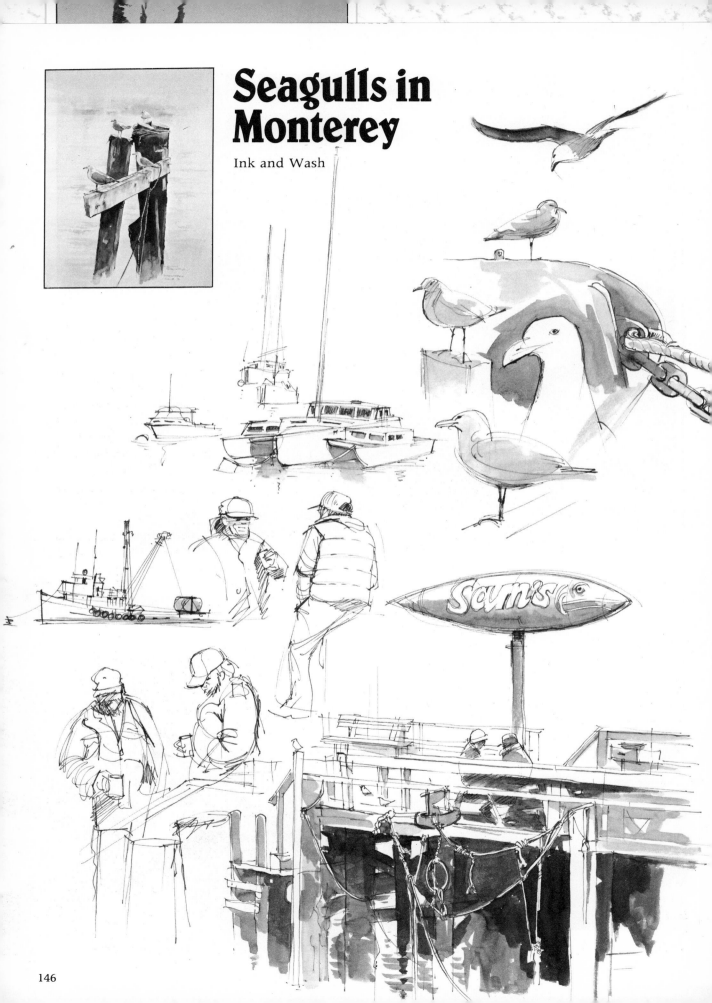

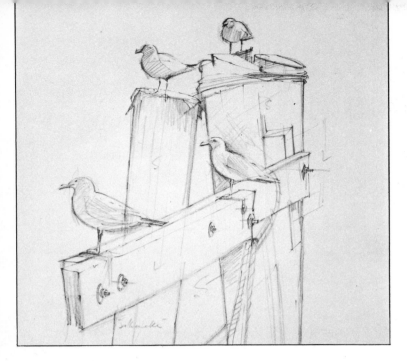

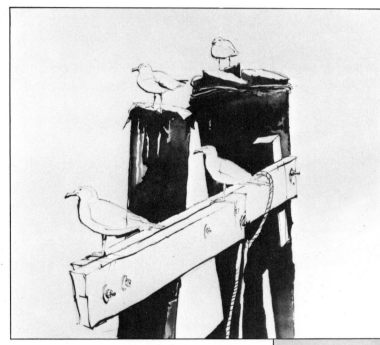

right, all the fishy, edible perks available.

The picture I wanted to make was of four tough birds on dried out, tar-stained wood posts. The drawing, taken from the rough pencil sketches, was done in ink. Sometimes a normal pen doesn't have quite the effect needed. It produces too spidery a line. So I used a piece of sharpened wood – balsa wood is excellent, it holds the ink well – and dragged this across the paper making firm, thick lines. This should make you feel quite brave and put you into the right frame of mind for blocking in great masses of shadow colour. Usually I attack this in a half-hearted way and have to paint over these areas time and again to get it dark enough. A mixture of ink and water-colour – black, blue and yellows – give the timber that dark sea-stained appearance. All the sunlit forms are left contrastingly light with rusty reds and seaweed greens staining the planks.

The gulls have their shadow areas painted grey before any feather detail has been attempted. The sea is not tranquil and in the background I've made an impression of boats, furled sails and a feeling that this is a 'seaman's' world.

'It happened in Monterey a long time ago,' so says the song. For me it so happened that I discovered the saltiest seaboard environment I've ever come across. No Spanish Missions, or new Californians moving on horseback up the sun-drenched coast, but a deckboard people, waterproofed against the sea, working and eating amongst the salt-pickled timbers, fishing boats, clam chowder and seagulls – tough seagulls that demanded, as their

147

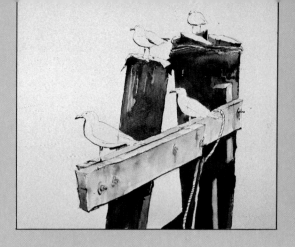

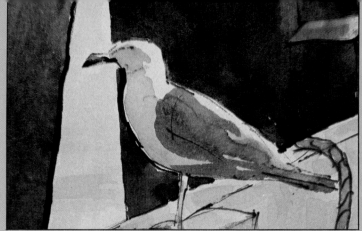

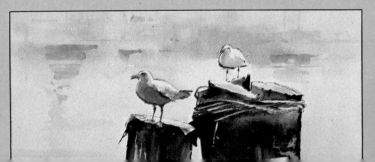

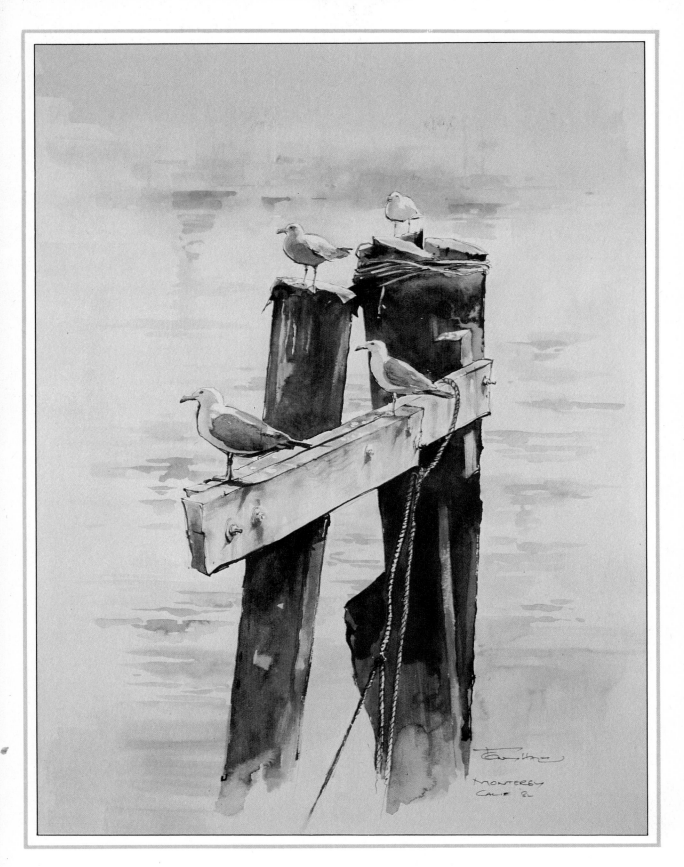

SEAGULLS IN MONTEREY
Ink and Wash
15" × 20"

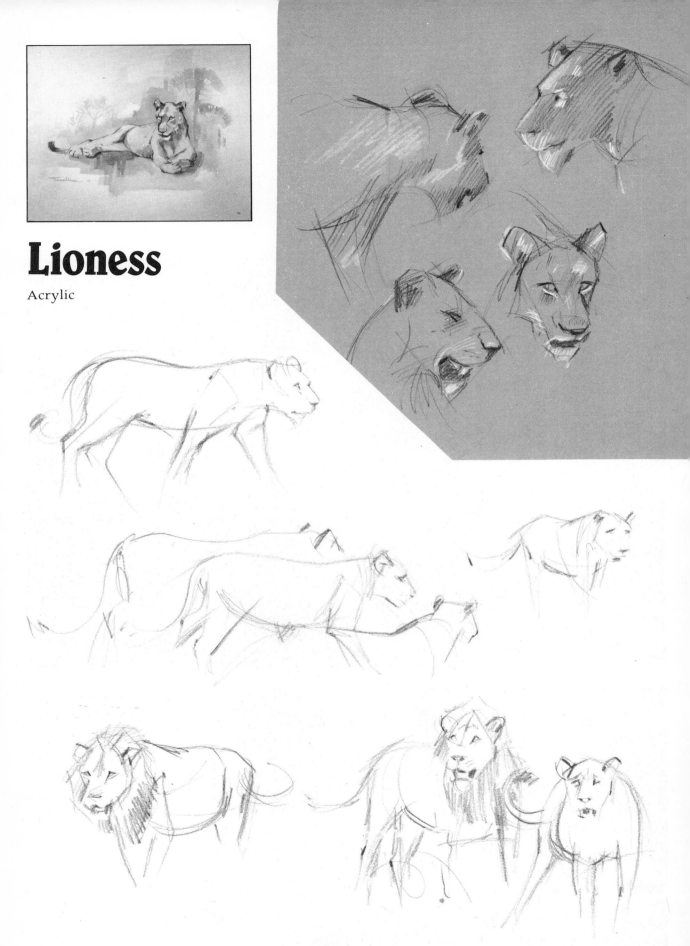

Lioness

Acrylic

Lions are bigger cats and even lazier. Last year we spent hours watching lions in their natural habitat. For the most part they lay sleeping off their latest meal of impala or wildebeest, just opening a disinterested eye once in a while. They seemed to think that both the Range Rover and its occupants were simply another species of animal, harmless and not to be harmed. Unless one were stupid enough to stand up, thereby breaking the recognised silhouette and confusing the otherwise peace-loving lion.

The home-loving, domestic pussy cat is really rather more belligerent than his large, wild cousin. The studies of my friend "Spencer" show how claws, teeth and a snarl come into their own on occasion! That's one difference between the cats. The lion, unless actually roaring, has a benign expression. It's not in the eyes – if you're close enough to notice – but in the mouth. It has a rubbery feel about it that usually hangs in a characteristic grin. Both the colour pictures that I've made of a lioness show this.

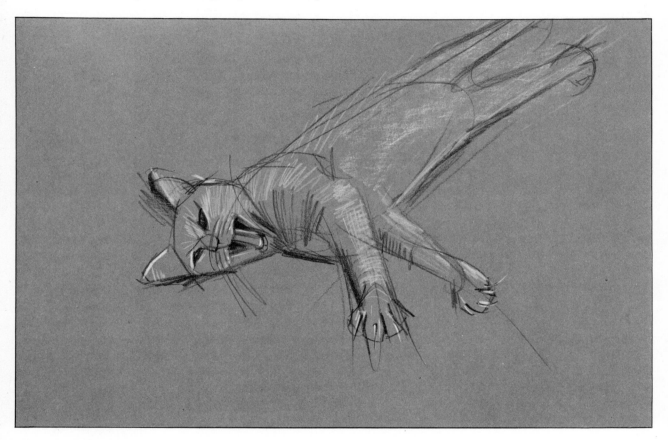

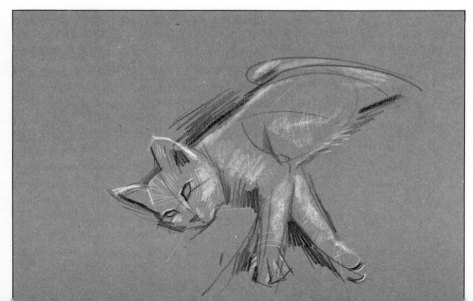

Black and white Conté Pencil on Mid-tone grey card.

151

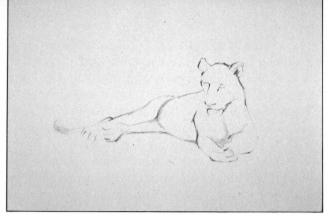

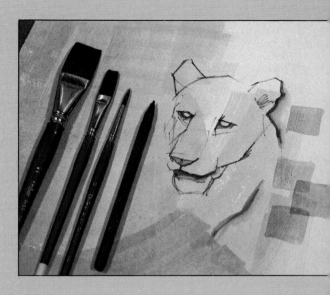

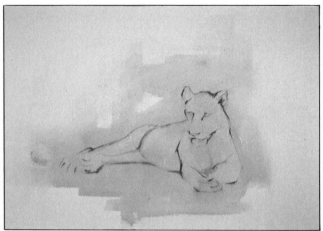

The Acrylic painting shows her in the bush in a completely natural pose. She's been lying on her side with her back legs quite relaxed, then she slowly twisted the upper body and raised her head. The acrylic paint has been used like water-colour. The original drawing was then being given a wash of sandy colour made up from yellow, orange, blue and a touch of black. The original drawing was done with a soluble brown marker which has run slightly when the wash was applied. This has given a colourful, tawny soft line which was very much in evidence. The grey blues of the trees and shadows are also characteristic of Africa. I've used them on dampened water-colour board to give soft edges in contrast to the head which stands out and becomes the focal point.

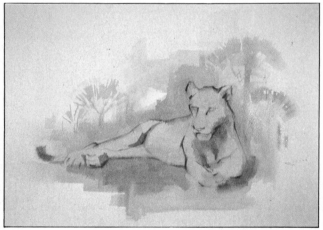

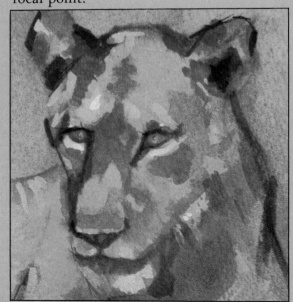

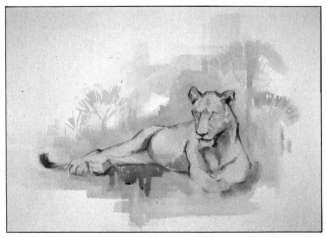

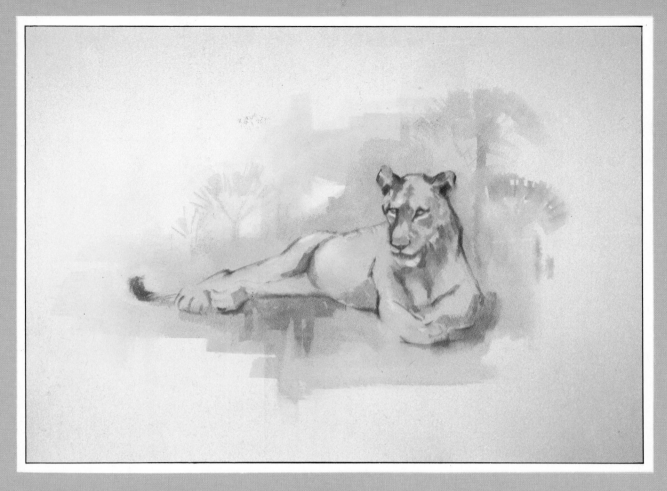

LIONESS
Acrylic
28″ × 21″

▼ 8 and 9 Pastel drawing on Terra Cotta Paper

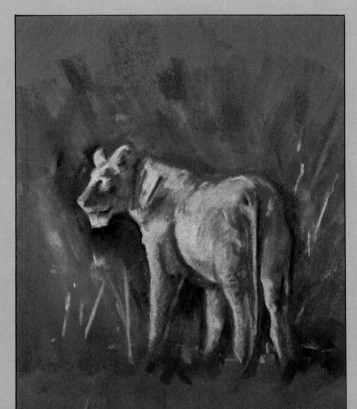

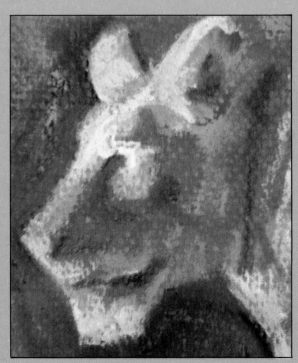

Buffalo

Ink and Wash

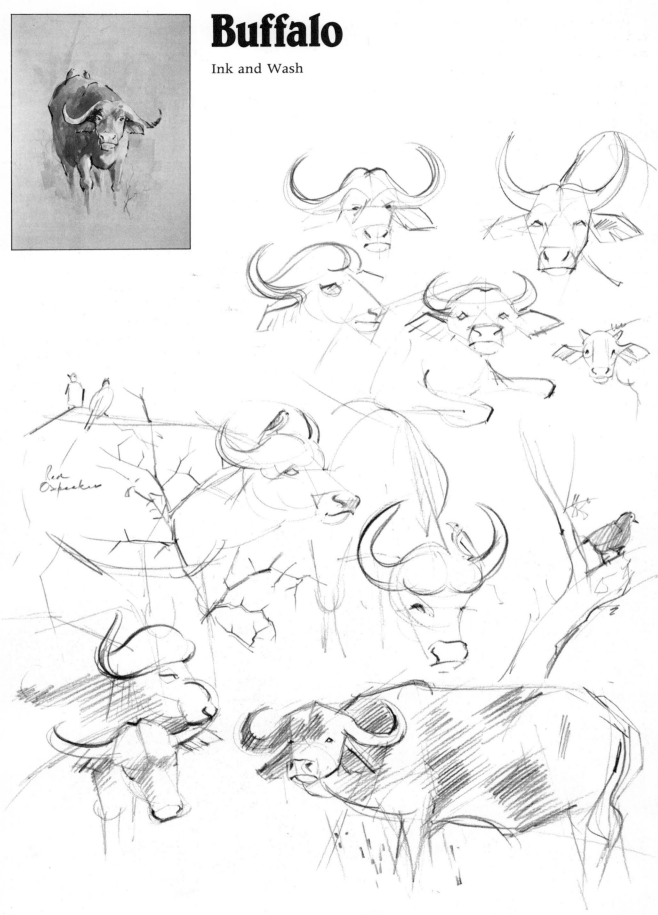

Buffalo look so placid, cud chewing and contented, but when aroused they can be one of the most dangerous of animals. They hear every little sound and are ever watchful. Probably every picture you will ever see of a buffalo will show him staring at you. Although I never left the safety of the Range Rover, I stayed for a long time among a herd. A cow and a bull were so besotted with one another that head and horns intertwined in such a manner that I wished I were a wood carver to sculpt them.

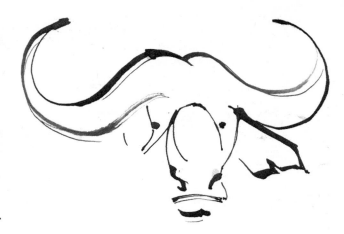

An ink drawing made with a sharpened stick inspired me to try an ink and wash drawing of the buffalo. It turned out to be a multi-media picture, the washes being made up of watercolour, acrylics and gouache! The basis was an acrylic wash of yellow covering a Not Surface Colour Wash board. The watery acrylic was applied with cotton wool. The ink drawing was made on the dry surface with water-resistant brown ink. The stick is ideal to draw with. It makes the odd blot – you never know what it will do next, thick lines, hair lines and lines that peter out. They really determine a well thought out, but casual approach to the colour washes that follow. I used flat brushes for background shapes and most of the body painting. A pointed brush was used for indicating thorn bushes and for the grey and white gouache used on muzzle and horns. This, to tone down the yellow which appears everywhere else. The tick birds are red oxpeckers. They can be seen helping to rid all manner of animals of the infuriating insects that irritate them.

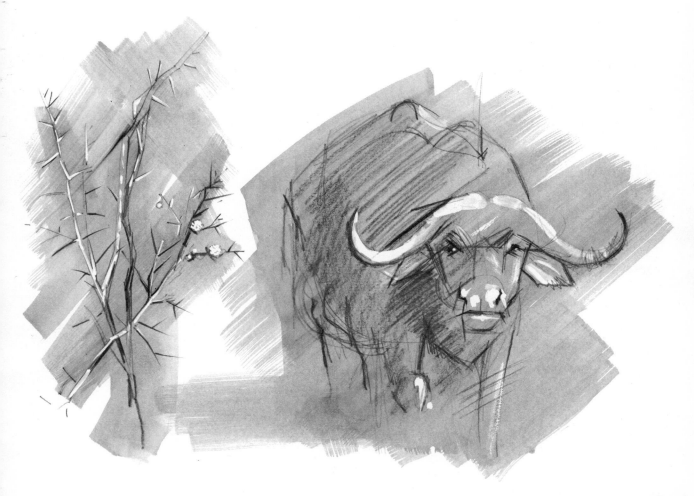

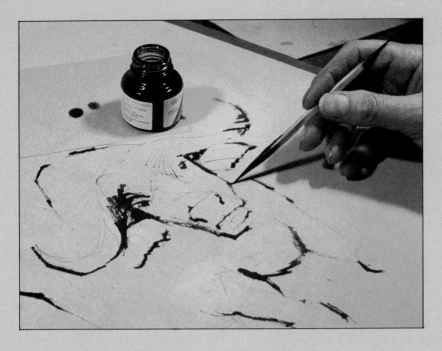

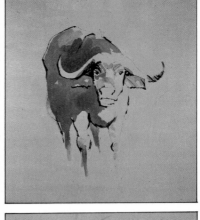

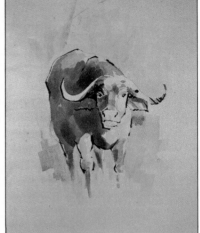

▲ 1 Drawing with ink and sharpened stick.

◥ 2 Red-brown water-colour wash.

▶ 3 Darker wash overlayed and grey-blue flat brush strokes over yellow.

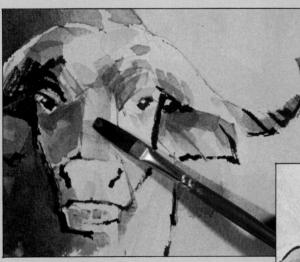

◀ 4 The tones of colour show up the planes of the face.

▼ 5 Grey and white tones down the yellow.

◤ 6 Materials include acrylics, water-colours, gouache and ink.

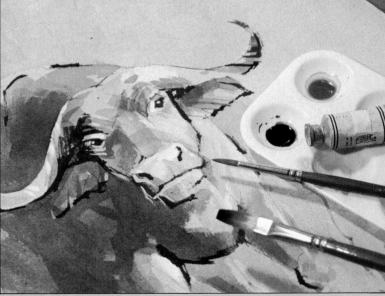

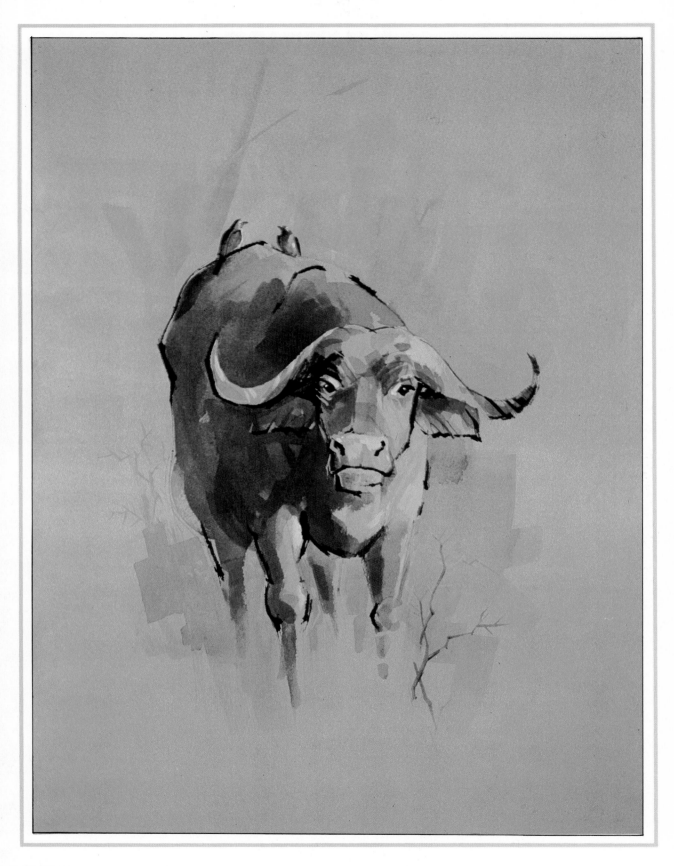

BUFFALO
Ink and Wash
20" × 14"

Bushman Cave Painting

Water-colour and Resist

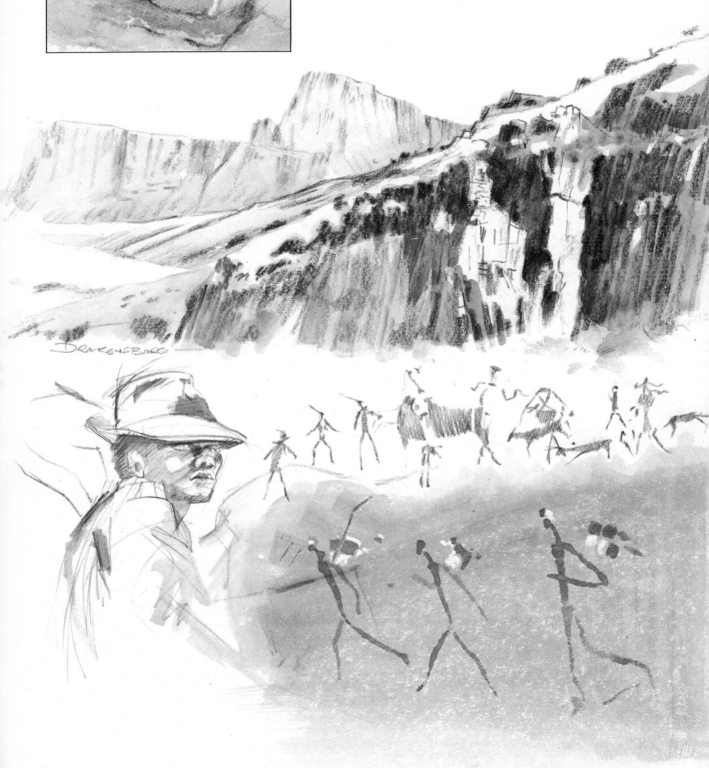

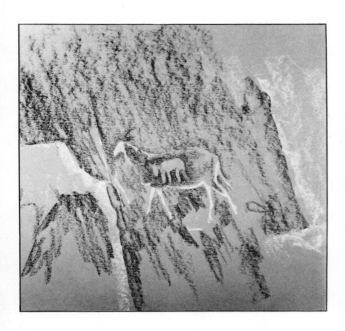

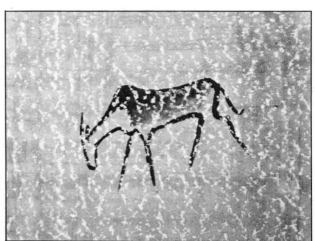

◀ Eland with unborn calf

▼ Candlewax resist and water-colour wash.

I'd long wanted to see the cave paintings of Southern Africa. These, in contrast to the cave paintings of Europe, are comparatively modern. The peace loving Bushman has been recording life on the cave walls for only a thousand or so years; the most recent within the last hundred. Unhappily the Bushman was slaughtered by warring tribes of black men, but his art lives on.

I set out to find some of this work one Easter Day after torrential rain in the Drakensburg Mountains, a sure-footed guide leading the way through meadow-land, craggy rocks and swollen rivers. It was well worth the effort. The paintings, tiny in comparison with those I've seen in the Dordogne, were painted in the colours of the local rock. The bushman used impermanent materials, ochres and oxides from the rock, charcoal, blood and vegetable juices. All the organic materials available. They painted life as they saw it, both animals and humans.

They had great reverence for the eland, an oxlike antelope. They believed it was the earthly form of their Goddess, the Moon. So you find a number of eland painted on the rock. I discovered one, from which I made a copy. It shows what I believe to be a pregnant eland. The nebulous form of a calf within the mother's body. Battles, home life, and hunting are all there on the rock. I discovered an obvious lion and hunter and what I think has to be a giraffe. This I decided to turn into a water-colour reproduction of a cave painting. The texture of the rock was brought about by using a rough water-colour board and also rubbing it slightly with candle wax. This makes it resistant to the water-colour and leaves white marks wherever the candle grease has been applied. The first drawing was done very lightly with Conté Sanguine. Rather apt, Sanguine, the nearest to blood! The colours chosen were all those of the area. Red and yellow ochres and blue greys.

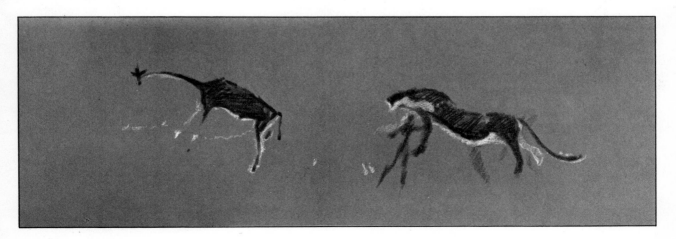

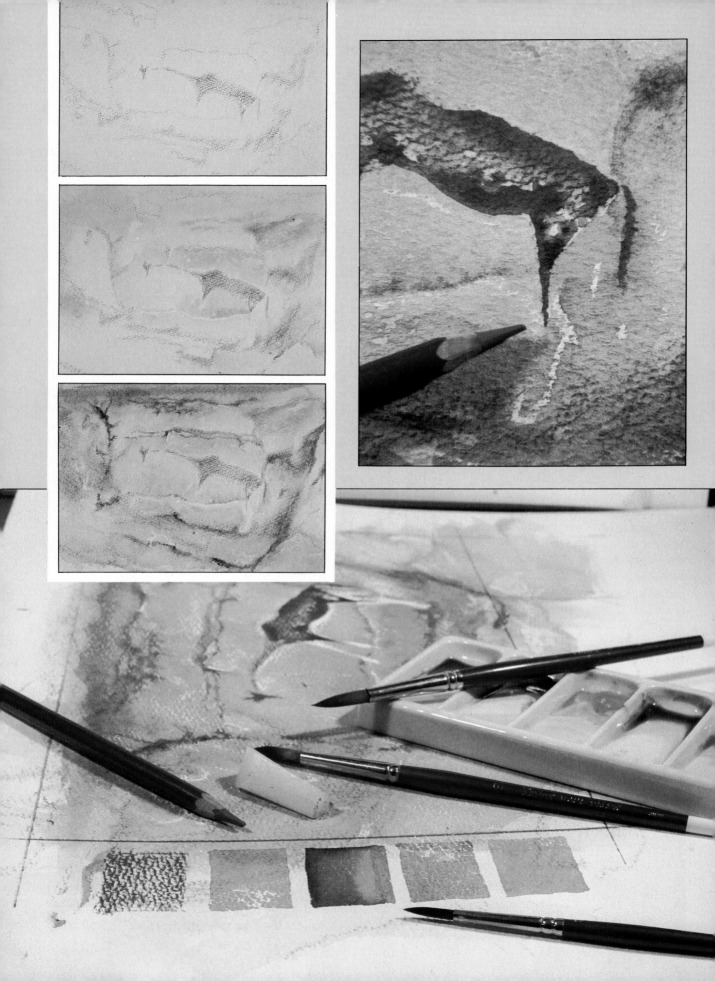

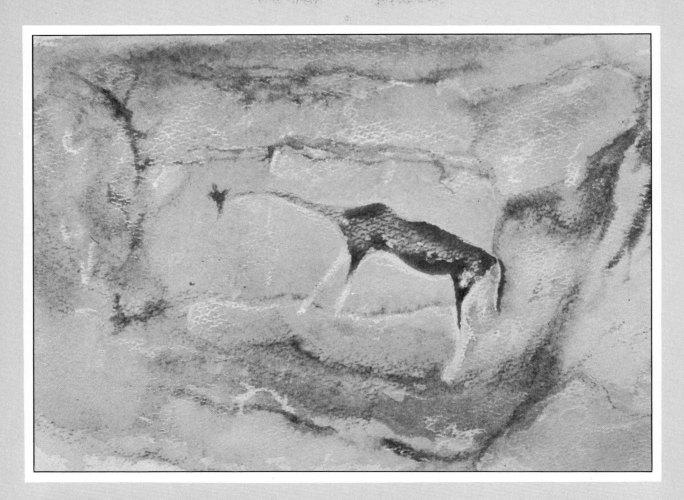

BUSHMAN CAVE PAINTING
Water-colour and Resist
12″ × 8″

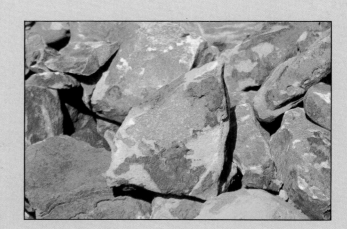

▶ Local rock from the cave area

African Elephant

Pastel Pencil and Water-colour

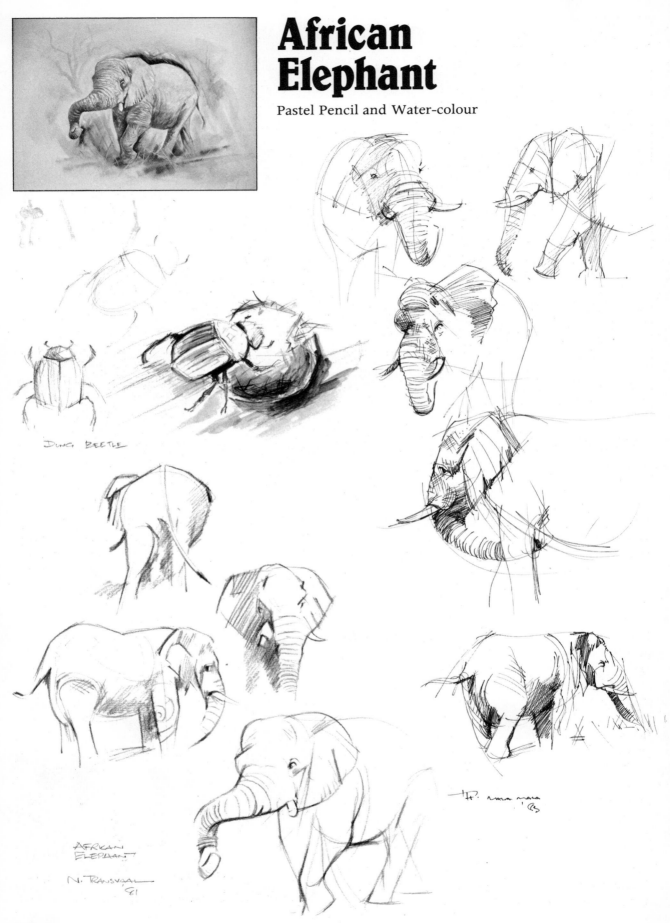

DUNG BEETLE

AFRICAN
ELEPHANT
N. TRANSVAAL
'81

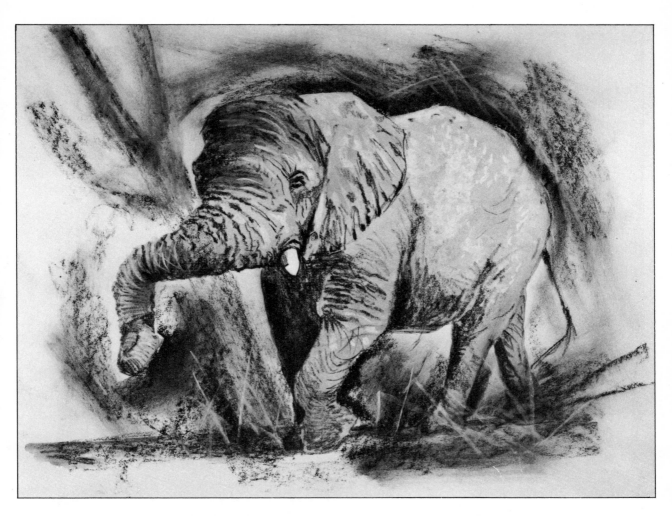

For many years I drew a very particular little elephant for television and as a strip cartoon. Illustrators who indulge in anthropomorphism are attributing to animals human characteristics which, of course, they do not have. It's a form of illustration that has been used since ancient Greece and Rome, and gives enormous pleasure to children, who take it for granted, and to most adults who find it amusing. For an artist who has spent much of his working life in drawing this sort of animal, it comes as a tremendous challenge to attempt to draw animals as they really are. That is why, in recent years, I have taken more and more interest in wild life and in trying to depict it. The greatest exponent of anthropomorphism was Walt Disney whose studio personnel still spend years in studying animal behaviour to bring about a compromise of animated drawing that is surely accepted as genius.

My African Elephant is a study in pastel pencil and water-colour. In the Northern Transvaal we heard a radio report that a single elephant was making his way across the bush, some twenty kilometres from our camp. We bounced and bumped across the intervening land in the Range Rover and found him at a water hole. We watched him for some time, spraying mud over himself until he lumbered

Continued on page 165

163

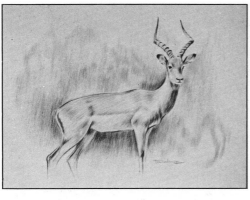

Impala
Ram

Conté Painting
Pencils

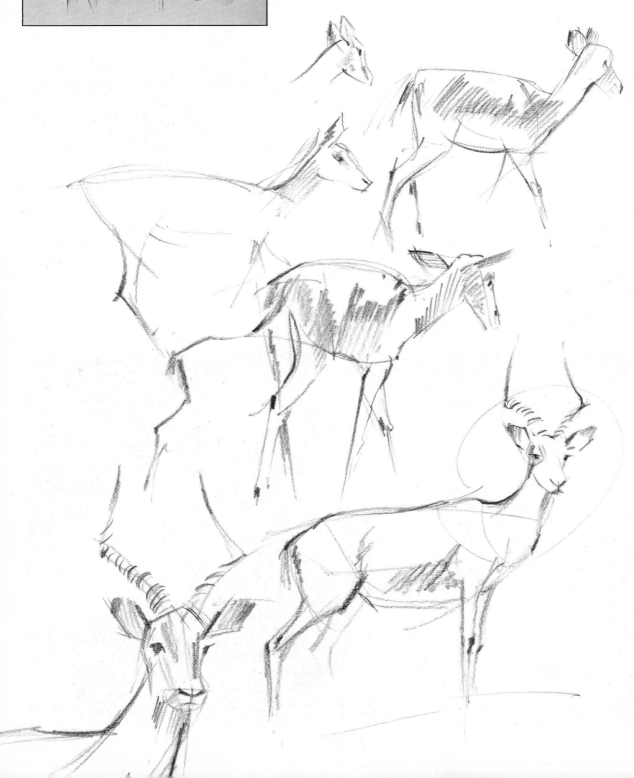

Wild animals are not easy subjects – they are not too happy about having humans near them and they won't stay still! The best animal drawings are done by artists who have a professional knowledge of animals, live alongside them and study them all the time. We, who just have an interest in drawing them, need all the help we can get. So – all the rough drawings you can make are going to be helpful, so are photographs – up to a point. You can use your own photographs to check on detail, the shape of feet, eyes and all those details the animal won't let you study at leisure. But the quickest pencil drawing done on the spot is worth dozens of photographs. A few lines will capture the way in which a leg bends or a neck is held. So don't try taking an easel, folding stool, pack of oil paints, palette and brushes, canvas, oil, turpentine, and the kitchen stove when you go after a deer in the park or an impala in the bush of the Northern Transvaal. A pad of cartridge paper, A3 size is fine, and a couple of soft pencils are really all you need at the outset.

The little impala is one of the prettiest of the African antelopes, they range in herds and when frightened can make spectacular leaps. The male, or ram, has curved black horns and considerably more apparent dignity than his wives! It is a study of him that I am trying out here, using the Conté painting pencils. These can be used dry like ordinary coloured pencils or with water like aquarelles. I haven't yet made up my mind how I'll use them. The first stage is to redraw the animal to the size I want, using my pencil sketch as a guide. This I do using a mid-tone brown pencil. Later I can use reference for further detail of colour and markings.

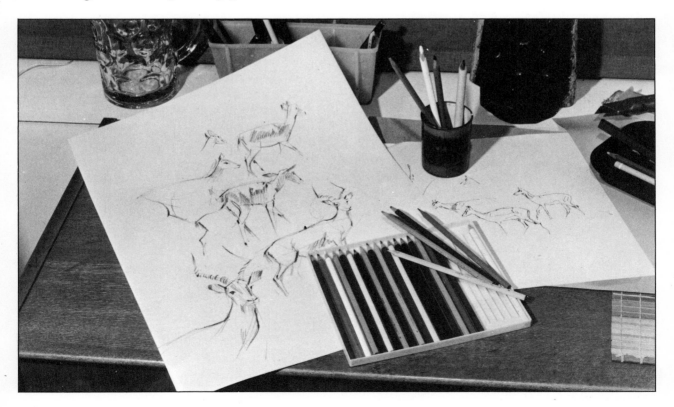

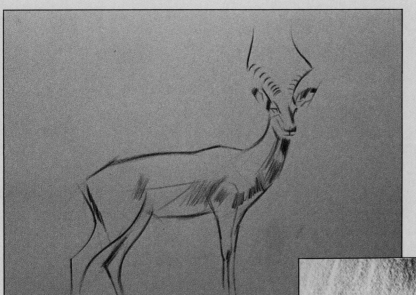

1 The brown conté pencil is used to outline the impala and indicate shadow areas. These lines shouldn't be rubbed out so they are kept light until the drawing appears satisfactory. Now extraneous marks can be lost in the general drawing and the right ones heightened with other colours.

The drawing is being done on an ivory Saunders water-colour paper with a slight texture to it.

▶ 2 This detail of the hind legs shows how individual colours show as separate lines. These will appear to merge as the drawing proceeds.

▼ 4 At this stage I decided not to use brush and water to merge the pencil colours. Seen from a few feet the colours merge sufficiently for effect, but still have the characteristics of a pencil drawing. This also applies to the background.

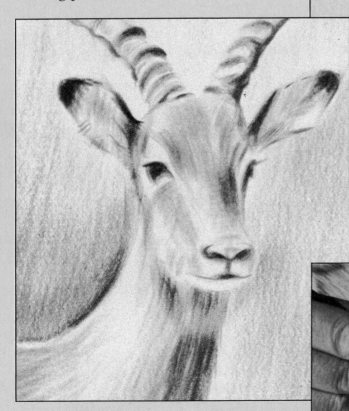

▲ 3 The head is drawn using 2 shades of brown, orange, yellow, blue and black. The black is used lightly to produce tonal greys and heavily but sparingly to heighten shadows.

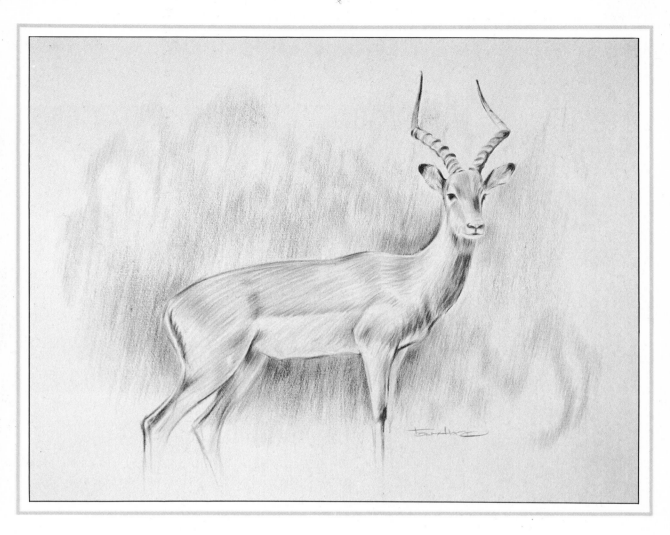

IMPALA RAM
Conté painting pencils on Ivory card
19" × 15"

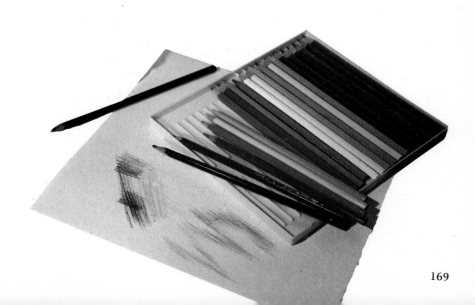

Forest Pool

Acrylic

▲ Any sort of water-based paint trickled down damp paper produces attractive results.

◀ Black waterproof ink brushed over tacky glue. As the glue and ink dry the surface cracks.

◤ Oil paint floating on water transferred to paper.

▼ Black automobile retouching paint sprayed over a glue-tacky surface.

As well as being fun to do, this and all the other pictures in this section could be described as Instant Art. Nature takes over to produce results by gravity or by the reaction of one painting medium to another. I also like to think that the word serendipity covers these abstract pictures. The word means: the faculty of making fortunate and unexpected discoveries by accident!

Multi-media describes the materials you can use. I'm sure you will discover new and wondrous uses for cleaning fluids, adhesives, oil products and various household commodities. The following are useful. Spray paint, glue, paste, oil, ink, varnish and all sorts of paint.

The textured pattern shown on this page was made by crumpling up an 8 inch square of tracing paper, smoothing it out, painting it over with poster paint and transferring the pattern to another piece of paper. You transfer it by the simple process of putting a clean sheet of paper over the wet paint and pressing it down with the hands and fingers.

Opposite is a design made by dripping oil paint on water, laying paper on the surface and removing the paper which takes up the oil paint pattern. There are patterns made by Indian ink brushed over tacky glue. Paint sprayed over glue and pictures made by allowing poster or acrylic paints to trickle down a sheet of dampened paper.

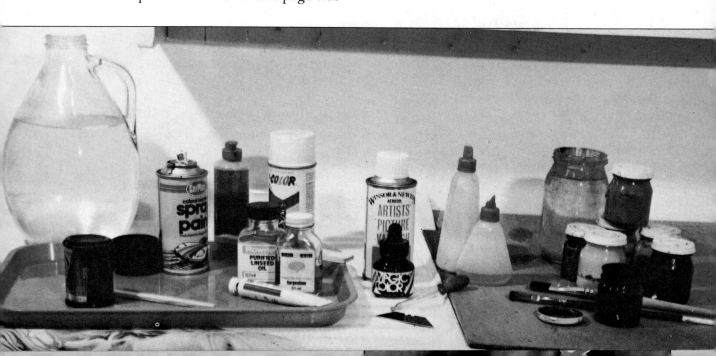

Op Art

Marker Ink

► 1 The author's left eye, enlarged many times, from a newspaper photograph.

▼ 2 Undulating curves that worry the eye if you stare long enough.

◄ 3 Stare at this grid for 15 seconds then look at a piece of white paper! You will see a negative after-image.

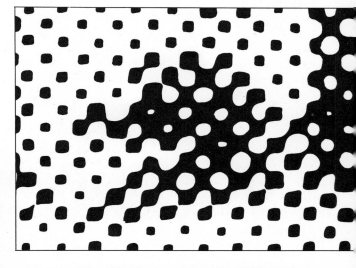

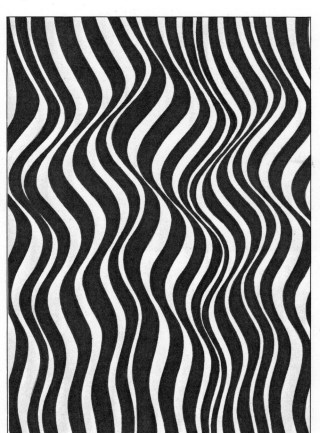

All paintings should convey a mood, preferably the one the artist intended. And often these bring about a feeling of activity or tranquility, gloom or delight. All these require composition and colour to make them work. They can be realistic or abstract. Op Art relates to abstract painting but depends on optical effects. These can be quite deceptive and very often make me feel that the picture is actually moving. The hard edge paintings worry the eye and can produce after images, so that dots or squares are seen again as negative forms. A well-known optical illusion is the Black Square covered with white squares—or is it a white square covered with crossing black lines. Anyway, stare at it and white patches appear at the black crossing

points. There is a great deal of geometry in these optical pictures.

You can make interesting patterns by moving two sheets of plastic netting together. A computer could make such designs and so could we, given enough time. The painter, Bridget Riley, paints pictures that seem to move. Undulating lines like waves. I've made such a design here by using a wavy-shaped template of card and using the same curves time after time but replacing the template in a different position each time and filling in alternate forms.

On the following pages I have made a picture of circles, geometrically laid out, based on a close-up of detail from a newspaper photograph.

A pencilled grid was drawn so that a geometric progression of circles could be made within the squares using coloured markers and the helpful template of cut-out circles. The markers were soluble in water which meant that tones of colour could be washed over the circles using a brush and clean water. Where I thought it helpful to the design I hand-drew diamond patterns at points where the circles meet.

OP ART
Marker Ink
16" × 12"

High Flyer

Pen and Ink

THE HIGH FLYERS' CLUB

got the rough drawing right it's easy to transfer it by rubbing black or dark coloured chalk on the back, turning it over and tracing the drawing onto cartridge paper with a hard pencil. A sort of instant carbon paper which can be used again if necessary.

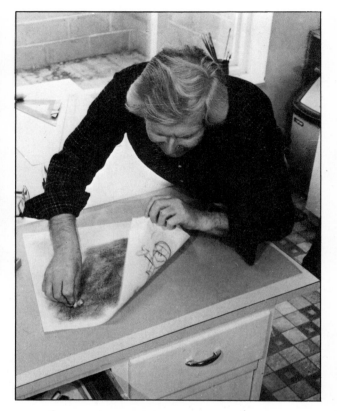

As I said at the beginning, the majority of the pictures in this book are not the sort for which I am generally known, but this one is. For over thirty years I've been a professional illustrator and graphic artist. Most of this work being the sort we call Cartoon illustration. It used to occupy most of my working life. Book and magazine illustrations, cartoons for television and years of the artist's nightmare, the 'deadline' strip cartoon. Nowadays I contribute this sort of illustration to industry and enterprises that you might not think required humorous illustration, like Crime Prevention and Computers!

This project was for a well-known British Travel Agency. Among their clients is an overseas group who encourage their staff to achieve their objectives by rewarding enterprise with holidays abroad. A presentation to this effect is given to members of the group, the lucky winners of which see and hear what is in store for them when, as members of the High Flyers Club, they make 'Peak Achievement'. My brief was to design a character of a go-getting nature, show it rising to and achieving the heights, and also to include in the drawing a logo for 'High Flyer', if I could think of one. Some of the roughs, done in pencil on detail paper, were used to make the final drawings. When you've

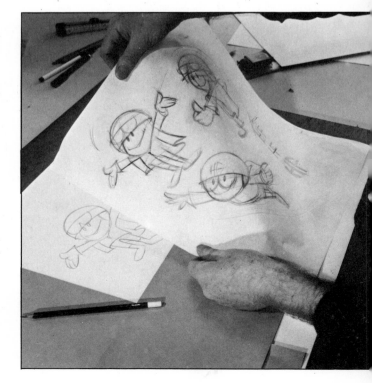

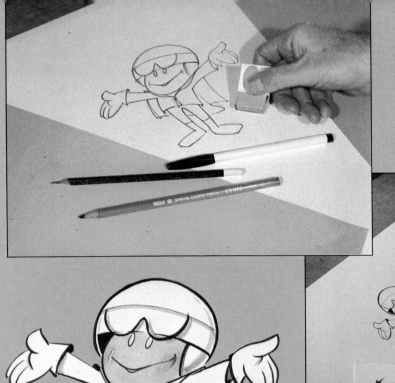

1 The 'carbon' trace has been drawn over with a black fibre-tip pen and cleaned up with a putty rubber.

▼ 2 Lines strengthened and forms filled in with waterproof black Indian ink, using a fine pointed brush.

◄ 3 Coloured drawing inks can be used straight from the bottle or diluted with clean water.

▼ 4 The inks can be laid as an overall flat colour or mixed and used with water to give other effects.

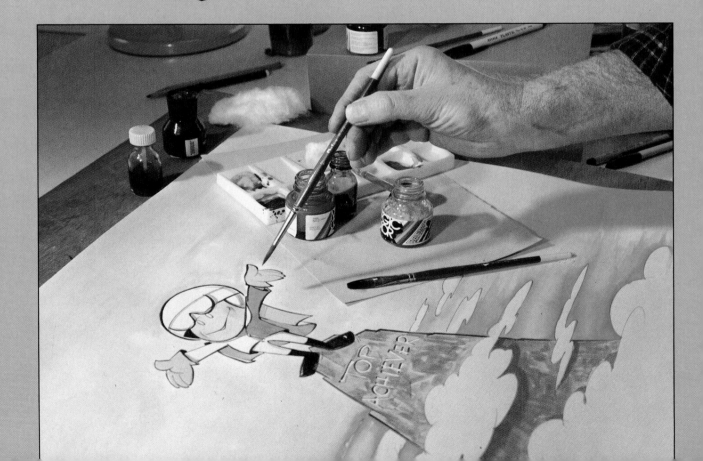

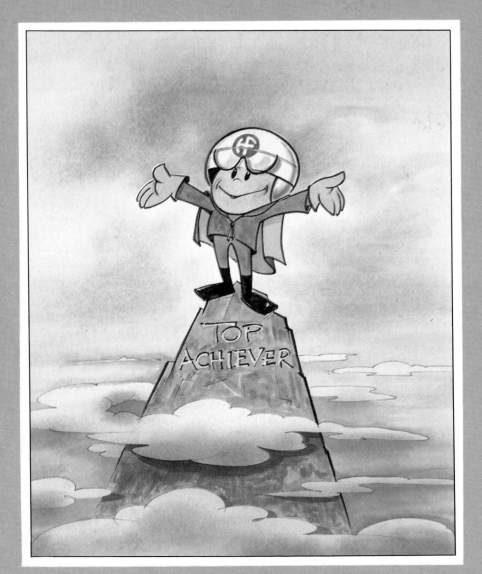

HIGH FLYER
Pen and Ink
15" × 10"
(for 35mm slides)
By Courtesy of
Hunting Lambert Ltd

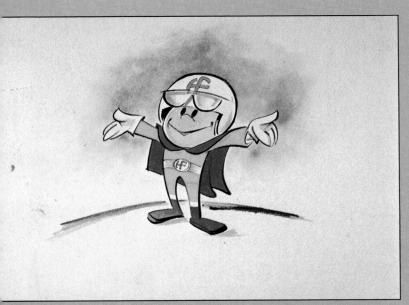

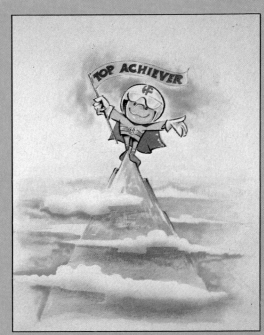

6 and 7 Alternative designs for the presentation.

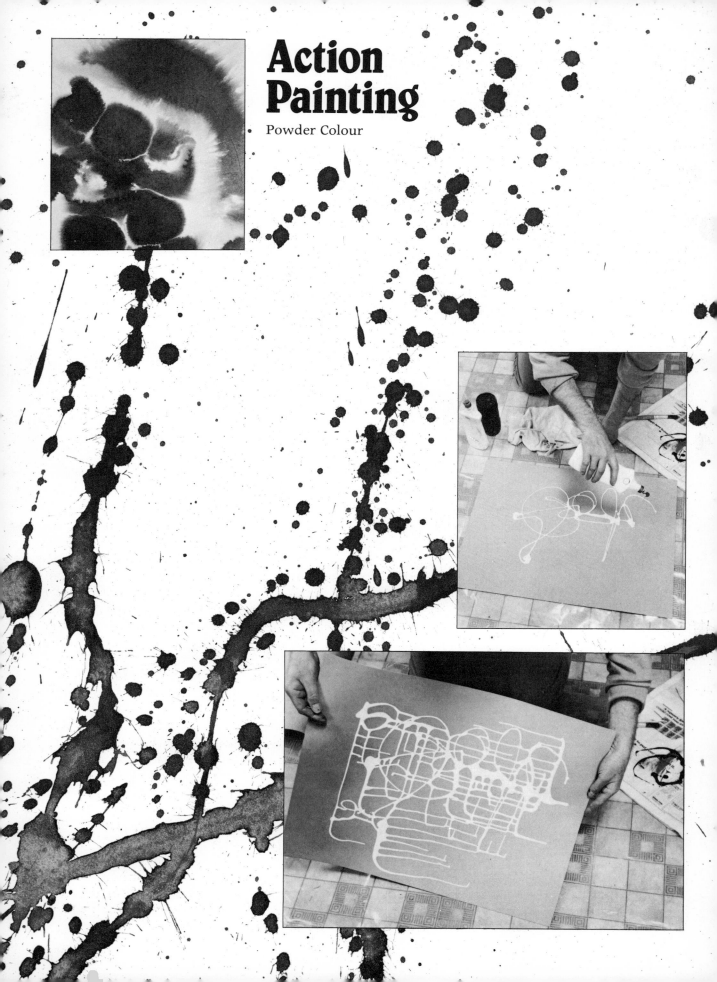

Action
Painting

Powder Colour

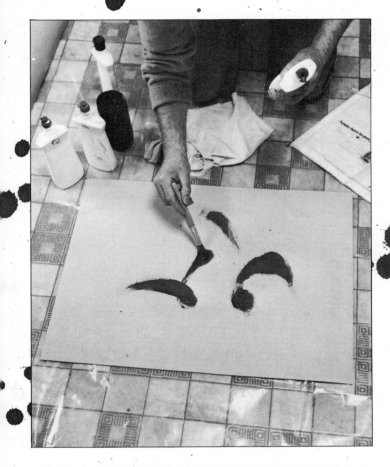

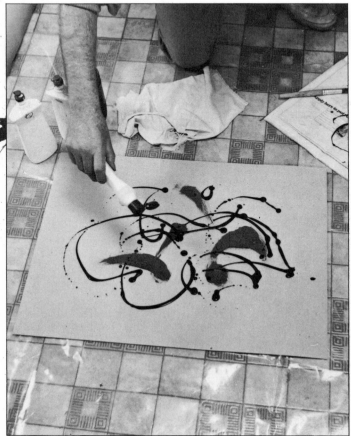

I have never been quite sure as to whether the "action" in action painting applies to the maniacal activity of the artist engaged in his work or the end result! Certainly the finished painting should give a feeling of movement.

I would put this sort of work in the category of Fun Art. Anyone who can command vast sums of money by flinging paint at a canvas must agree. But, of course, you have to be able to recognise a pleasing, colourful composition after the flinging! The abstract picture in the top left-hand corner of the opposite page could be called 'Action Man'. I flung some ink, (well, dripped it then,) onto damp paper without knowing what would happen. The forms look like a soft-edge figure flexing his biceps – see what I mean?

On the same page I've used plastic detergent bottles to drip and squeeze white powder-colour paint onto card. I then tilted the card and let the paint run – turned the card and let it change course, repeating the process until I thought the pattern looked interesting enough.

The painting that starts with a few brush strokes was continued in the same way, dribbling black, white and red onto orange paper. The American artist, Jackson Pollock, painted abstract expressionist pictures like this, but I don't know if he used squeezy bottles. On the next page you can see how colourful pictures made in this way can be.

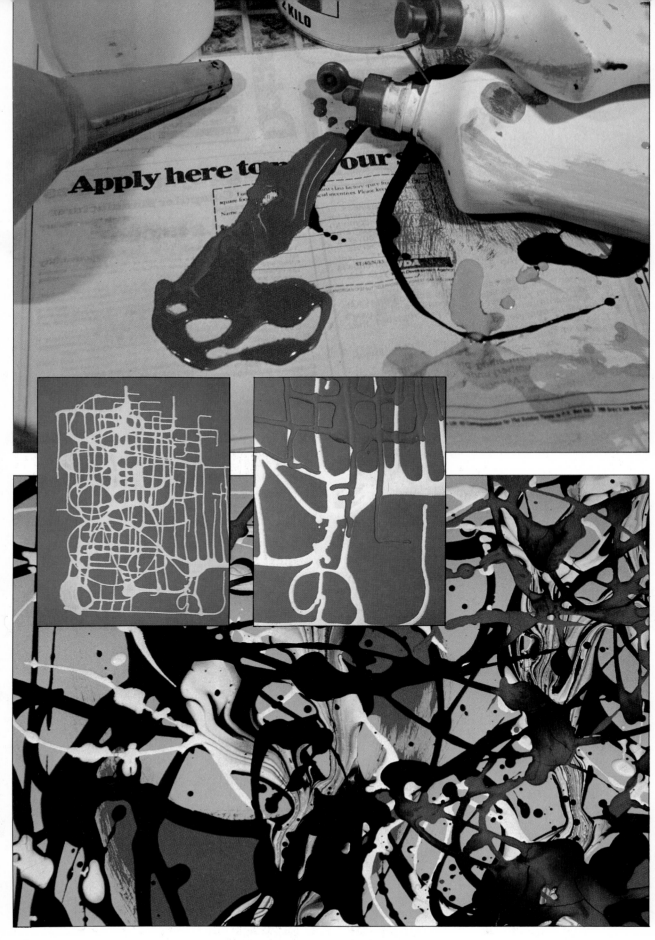

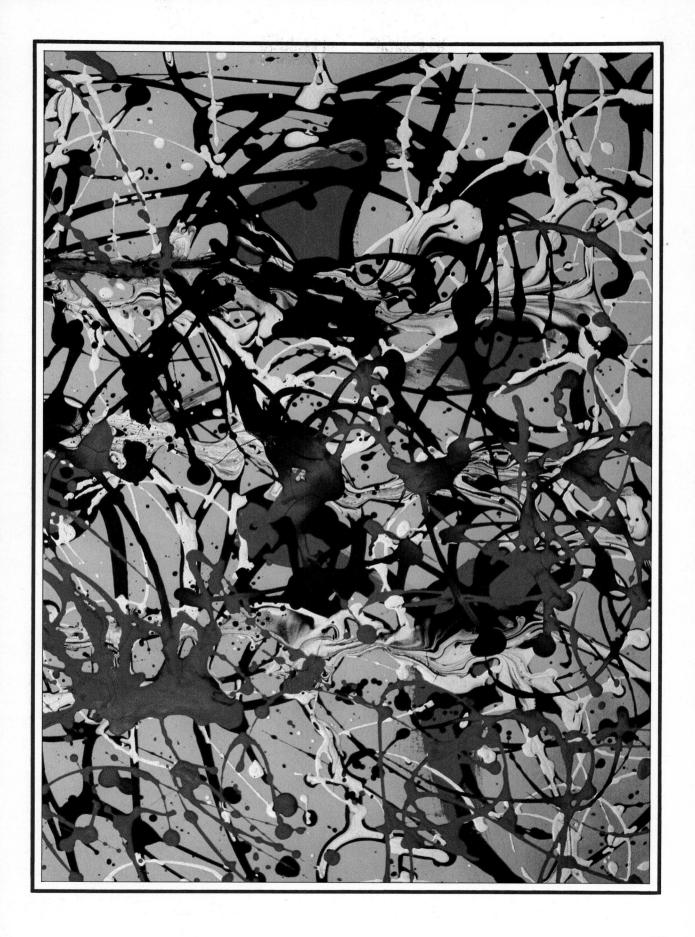

Landslide

Cellulose paint

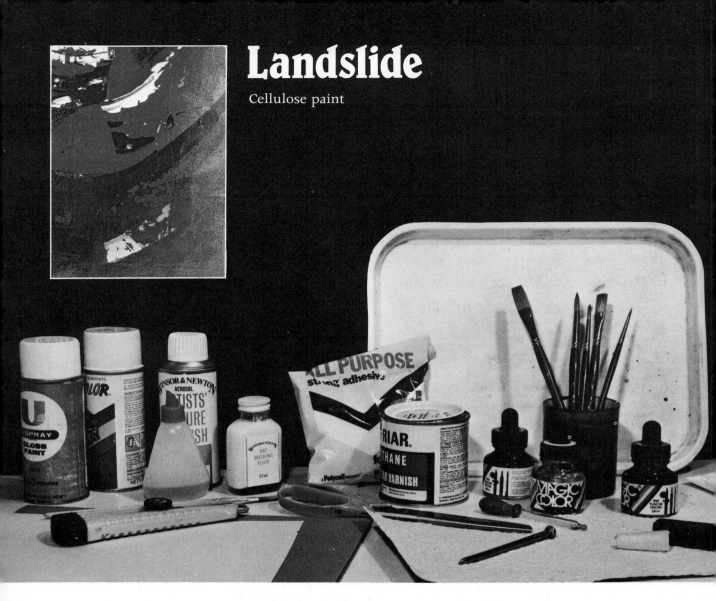

This is not quite such 'Instant Art'! This time the artist has to help the design along. After gravity or natural reaction of the medium on a surface has made a pattern, you can add to it by your own artistry. The cracking up of ink on glue or paste brought about by the drying process produced natural effects. Art can continue the process. I found that a sharp piece of wood or a nail could be used to do this when the media were still wet and also when dry. A craft-knife blade or something similar could lift or scrape the ink from the glue surface revealing any size or shape of form from the underlying card, the colour of the card contributing to the end result. It's worth experimenting with various adhesives on which to put the ink. Some are transparent, some transluscent and a few opaque when dry. Ink can be replaced by any other sort of liquid paint. Some of the experiments will be failures, but others will give

push the lines about in a controlled way. It's just like the feather pattern used on an iced cake and done in exactly the same way. You then transfer the pattern to paper. In lifting the paper from the tray you pick up lots of paste too. This is washed off under a tap and you're left with a delightful result. You can see this on the next page.

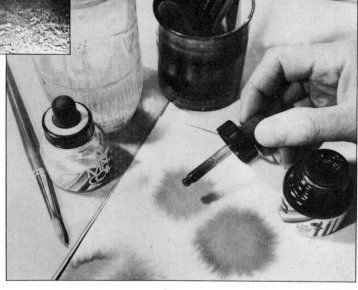

such exciting results as to make you go on and on trying to produce the result par excellence. As in cooking, try to note ingredients, quantities and timing.

The fascinating, cloud-like results of dripping ink onto a damp paper surface can be added to by using a pipette or eye dropper to drip the ink and also to use as a pen to make curves and whorls as extensions of the design.

The other watery way of making patterns with oil paint – Marbling – can be extended to a controlled form. Instead of dripping oil paint on water, in a tray, and letting nature do the rest, you add wallpaper paste to the water, thereby making a very thin paste on which you drip the oil paint. If this is done in a series of parallel lines you can use a stick to

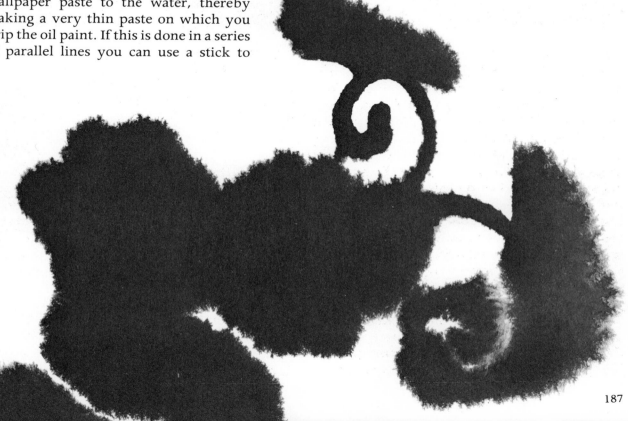

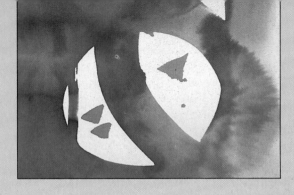

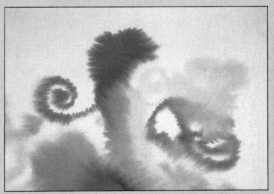

◀ 1 A brush and clean water has dampened the paper but left islands here and there. Inks dripped onto the damp parts find their way everywhere except the dry bits.

◣ 2 The dripped ink has been extended from the blots by using the end of the glass dropper.

◣ 3 Lines of red oil paint on wallpaper paste have been dragged into looped patterns and transferred to paper.

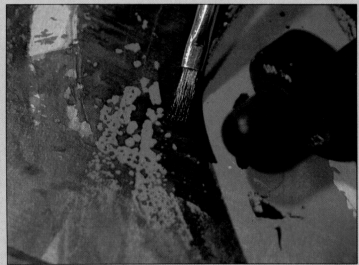

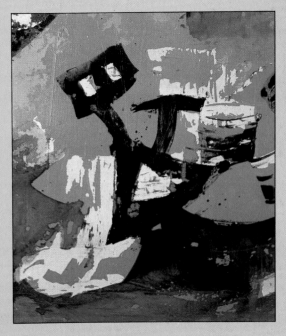

This abstract picture opposite is simply a detail from an experiment. The stages are shown here. The materials used were a sheet of grey card, orange spray paint (automobile cellulose spray) stationers glue and black ink. Having sprayed the card I painted haphazard lines and forms on it with black ink, as the ink dried it was scraped with a knife blade. The end result looked like a robot blacksmith. I preferred to show a detail of this which looked like a landslide.

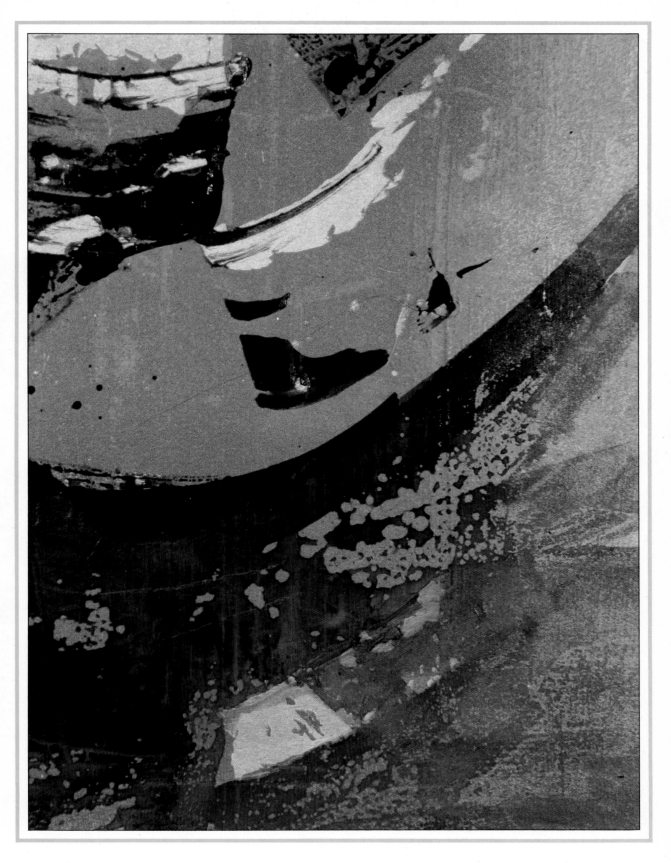

LANDSLIDE
Ink and cellulose spray
$5\frac{1}{2}'' \times 4''$

Abstract

Gesso

The idea for my Gesso Abstract came from the pattern made by a holly hedge against the light. Having photographed an area, enlarged part of it and cut a number of frames, I chose a part that I could adapt. Rough drawings made in charcoal gave me a basis. I prepared a piece of hardboard and redrew my design on that. Now it was ready to make a relief by applying the Gesso.

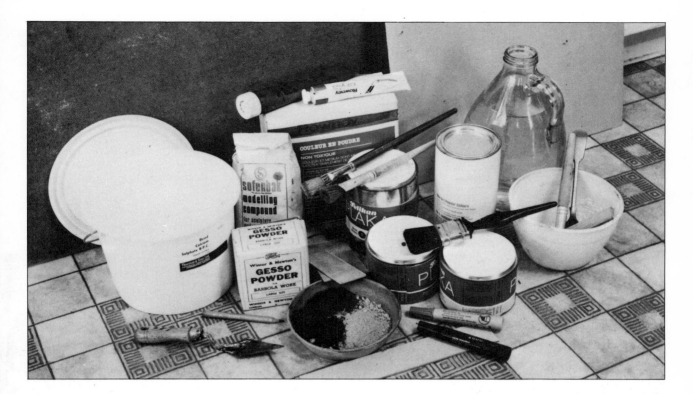

Gesso, as sold in Art Material shops is a ready-to-use preparation containing acrylic polymer, latex emulsion and white pigment. It can be thinned with water and applied to a sheet of hardboard to use as a background for painting or for applying more Gesso, thick and undiluted to create textures. If you can't find Gesso, either prepared in a can or as powder in a packet, you can make a more than reasonable substitute by mixing Plaster of Paris and white powder-colour in more or less equal quantities and adding enough water to make a paste. The more Plaster of Paris you use the less will be the setting time. So if you work quickly you don't need so much P. of P. The powder colour doesn't have to be white. I have mixed green and black powder with Plaster of Paris which turned into a grey-green paste. This was excellent to apply to my prepared board as I could see exactly what was happening. The design was gone over in relief. The thickest parts being shovelled on with a palette knife or a piece of card. An old brush was used for the smoother areas. When completely dry and set hard, I painted it yellow overall with acrylic paint. When dry again I dripped blue ink all over it. The ink found its own level among the hills and valleys and dried in different tones of green. When that was dry I rubbed the highest pieces of the relief with cotton wool until patches of the original Gesso showed through.

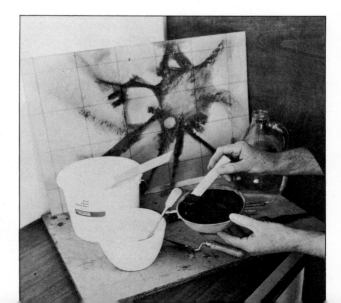

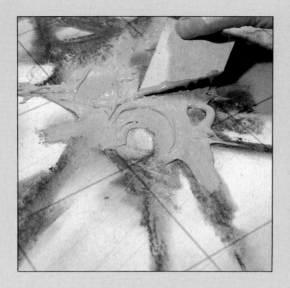

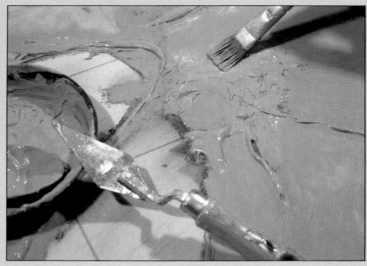

▲ 1 Gesso being applied to the backing board with a piece of card.

◥ 2 Palette knives and brushes can be used.

▶ 3 The finished relief painted yellow.

▼ 4 Starting to cover it with blue ink.

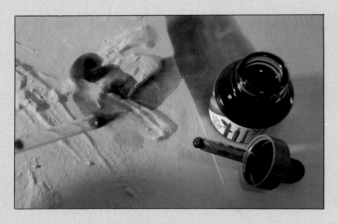

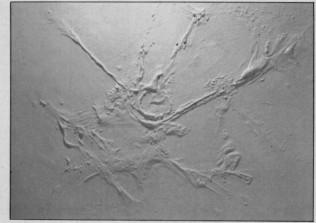

▲ 5 The still-wet ink turns the relief to tones of yellow-green.

▼ 6 Dry and rubbed.

◢ 7 Lighting effects on the relief.

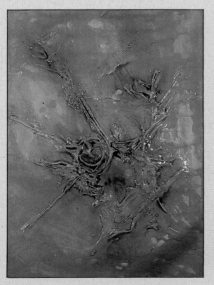

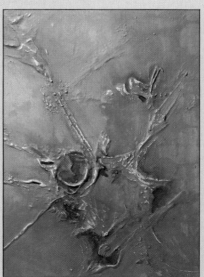

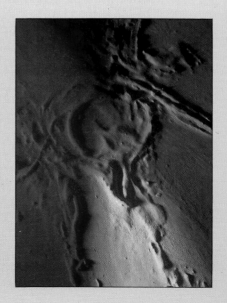

ABSTRACT RELIEF
Gesso
15″ × 23″

Mirror Image Pictures

Powder Colour

▶ If you turn the page sideways you may be able to read what it says.

▼ An ink bottle dropper was used to make this design.

◣ Made in the same way, this design has two tones of ink used.

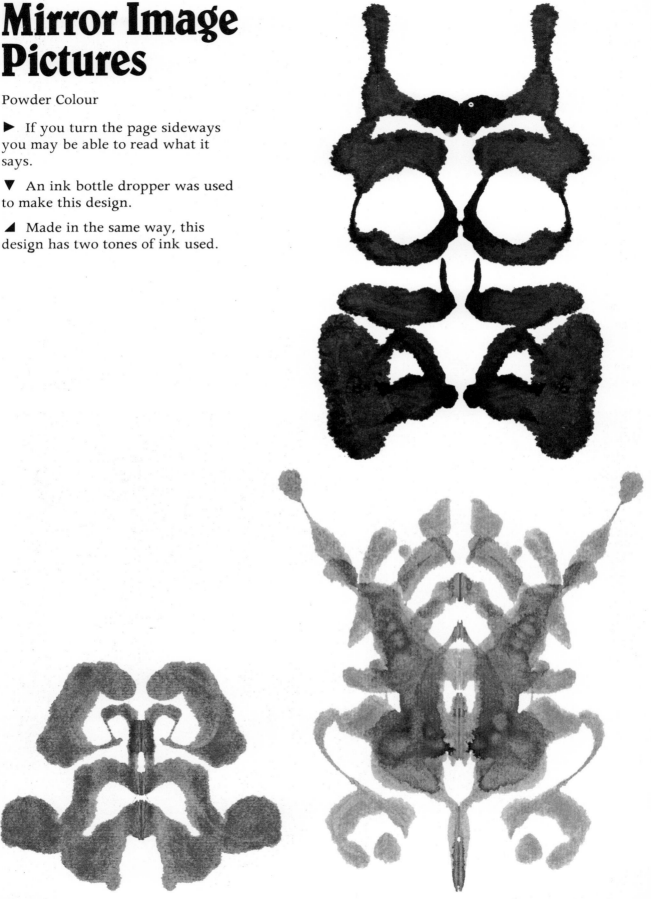

All the designs on these pages have one thing in common. They are mirrored images. Split down the middle, one side is a reflection of the other. You've probably done this in ink with your name, like the BLOT that has turned into Felix the Cat. There is one disadvantage to these designs, you always get a fold mark down the middle because you have to fold the paper after you've put paint or ink on it. You then iron it firmly with the palms of the hands to print one side to the other. I've found a solution for eliminating the fold. Instead of dripping paint onto the paper you drip it onto a sheet of transparent polythene and make the mirror image in the usual way. Then, after unfolding and *not* waiting for the paint to dry, you transfer it to an unfolded sheet of paper. On the colour pages you can see exactly how to do it.

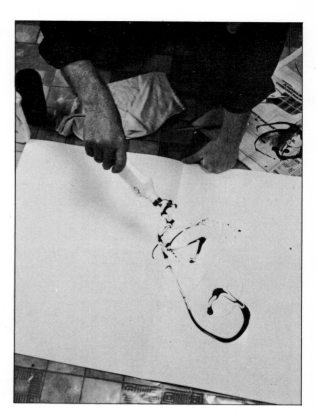

► Black and white powder paint spilled from a plastic bottle onto cartridge paper.

▼ After folding and pressing, the paper is opened out. See how the white paint has merged with the black to produce tones of grey.

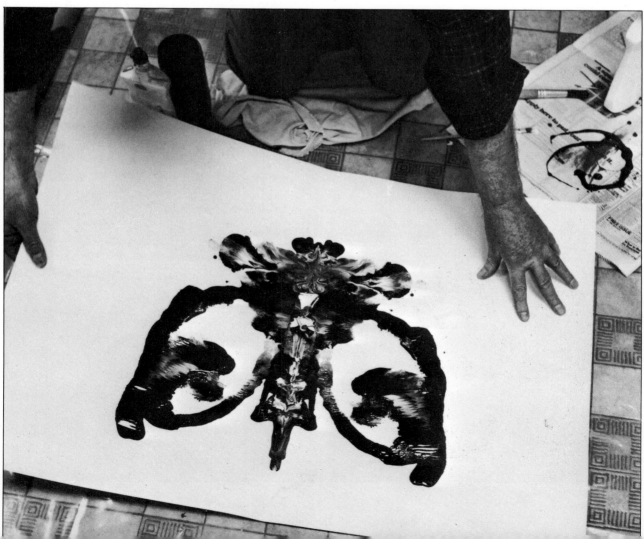

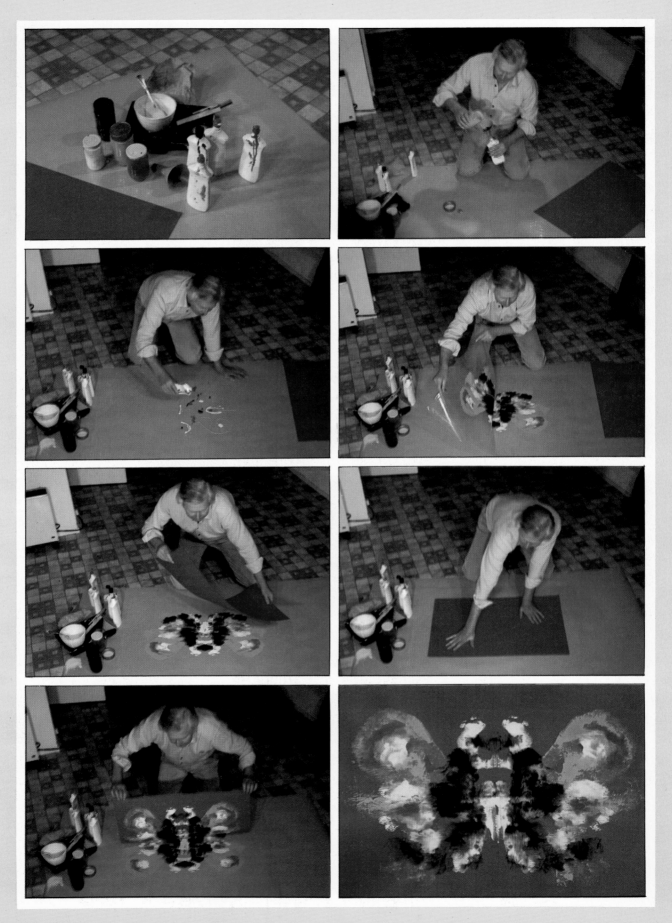

A plastic funnel is useful to get the paint into the bottles. The paint needs to be the consistency of tomato ketchup and, with this process, a little goes a long way.

The colour of the paper on which the pattern is to be printed becomes part of the colour scheme. Paint of the same colour as the background paper should be used sparingly or not at all on the plastic sheet.

After unfolding the transparent plastic sheet, with the mirrored image now on it, place over the still wet paint the sheet of coloured paper and press with the palms of the hand to transfer the pattern.

Beautiful, accidental results can be achieved by this method opening up a whole new field of abstract art.

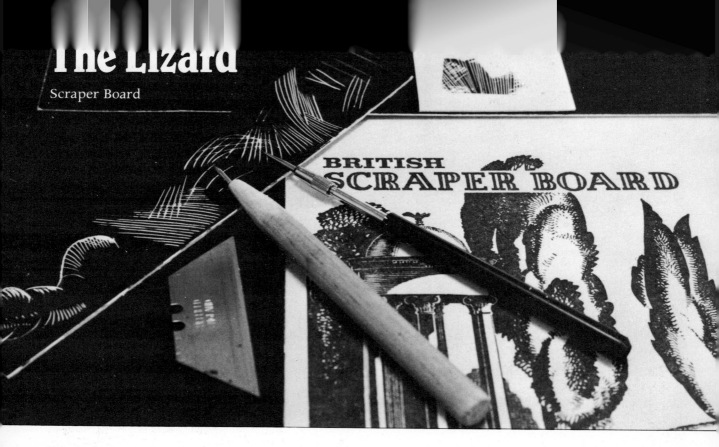

The Lizard

Scraper Board

You can always draw a finer line by scratching with a sharp point than with a pencil. And certainly your lines will never be as clean when made with a white pencil, crayon or anything else. The board we scratch or scrape to obtain these lines is made of high quality card surfaced with china clay and then resurfaced with black ink. The scraping reveals the white beneath the black. You can make a substitute scraper board by covering card with white or light-coloured wax crayon then painting it over with a mixture of black ink and black poster paint. When dry you use it like scraper board; scraping the design with a sharp point. I have a home-made implement comprising a fine nail stuck in a piece of wood.

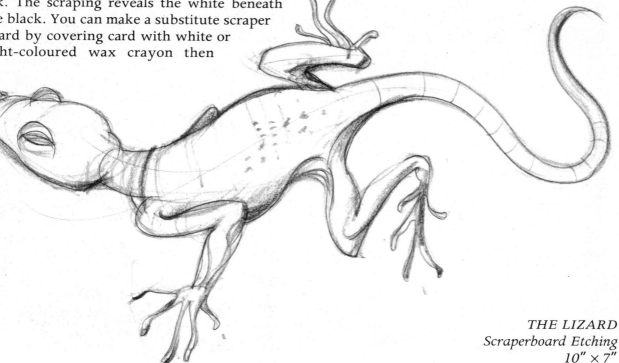

THE LIZARD
Scraperboard Etching
10" × 7"

PERTH AND KINROSS DISTRICT LIBRARIES

Compass sets have steel points among the pens and compasses, these do very well. Craft knife blades can be used for removing large areas of black. Personally I prefer the almost microscopic etchings which bring about the characteristic marks of fine scraper work.

These pages show the stages of etching a lizard designed from my rough pencil drawing.

All the etching was done with the steel point shown.

A duster used as a pad under the working hand prevents accidental scratches or greasy marks on the black surface.

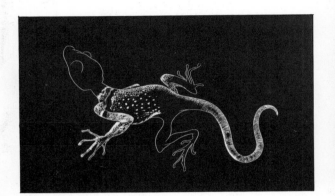

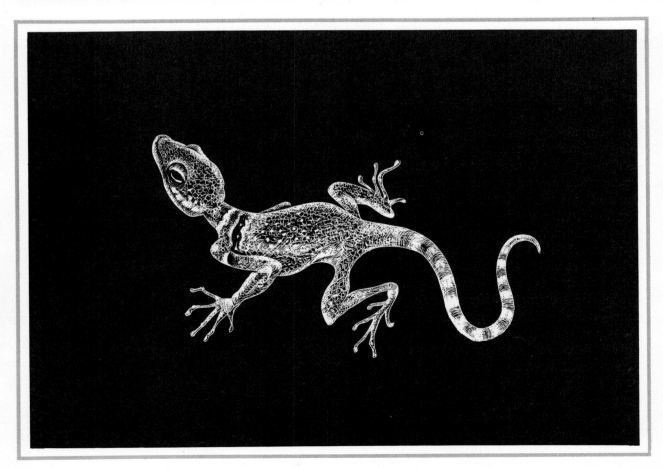